ON DEPICTION
selected writings on art

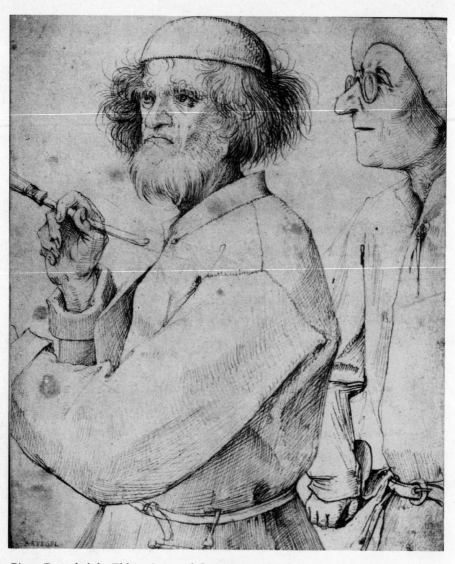

Pieter Brueghel the Elder, *Artist and Connoisseur*, *c*.1565, pen and bistre ink, 25.5 x 21.5 cm. (Vienna, Albertina)

Avigdor Arikha

ON DEPICTION

selected writings on art
1965–94

Bellew Publishing · London

Originally published in French
in a slightly different version as
Peinture et Regard,
Hermann, Paris 1991

First published in Great Britain in 1995
by Bellew Publishing Company Ltd
8 Balham Hill, London SW12 9EA

ISBN 1 85725 063 X

Typeset by Antony Gray
Printed and bound in Great Britain by
Hartnolls Limited, Bodmin, Cornwall

CONTENTS

For Anne

PROLOGUE

Painters are meant to paint. Not to write – and yet almost all did. On technique or theory, diaries or letters. Although it is not by words that a pictorial difficulty can be overcome. Nor can words supplant or even explain the visual sensing of line, form and colour in interaction. Is this attraction to writing due to the fact that painting is mute, often mis-seen, in need of words to shield it? I haven't been able to resist the temptation, going even against my grain as a painter, often studying and writing on artists for whom I had more esteem than with whom I had an affinity, and nothing on Piero or Vermeer, Chardin or the early Menzel. Engulfed in the study of the Classical Ideal, I soon realized that the need for moderation and proportion, on one hand, and the romantic call of vertigo, on the other, are two facets of one and the same drive; that idealism is deeply rooted in the Western world's subliminal notion of art, and some of its components were, and still are, responsible for totalitarianism – not only political, but aesthetic as well. In the end, everything hinges on a hair.

The history of art is a history of exceptions, and cannot be reduced to a history of tendencies, of schools, of 'isms', or explained by social causes. Such an approach stems from mis-seeing and this is the menace to art today.

Paris, January 1990 · A.A.

NOTES FOR A LECTURE[1]

Each generation of young artists seems to stand in front of a closed gate: everything seems already to have been said. Moreover, each new generation of artists seems to have its peephole and its dustbin: the latter defines the former: what's elected for admiration is seen by what's thrown away. The totality of art is never perceptible without partiality. The sequences up for admiration are often alien to subjective taste, but attractive as being exotic or new. Vacillating and uncertain subjective taste then gives way to acquired taste, which emanates from the collective style, a sort of aggregate, expressing the urge for the new. This urge for the new seems to be prompted by its inherent endemic erosion. It tends to set in as soon as a mystery is clarified and loses its charm, having become self-evident. Banal. This is the way the most subjective expressions fuse with reality. And that's how reality is unknowingly, but not simultaneously, perceived through art.

There seems to be a parallel between solving a scientific problem and an artistic one: in both cases the creative moment is the initial state, that of solving a problem, but not the repeated demonstration of its solution. Whence the short periods of 'singing' or intense creativity, and the reason for decay in style, and rupture in collective styles.

The span of collective styles, within which individuals expressed themselves throughout the ages, varied between thousands of years, in the Palaeolithic era, and two decades, as in the case of the Amarna period in Akhenaton's Egypt. The variation is irregular. For example, the Greek classical period lasted about seventy-five years, but the Byzantine style lasted a millennium. The interesting fact, however, is that the periods oriented towards observation and work from life were brief, whereas the dominance of ornament, mannerism or codified styles were lengthy. High Renaissance lasted two decades, just as Impressionism did, but Mannerism went on for about six decades. It would be too flat to state that the modernist creed, which lasted a century, is over. Is it over? Can we say that its terminal phase is over? We

[1] Delivered at the Graduate School of Arts, University of Pennsylvania, Philadelphia, and Yale University, School of Art, in February 1989

11

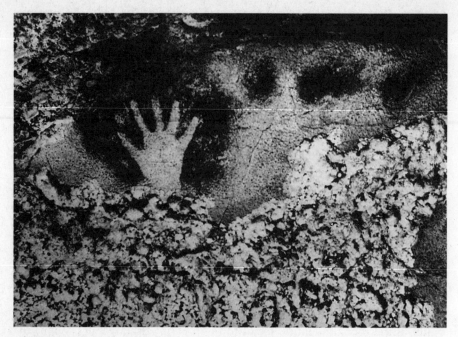

Hand imprints, *c.* 25,000 BC (Pech-Merle, France)

can't really know that, since the modernist creed is increasingly marked by a stylistic pluralism, which has no precedent in the history of art, regardless of its affinity with turbulent periods of migration, invasion and change. In fact, we live in just such a period. But instead of being invaded by 'barbarians' we are invaded by information, by the media. What the 'barbarians' did in Antiquity in disrupting the Hellenistic order, the media do to ours – to all orders. Indeed, the increase of pluralism seems to be due to the increasing rupture. It is due to the fact that no trend other than change remains credible.

Is it possible to paint a picture without aiming for permanence, and let the terror of being obsolete take over and let change wipe out permanence? But an inspired square will remain preferable to any uninspired portrait or figure.

However, rift in style – or shift towards something else – was there from the start. A striking example is the sudden appearance of hand imprints on the walls in the Pech-Merle and Gargas caves (Aurignaco–Perigordian period, *c.*25,000 BC), which, although prompted by magic or religion, seems to have been the earliest group phenomenon of individual expression, of leaving one's mark. (It looks very much like certain exhibitions today . . .) It was a ritual but at the same time the earliest example of fashion. Fashion is indeed an

12

epidemic phenomenon which is followed unquestionably, as if it were a religion. It is a short cut by which personal taste or judgment is eluded, or abdicated, and replaced by participation in a collective expression, still perceived as a ritual.

Taste, subjective taste, and the right to have it, was recognized late. It is, no doubt, in so far as it is tolerated, a phenomenon of high civilization. And yet, even though timeless in principle, subjective taste is apparently always in peril. Whereas imposed or acquired taste is not. Not all civilizations tolerated its bloom.

Emanating from without, collective style reverberates like a tune to a dance. Fashion evolves by excluding those who are inattentive to it and including those who consent to it. But it wears away as soon as it is imposed. In a way, fashion's antinomy is permanence, which is the artist's highest ambition. It is qualitative permanence that enables a work of art to reverberate through time. Not its momentary spark. However, the increase of mediation contributes to enhance the spark and obscure the permanent qualities.

We are now in the midst of a period without precedent in history: *difference*, which is the root of identity, seems to be in peril. Although all is open, and maybe because it is so, all seems closed. Furthermore, and because of this peril, qualitative differences seem to dim, and with them the difference – between viewing pictures under natural or artificial light, between an original and its reproduction, between painting and poster, genuine and fake, art and rubbish – seems to vanish. All appears to be equal under the power of the media. One would think that things couldn't have been clearer, and yet, they are not. There was probably never a confusion of such magnitude as now, in regard to the nature of art, and consequently of its purpose. Indeed, it can be said that the preceding confusions were mostly between content and form. Not between art and artifice. The difference was rather clear, despite several exceptions. It was always clear that art was produced by those 'gifted' by nature; in fact, we now assume, by those suffering from a slight genetic distortion. It was clear that art can only be produced by this special breed, just as honey can only be produced by bees. One cannot become a bee. But we now witness an increase in the amount of people who believe that everybody can be an artist. Whence the inflation of things which are not art and yet are accepted as art. The fact that they don't have the quality of art is turned into an advantage, as a mark of 'avant-garde'. These things serve as an example to other people without talent, who, in their turn, serve as an example to the next wave. Some of them are recognized, temporarily, as 'avant-garde' by 'other criteria' theorists, who are as doctrinaire as the compilers of the treatise

governing icon painting, *The Painter's Manual of Mount Athos,* but inversely: they are about *how not to paint* . . .

The purpose of art for the Ancients, and even those nearer to us, was clear: beauty. Beauty was recognized as being the vehicle by which faith and myth were conveyed. Beauty was their essence. Sublimity its attribute. *Immediacy* was the dimension by which it was apprehended. Beauty is an experience by which the senses and the mind are satisfied, but not only; it is a disquieting unnameable experience. Since the beginning of historical time, it was clear that the visual arts were mute, but that this deficiency was an advantage: it communicated the unspeakable, the unnameable. Contrary to the written word, drawing, painting and sculpture are immediate. What they communicate is not information, but sensation. Feeling. Emotion. Content is transformed through form and transmitted by way of its frequency and intensity. Not only by its content, which is the domain of the image. The image is a reminder, a signifier to be decoded. Not a picture. Indeed, a painting will move or not, according to *how* it is painted and not by what it represents. It can of course be seen as an image – for example, we can view the *Meninas* as an image, a document only, extracting from it social and other information, and not be moved by it at all. Iconology did serious damage to the perception of art. But there is an old confusion between art and aesthetics. In fact Plato had a mediate conception, hindering the immediate feeling for art. His taste in art must have been rather poor, in spite of his deep insight into the creative process. His belief in the supremacy of *idea* and the inferiority of *mimesis* gave birth to idealism in art, to the ideal form, which still prevails. But outside the Western world, art was the mass media by which mankind communicated with the sacred, or invoked the unknown, the remote or the desired, by visual means. With line, shape and colour, one can hold a moment of life, and preserve its echo as illusion. Art is illusion, certainly. But this illusion is indispensable for the transmission of feeling from one individual to the other, and through death, to other lives. Its experience is subjective and not collective. It is in fact, when truly felt, the passive equivalent of the creative act.

It was irrelevant for tens of thousands of years to get the likeness, the exact likeness, of someone's face. Prehistoric art was about the typical. Man, woman, animal. Not *this* man, *this* woman or *this* animal. But only about *a* man, *a* woman, *an* animal. The typical dominated art for tens of thousands of years during which nobody's face was drawn. There was no other style but the collective. The evolution of the prehistoric hunter-gatherer tribes into more complex communities, such as city-states and finally empires, bestowed

upon the collective style a stately aura. The typical became sacerdotal and imperial. Its tyranny was absolute. Can one imagine the fate of an Assyrian or Egyptian sculptor who, except for the twenty-two years of the reign of Akhenaton, would have 'expressed' himself in a personal style? No such trace exists. Can we imagine someone in Byzantium trying to follow his fancy or paint from life? No such trace exists. It is interesting to note that the transition from the imposed collective style to the highly individual one was not possible without the passage from the closed to the open society. Tyrannies don't tolerate freedom of expression, and they impose the collective style by which they exercise their power – tribal, religious or imperial – until this very day. Social realism in Soviet Russia was the last example. The generalized image accommodates with tyranny. On the other hand, the transition from the generalized to the particular, from the cult of the typical to the one of the exceptional is an epiphenomenon of the passage to individual freedom, and to a higher degree of civilization. It took one million years for evolution to produce such exceptions as Dürer, Beethoven or Shakespeare. It took as much to let a sole person experience the emotional impact of a Beethoven quartet, or a Velazquez portrait. But what is that impact made of? Is it beauty and if so, what is beauty? A constant fluctuation renewed from life to life. For Kant, beauty is a form of finality of an object as long as it's perceived without the representation of that finality ('Schönheit ist Form der Zweckmässigkeit eines Gegenstandes, sofern sie, ohne Vorstellung eines Zwecks, an ihm wahrgenommen wird').[2] In other words, beauty is a finality without an aim. And yet it became normative, *ideal beauty* opposing measure to nature, because it was thought to be made of regularity. 'Beauty is when all parts concord simultaneously in achieving proportion and discourse, in such a manner that nothing can be added or taken away, but for the worse,' said Leon Battista Alberti.[3] Four hundred years later, Owen Jones wrote that:

> True beauty results from that repose which the mind feels when the eye, the intellect, and the affections, are satisfied from the absence of any want.[4]

And further: 'Beauty of form is produced by lines growing out one from the other in gradual undulations: there are no excrescences; nothing could be

[2] Kant, *Kritik der Urteilskraft*, 17
[3] Leon Battista Alberti, *Di Re Aedificatoria*, VI, 2
[4] Owen Jones, *The Grammar of Ornament*, 1856, Proposition 4

removed and leave the design equally good or better.'[5] It is in fact a variant of Alberti's definition. Although it is possible that Owen Jones, whose concern was ornament, may have been aware of Alberti's definition, which was about architecture, his formulation is more about the perceiver than about the perceived. But he couldn't have known the sculptor Orfeo Boselli's then still unpublished manuscript, written *c.*1657 (first published fragments, 1939):[6]

> The grand manner, accordingly, and the exquisite taste appear in making the work with sweetness and tenderness, which consists in knowing how to hide the bones, nerves, veins and muscles, in keeping one's eye to the whole and not to the parts – something so difficult that only to the ancients was conceded the great marvel of seeing a figure consummately beautiful, with everything and with nothing being there; . . . This tenderness of manner was not only practised in the *Apollos, Antinouses, Bachuses, Faunes* and youth and natural statuary, but also in the great river gods and even in stupendous colossi. The more they remove the grander the style becomes . . . [7]

Disegno, Proportion, Attitude within *Leggiadria* (grace, charm). The quest of the whole rather than the parts. *Weglassen* in German, 'leaving out' was the painter's key to it. Beauty was believed to be the goal of all the arts. However, the concept of beauty evolved from ideal to real, before ultimately vanishing altogether. But did it really vanish? The philosophical concept of Beauty differs from the artistic one. Because of the concreteness of the latter.

Drawing or painting is a way of investigating and seizing visual data by pictorial means. The inquiry by pictorial or graphic means – how this hill, this apple or your face are constituted – results in a sequence of marks, forming a structure, holding ultimately this hill, apple or face by pictorial or graphic means. This depiction is a process by which visual sensations transformed by velocity, touch, rhythm and pictorial means constitute an echo of what was seen and felt. It is a process equivalent to freezing or to petrification. But also

[5] ibid, Proposition 6

[6] M.Piacentini, 'Osservazioni della scoltura antica di Orfeo Boselli. Un inedito tratatto del Seicento e la teoria dellla scoltura dal Rinascimento al Barocco', *Bolletino del R. Instituto di Archeologia e Storia dell'Arte*, IX, 1939, pp. 5–35

[7] Orfeo Boselli, *Osservazioni della scoltura antica di manoscritti Corsini e Doria e altri scritti a cura di Phoebe Dent Weil*, Florence 1978, folio 11; the English translation is quoted from Charles Dempsey, 'The Greek Style and the Prehistory of Neoclassicism' in *Pietro Testa*, Philadelphia Museum of Art, 1988

to ontogeny. The condition of its success is that it be generated from within. Dot after dot. Not skilfully, nor from without, following a concept, but from within a deep state of concentration and oblivion of all other visual precedents. The memory and skill by which we are able to draw a hill, a tree or a face, is in fact a disturbing factor. It leads away from the particular to the general, from truth to fiction. Skill is negative talent, but was not really recognized as such until this century (just like viruses), being confused with talent. For example, Bouguereau developed his skills to the detriment of his talent. But old Titian avoided skill instinctively and Cézanne seems to have had no skill at all. It is his weakness which makes for his greatness: unable to emulate the masters he admired, he painted as he could, remaining in torment.

Following the Platonic concept of Ideal Beauty, and the belief in the imperfection of nature, artists during the later part of the sixteenth century avoided strictly following visible reality dot by dot. They aimed for ideal generalization, by moving away from *this* hill, apple or face to *a* hill, apple or face. Thus giving up, as was said above, truth for fiction. Besides, drawing from visible reality dot by dot was also increasingly considered as pedantic and inelegant. This is how academicism came about.

Five centuries later this belief seems still to be deeply rooted.

NOTE ON MANTEGNA'S *CRUCIFIXION*[1]
and the origin of its circular plan

Degas believed that one has 'to copy and recopy the masters and it is only after having proved oneself a good copier that one can justifiably be permitted to paint a radish from nature'.[2] In his unfinished copy [3] of Mantegna's *Crucifixion*,[4] Degas left out the key of this painting, namely the red standard bearing the inscription SPQR (*Senatus Populusque Romanus*).[5] It is not even indicated. And yet, this red spot triggers the entire composition.

But this omission is not surprising. Degas' interest was indeed elsewhere: not in the conceptual but in the lifelike. The obsession with geometry and perspective prevalent in Mantegna's century vanished in Degas' time, and the ardour of the *scienza dell'arte* was extinguished. On the other hand, painting directly, spontaneously, freely, letting feeling overcome calculation, was still unthinkable in Mantegna's time. Making a picture without *scienza*, without

[1] This is a shortened version of 'Note à propos du Calvaire de Mantegna', written originally in French in 1993, published in: *Hommage à Michel Laclotte*, Réunion des Musées Nationaux/Electa, Paris/Milan, 1994, pp. 251–9

[2] See Henri Loyrette, *Degas Exhibition Catalogue*, RMN, Paris, 1988, p. 87

[3] Oil on canvas, 69 x 92.5 cm., *c*.1861 (Tours, Musée des Beaux-Arts). See Henri Loyrette, *op. cit.*, pp. 87–8, and *Degas*, Paris, 1991, p. 168

[4] Tempera on poplar wood 76 x 96 cm. (Paris, Musée du Louvre, INV 368). Central panel of the dismembered predella of the *San Zeno Altarpiece*, 1456–9; the two other panels, *Christ on the Mount of Olives*, 75 x 94 cm., and *The Resurrection*, 71 x 94 cm., (Musée des Beaux-Arts, Tours). The entire altarpiece was deposited at the Louvre in 1798 after being carried away from Verona in 1797 to France by Bonaparte. The predella was detached from it *c*.1803 and the two lateral panels sent to Tours in 1806. The altarpiece was returned to Verona after the Vienna Congress in 1815, but the predella remained in France.

[5] 'The Senate and People of Rome' was the motto borne on the standards of the Roman legions until it was replaced *c*.312 with the Christian symbol XP (chi–rho) by Constantine. The SPQR inscription was used in medieval iconography in order to set the Jews apart from Romans, gradually vindicating the Romans and accusing only the Jews of deicide.

the geometrical division, without a perspective construction was ludicrous in Mantegna's century. It wasn't yet known that

> perspectival construction ignores the crucial circumstance that this retinal image – entirely apart from its subsequent psychological 'interpretation', and even apart from the fact that the eyes move – is a projection not on a flat but on a concave surface.[6]

Mantegna, however, was obsessed both by antiquity and by perspective, which he believed to be at the root of art. The sharp foreshortening, the *di sotto in sù*, is his stamp. He certainly used several methods of perspective, maybe without exactly following the Albertian *construzione legittima*. He may even have used a plane projection in the manner of Piero,[7] or abacus books and 'triangulation techniques of surveying lengths, breadths and height'.[8] But where could he have learned all these methods? True, the bifocal system of foreshortening was an old studio practice preceding Brunelleschi and Alberti.[9] Squarcione must have had experience with these old studio practices to which the centre-point perspective may have been added, perhaps through his students (although Padua was a cradle for perspective theories before Brunelleschi's and Alberti's Florence. It is in 1390 that Biagio Pelacani in Padua wrote his *Qaestiones Perspective*).

Neglected for centuries, antiquity was now resurrected. Suddenly a rupture and a mutation occurred due to the fact that some enlightened people began not only consulting the ruins, but also scraping and digging the soil. It was not archaeology yet, but an urge for the antique. This urge, shared by most men of letters, was to leave its imprint and dominate Mantegna throughout his life. For Mantegna, '. . . the visible remains of antiquity conjured up a grander, more ordered world than the one in which he lived. Only in Alberti's

[6] Erwin Panofsky, *Perspective as Symbolic Form* [*Die Perspektive als symbolische Form*, 1927], trans. Christopher S. Wood, New York, 1991, p. 31
[7] See Martin Kemp, *The Science of Art*, Yale and London, 1990, p. 43
[8] Kemp, ibid., ch. IV, p. 168
[9] 'The ensemble of characteristics resulting from the use of two distance points (the 2AxA format, the preference for prismatic bodies seen in oblique setting, an eye distance equal to or less than half the width of the panel) permits us to say that the system was being used before 1435 . . . ' Robert Klein, 'Pomponius Gauricus on Perspective' [1961], in *Writings on the Renaissance and Modern Art,* New York, 1979, p. 118.

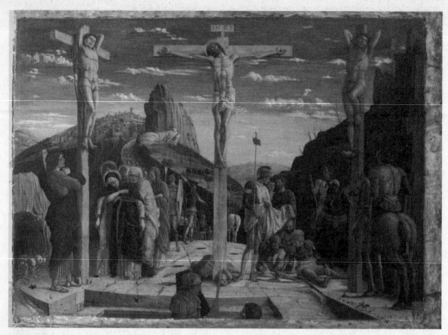

The Crucifixion, tempera on poplar wood, 76 x 96 cm. (Paris, Musée du Louvre)

architecture does one find a similar understanding of the intrinsic character of Roman art.'[10] Copying from the antique, from the *exempla* drawings which Squarcione collected so avidly, the study of theory, and life drawing to a lesser extent, was apparently the curriculum practised in his workshop. Squarcione, who had the habit of legally adopting his most gifted pupils, was also an ardent traveller. It was on one of their trips to Venice that the precocious Andrea gained his freedom from his master and adoptive 'father', met Jacopo Bellini and married his daughter, Niccolòsia, in 1453. Before that, in 1449, the young Mantegna was invited by Lionello d'Este to paint his portrait (now lost). Did he, on this occasion, see the Rogier van der Weyden? All of this has been told and retold by Vasari and questioned by historians beginning with Kristeller and Knapp.[11]

[10] Keith Christiansen in *Andrea Mantegna Exhibition Catalogue,* ed. Jane Martineau, RA, London/MMA, New York, 1992, pp. 107–8
[11] P. Kristeller, *Andrea Mantegna*, London 1901; Fritz Knapp, *Andrea Mantegna Des Meisters Gemälde und Kupferstiche*, Klassiker der Kunst, Stuttgart and Leipzig, 1910

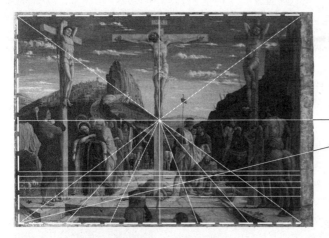

Division and perspective (reconstruction)

Donatello and Uccello's 'Giants' frescoes in the Casa Vitaliani were Mantegna's lighthouse. Donatello spent ten years in and out of Padua, leaving the city in 1454, leaving 'his pattern to others' in Vasari's words. His reliefs for the high altar of the Santo, based on the central perspective, were a major influence on Mantegna. This influence on Mantegna must have been made explicit by its having been put into practice by Niccolò Pizzolo, who was an assistant to Donatello at the Santo between 1445 and 1448 and again in 1450. In 1448 Pizzolo was commissioned to decorate the chapel Antonio degli Ovetari in the church of the Eremitàni in Padua along with Andrea Mantegna, younger by ten years, and in collaboration with Antonio Vivarini and Giovanni d'Alemagna. (The Eremitani was destroyed by an allied bomb in 1944.) It was to become a cycle of frescoes which changed the course of painting in northern Italy. Although the partnership between the two was legally dissolved in September 1449, Pizzolo's name recurs three times, the last time on 9 June 1452, before his violent death in 1453.[12] In that time Mantegna must have learned quite a bit from him. 'The degree to which Mantegna absorbed the lessons Pizzolo had to offer can be gauged from the fact that the work of the younger artist painted in the Ovetari chapel in 1448 and 1449 was long ascribed to his older partner.'[13]

On the other hand, the influence of Donatello's reliefs in the Santo on

[12] For Niccolò Pizzolo see Erice Rigoni, 'The Painter Niccolò Pizzolo', in *Renaissance Art*, ed. Creighton Gilbert, New York, 1970, pp. 69–91
[13] Keith Christiansen, op. cit., 'Early works: Padua', p. 101

Mantegna is discernible not only by the low horizon line and sharp foreshortening, but by the sculptural approach itself, to begin with in the St James cycle of the Ovetari chapel. In the *Crucifixion* the foreshortening is milder than in the Ovetari cycle, but Christ's figure is nearly a painted sculpture; the question is whether the horses were also drawn from a sculpture, namely after the equestrian monument of Niccolò d'Este III by Niccolò and Giovanni Baroncelli, as suggested by Castelfranco.[14] They could have been partly drawn from life. But Mantegna did not make such distinctions. He probably did not shun the sculpted model, on the contrary, his entire work is sculptural. Rocks were apparently his passion. They are, in a way, the embodiment of his craving for sharp diagonals, cutting lines, and for rhythmic hatching. His engraving style was present in his paintings prior to his engravings: he started engraving with the chisel or the drypoint – probably not before 1466. Even if he engraved only seven plates,[15] his engravings reached an unsurpassed peak.

The constitutive element of his painting is the line. He drew in paint – as in the *Crucifixion*, the surface of which is covered by minute lines depicting every hair, every hoop of the legionaries' *lorica*, every wood-vein of the crosses, every fissure in the rocks. This tempera painting is executed with round sable brushes on a panel composed of three spindle-shaped poplar rails placed top-to-tail with a fine silk-strip glued over the joints before the white gesso was applied.[16] The geometric division was first incised with a stylus (one diagonal line was spotted under the microscope by this author) before the drawing, traces of which remain visible through the painted surface, particularly in the white robe of the mourner left of the Virgin (our right); Mantegna did not follow the lines of his underdrawing, but painted the robe freely,

[14] See Giorgio Castelfranco, 'Note su Andrea Mantegna', *Bolletino d'Arte*, XLVII, 1962, pp. 23–39. The first equestrian monument in Northern Italy – inaugurated in Ferrara in 1451 and predating Donatello's *Gattamelata* monument in Padua – was destroyed by French troops in 1796.

[15] See Fritz Knapp, op. cit., p. 182; David Landau, 'Mantegna as Printmaker', in *Andrea Mategna Exhibition Catalogue*, op. cit., pp. 44–66; Keith Christiansen, 'The Case of Mantegna as Printmaker', *The Burlington Magazine*, vol. CXXXV, no. 1086, London, September 1993, pp. 604–12

[16] See J. Marette, *La Connaissance des Primitifs par l'Etude du Bois*, Paris, 1961, no. 695; I wish to thank here my friends at the Musée du Louvre, particularly Dominique Thiébaut and the team of the Laboratoire de Recherche des Musées de France, especially Mme E. Martin and P. Le Chanu, for their assistance in analysing this work.

probably from observation, maybe from a mannequin – the modified folds prove it. The robes of this entire group are painted from observation, whereas the faces are obviously from imagination, and even according to the canon. The expression of grief reaches its peak in the pale face of the Virgin, shadowed with black, contrasting with the sumptuous execution of the robes, their embroidered hems, their folds shaded with black and highlighted with gold.[17] The gold is not a pigment, but actually pure gold powder, applied directly and lightly on to the fast-drying medium. In spite of painting minutely layer on layer, it is his medium – which must have been his secret – that permitted Mantegna to keep up this extraordinary transparency and freshness.

Mantegna probably painted the three panels of the San Zeno predella after having finished the upper triptych, and this central panel at the very end, just before his final departure for Mantua in January 1460. Indeed, the central panel is the conclusion of the whole, justifying the whole: the *Crucifixion* [18] carries visually the upper panels by virtue of its central point on top of the cross which constitutes the optical pivot dynamizing the entire composition. Having conceived the entire altar as being lit from the right, Mantegna had a right-side window opened to this effect (but this window was bricked up in the sixteenth century),[19] his point of sight originating from the same direction. It is a low-set point of sight stimulating the *di sotto in sù* foreshortening which is amplified by the tension between the strict symmetry (the cross is in the exact centre) and the invisible diagonal ascending from below. The last two steps of the eighteen carved in the rock, according to legend, were apparently painted in order to correspond to eye-level in the chapel; the field of vision is defined by the fragmented head [20] emphasizing the low point of sight.

The reason for the symmetrical division is theological: it segregates right

[17] The use of gold powder appears first in *The Adoration of the Shepherds*, tempera on canvas, 1450–1, New York, Metropolitan Museum

[18] The entire rim of *The Crucifixion* has been roughly repainted and even enlarged following the dismemberment of the altar in 1803, adding about 1 cm. to the height and 2 cm. to the width.

[19] See Lionello Puppi, *Il Trittico di Andrea Mantegna per la Basilica di San Zeno Maggiore in Verona*, Verona, 1972, p. 51

[20] Missing in the copy made to replace the missing original predella *in situ* at San Zeno, Verona.

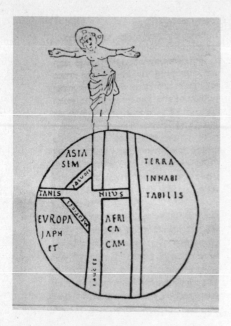

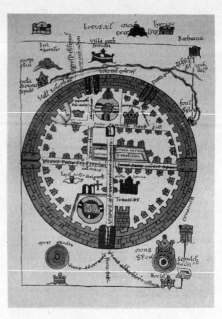

Map of the World, ninth century (Saint-Gallen, Stifsbibliothek, Cod. 237, 63)

Map of Jerusalem, c.1150, *Codex Aldomarensi*, folio 15b (Saint-Omer, Bibliothèque Municipale)

from left, the righteous on the right from the wicked (sinister) on the left, magnifying Christ in the centre: on his right (the viewer's left), the righteous, and animation of life; on his left (the viewer's right), the sinister, evil and death. But from the formal point of view, a symmetrically centred composition is doomed to become inert and fall apart, whence the red standard. It is painted at the harmonic horizontal and diagonal intersection. Without this harmonic counterpoint and the slight angle to the right of its pole, the composition would have been inert indeed. However, this point was apparently not preconceived by Mantegna: the standard was painted at a later stage, over the already finished landscape. Although it is the key to the painting, it ostensibly came at the end.

At the median intersection, exactly at the apex of the visual pyramid, the Albertian 'centric' point, are Christ's feet. Our gaze, caught between the distance point on the right and the vanishing point on the left, follows the low-levelled foreshortened plateau, being pulled to the left at pavement-level behind the cross, and drawn up on the cross by the terrifying image;[21] our eye

[21] First symbolized by a naked cross (fourth century), Jesus on the cross appears in

24

remains arrested there by the power of the horizontal tension: it is provoked by the contrast between the hard (crosses) and the tender (clouds) acting as inflections, like arpeggios.

From there our gaze is driven to the red standard again, to the onset of a dual chromatic theme, red-yellow, with the red dominant first; from the red standard to the red crest on the yellow (gold) on the black helmet of the centurion, to the red reins of the dappled horse, to the trousers of the second rider, to the red cuirass of the rider on the white horse (a red spot without which the composition would have split), then to the shield and

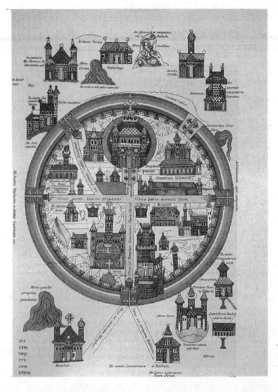

Map of Jerusalem, Florence, *c.* fifteenth to sixteenth century (whereabouts unknown)

sandals of the soldier downhill, the collar of the one coming up, and finally to Mary Magdalene.

Dividing left from right, Mantegna had the red and yellow invert their functions accordingly. On Christ's right (the viewer's left), the side of the righteous, yellow encircles and underlines the red (but also the blue, green and black); the yellow (gold) is the colour of the haloes – of light, of life – unfolding behind St John and the group of the holy women supporting the Virgin. On Christ's left, the sinister side (the viewer's right), the red encircles

the early fifth century; the Syriac *Rabbula Gospels* (*c.*586, Florence, Biblioteca Laurentiana) is one of the earliest painted examples. The iconography, however, which appeared after the disappearance of this atrocious execution does not correspond to reality: the executed was not nailed to the cross by his hands, but his arms were tied behind him: see Joseph Zias and Eliezer Sekeles, 'The Crucified Man from Givat haMivtar – A reappraisal', *Israel Exploration Journal,* vol. 35, no.1, Jerusalem, 1985

and underlines the yellow, there is no blue, less and less light towards the edge, but death: dead trees and bare earth; of the three horses, two of them, the white and the dappled one, are carrying their riders to the abyss, as if pushed by the red. Concluding it all, the warm colours are intensified by the cold grey of the plateau.

This red-yellow division is summarized by the red-yellow circular shield, divided into four yellow and four red sharply foreshortened triangles, on which the three soldiers are casting their lots. The shield, like an engine, but an optical one, activates the pavement's orthogonals, it spins optically, in contrast with the dominant static verticals, sending off a horizontal quiver through the entire composition.

<div align="center">★ ★ ★ ★ ★</div>

What part did the patron Gregorio Correr,[22] apostolic protonotary and abbot of San Zeno Maggiore in Verona, play in the iconographical conception of Mantegna's Altar? Puppi [23] found evidence that the abbot wanted it to be 'heroic'.

Regarding the depiction of Jerusalem it is generally admitted that Mantegna used Flavius. An Italian translation existed from the fourteenth century. From the second half of the second century onwards Flavius 'was welcomed as a principal witness from the enemy camp'.[24] Flavius, who wrote his history between 72 and 75, was adopted and adapted by the founding Fathers of the Christian Church – Origen, Eusebius and Chrysostom – who manipulated the text to fit their 'punitive theology'.[25] The question is whether Mantegna

[22] Born in Venice in 1411, he was a disciple of Vittorio da Feltre and a colleague of Gianfrancesco Gonzaga's children. Infused by the humanist legacy with an eschatological bent, Gregorio Correr took the cloth in 1431. He imposed upon the Benedictine monks of San Zeno the rules of Santa Giustina of Padua (that her beatification was based on a fake document had not yet been discovered) and elaborated a precise liturgical plan for the reconstruction of San Zeno Maggiore.

[23] Lionello Puppi, op. cit., p. 35–49

[24] See Heinz Schreckenberg, 'Josephus in Early Christian Literature and Medieval Christian Art', in *Jewish Historiography and Iconography in Early and Medieval Christianity*, Maastricht and Mineapolis, 1992, p. 134

[25] See Heinz Schreckenberg, op. cit., and *Die Christlichen Adversus-Judaeos-Texte und ihr literarisches und historisches Umfeld*, I, Frankfurt, 1982, II, 1988. The texts especially manipulated were: Flavius's *Antiquities* XVIII, 63–4 (see S. Pines, *An Arabic Version of the Testimonium Flavianum*, Jerusalem 1971), and XX, 200 (see David Flusser, *Yahaduth umkeroth hanazruth*), Jerusalem, 1982

followed Flavius's topography in regard to the circular conception of Jerusalem. He painted from imagination a city in which there are details mentioned by Flavius, such as the column (depicted in both versions of the *Agony in the Garden*, Tours, and London, National Gallery), but giving the houses an Italian aspect. His circular hill is an allusion to the circular plateau of Golgotha [26] which does not derive from Flavius. The question is whether it derives from a visual source rather than from a literary one.

According to Millard Meiss, the concept of the circle in *Crucifixions* and *Lamentations*, the circular plateau, is an invention of Jan van Eyck as exemplified in a lost *Crucifixion*[27] once in Padua. He states that, 'Jan van Eyck's plateau *Crucifixion* combined with the departing soldiers was disseminated, chiefly by Mantegna, throughout North Italy.'[28] But Mantegna's circular plan is unlike the one depicted in the extant copy of the lost van Eyck (anonymous Paduan, Venice, Accademia) and attests to another source. On the other hand, Meiss points out elsewhere [29] that 'the circle of perfection was of course current in late antique and Medieval imagery'. Indeed, the 'circle of perfection' was also recognized as Divine and theologically suitable for the representation of the world (as in the ninth-century map at Saint-Gallen), and of Jerusalem in particular.

The earliest map, the mosaic of *Madba* (sixth century),[30] is, however, oval. It is the Crusaders that give it the circular shape. In the new Crusader maps of Jerusalem, topography follows theology, not reality. These maps,[31] an off-shoot of the Carolingian style, are abstract but also symbolic schemata. They all indicate the two main streets, the cardo and the decumanus maximus, which cross at the exact centre of the Holy City, hence forming a cross.[32]

[26] The name *Golgotha* (skull in Aramaic, *gulgoleth* in Hebrew) is not in the Old Testament; it is likely that St Matthew gave this name to the sinister site. The legend that it was Adam's sepulchre stems from Origen.

[27] Millard Meiss, 'Jan van Eyck and the Italian Renaissance', in *Venezia e l'Europa, Atti del XVIII congresso internazionale di storia dell'arte*, Venezia, 1956, pp. 58–69; reprinted in *The Painter's Choice*, New York, 1976

[28] ibid., p. 30

[29] Millard Meiss, 'Masaccio and the Early Renaissance: The Circular Plan', 1963, in *The Painter's Choice, op. cit.*, 1976

[30] See M. Avi-Yonah *et al.*, *Jerusalem, The Saga of the Holy City*, Jerusalem, 1954

[31] See Milka Levy, in 'Medieval Maps of Jerusalem', in *The History of Jerusalem – Crusaders and Ayyubids*, 1991, pp. 418–507

[32] See Bianca Kühnel, 'Influence of the Crusades on the Visual Depiction of

This model of the circular map was perpetuated for centuries. There is no difference between Cannon Lambert's map in the *Liber Floridas* (*c.*1260, Bibliothèque Nationale, Paris, Lat. Mss. 8865 fol. 93r) and the earlier map of Saint-Omer (*c.*1150, Bibliothèque Municipale, *Codex Aldomarensi*, folio 15b). They all follow the world-map of Ranulf Higden, with Jerusalem at its centre (London, British Museum, Ms. 14c IX), and essentially such maps as the ninth-century Carolingian map of the world with Christ in its centre (Saint-Gallen, Stiftsbibliothek, Cod. 237, 63). In this map, Christ is rising on the cross above the centre, hence marking the place of the crucifixion as the world's centre. The cross-centre of Jerusalem sprang from the union of two separate monuments present in the *Madba* map: the cross on Golgotha in the Templum Sancte Crucis built by St Helen on a spot of Solomon's Temple, and the column bearing the emperor's effigy on its pinnacle. This column (painted by Mantegna, see above) was erected in front of the northern city-gate, baptized St Etienne by the Crusaders. The Emperor Constantine replaced the effigy on this column with a cross. A legend spread that it marked the centre of the world. The belief that Jerusalem is situated at the midpoint of the world is asserted by Ezekiel who qualifies it as *tabur haaretz* – the navel of the earth (XXXVIII, 12). This tradition continued in Judaism as well.[33] Christianity transformed the prophets' metaphors, like the one of Jerusalem, into Christian certitudes. Victorinus Pettavionesis (second century) and Sophronius Patriarch of Jerusalem (fourth century) locate Golgotha as *medium orbe*, beginning a tradition according to which the centre of the world is the Saint Sepulchre.[34]

Simultaneously the 'earthly' Jerusalem is abandoned for a 'celestial' one, whence the circle.

Mantegna apparently took into account the circle and the centre in his *Crucifixion*. His Christ towers in the centre just like in the Saint-Gallen map. His 'circular plan' is by far more radical than van Eyck's (mentioned by Millard Meiss), who may also have had in mind Jerusalem's cartography.

Mantegna painted a *Crucifixion* without the sponge-bearer, nor wound, nor angels and chalice, without sun or moon, without Church or Synagogue – but essential, and with an immutable formal invention: an *exempla*.

1993–4

Jerusalem', in *The History of Jerusalem Crusaders and Ayyubids (1099–1250)*, Jerusalem, 1991 (Hebrew), pp. 399–417

[33] *Midrash Tanhuma*, chapter Vaykra

[34] See A. Piganiol, 'L'hémispharion et l'omphalos des Lieux Saints', in *Cahiers Archéologiques*, I, 1945, pp. 7–14

ON PETER PAUL RUBENS [1]

Rubens's immense oeuvre never stopped reverberating; he was one of the greatest draughtsmen of all time and his activities were multiple: he was an antiquarian scholar, connoisseur and collector, courtier and diplomat, besides being a painter; his correspondence with some of the most brilliant and significant personalities of his time (250 letters survive, written in Italian, French, Flemish, Latin and Spanish), his sense of duty, of loyalty and friendship, his elegance, his impact on his own time and on posterity, are of such magnitude that one would need a lifetime to tell his life. From Roger de Piles (the apostle of 'Rubenism'), Charles Ruelens and Max Roosses to Julius Held and Michael Jaffé, all those who entered the giant's den were absorbed into its density.

But are any words really possible – or necessary – in front of such marvels as *Hélène Fourment with Two of her Children* (c.1636, Paris, Musée du Louvre), or *Hélène as Aphrodite* (*Het Pelsken*, 1630s, Vienna, Kunsthistorisches Museum), *The Judgement of Paris* (1638–9, Madrid, Prado), or in front of Rubens's *Self- portrait with Isabella Brant* (1609–10, Munich, Alte Pinakothek)? Painting communicates without mediation, and yet the spontaneous love of art calls for inquiry, which intensifies it. The art historian's purpose is to shed light and allow the flame of passion to blaze. The most important publication in the field of Rubens studies was the one of his documents and correspondence, by Charles Ruelens and Max Rooses, published in six volumes between 1887 and 1909,[2] now a great rarity (waiting for a daring publisher . . .) The latest light on Rubens studies has been shed by Julius Held's critical catalogue of the oil sketches, which is an insightful and indispensable work on Rubens – a

[1] Originally written in 1987 as a book review on *Peter Paul Rubens Man and Artist*, by Christopher White, Yale University Press, 1987, for *The New Republic*, Washington DC, and published, slightly shortened, in the 28 March 1988 issue. Subsequently enlarged and modified.

[2] M.Rooses and C.Ruelens, *Codex Diplomaticus Rubenianus – Documents Relatifs à la vie et aux oeuvres de Rubens*, 6 vols, Anvers, 1887–1909

monument of scholarship.[3] More recently, condensing the vast material, although not as a critical catalogue but as a 'life', Christopher White has written a very fine biography.[4]

I

Rubens's father, Jan Ruebbens, Alderman of Antwerp, Doctor of Laws both Roman and Ecclesiastic, whose family history can be traced back in Antwerp to the fourteenth century, a Calvinist, had to flee his home town in 1568 because of religious conflict and Spanish oppression. He went to Cologne with his wife Marie Pypelincx and their four children. There he became Councillor to Anna of Saxony, Princess of Orange-Nassau, wife of Prince William 'the Silent', founder of the Dutch republic, who was assassinated in 1584. In 1571, Jan Ruebbens was sent to prison by order of Count Johann of Nassau, in the name of Prince William, on charges of adultery with the Princess, after she had given birth to an illegitimate child. Jan Ruebbens pleaded guilty, facing the death penalty, awaiting execution in the dungeons of Schloss Dillenburg. But Marie Ruebbens-Pypelincx intervened by writing two profoundly moving letters of forgiveness and begged for his pardon, which was later granted (to avoid scandal?) The Rubens family was, however, banned from Cologne until 1678 and moved to Siegen where three more children were born, all sons: Philip in 1573, Peter Paul in 1577, and Bartholomeus who died in infancy. Cologne was the first city Peter Paul learned to love, but after Jan Ruebbens's death in 1587, Marie Pypelincx-Rubens and her three surviving children returned to Antwerp, where they settled in a fine town-house in the centre. Philip and Peter Paul received an outstanding humanist education under Rombaut Verdonck. Philip, who was extremely brilliant, continued under the guidance of Justus Lipsius, one of the greatest minds of the time, whose most beloved pupil, and designated heir to the chair at the University of Louvain, Philip became. (However he chose another career, and died in 1611 at the age of thirty-eight.) Probably at the age of fourteen, Peter Paul entered the service of Marguerite de Ligne-Arenberg, Countess of Lalaing, as a page, probably at her castle of Audenarde. His gifts for painting must have been very striking and convincing, for he was soon to enter the workshop of

[3] Julius S. Held, *The Oil Sketches of Peter Paul Rubens*, Princeton, 1980, 2 vols
[4] Christopher White, *Peter Paul Rubens*, New Haven and London, 1987

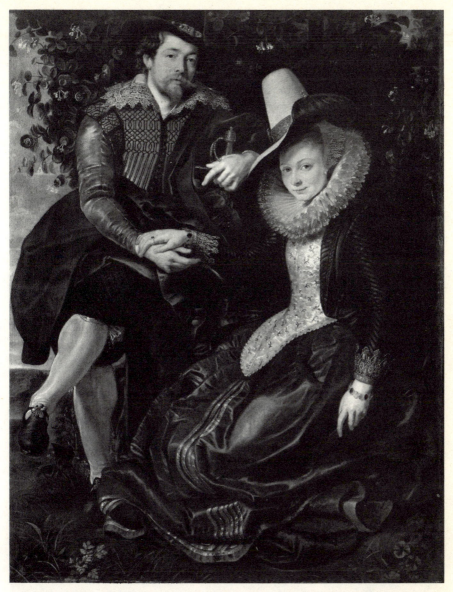

Rubens, *Self-portrait with Isabella Brant*, 1609–10, oil on canvas, 174 x 132 cm.
(Munich, Alte Pinakothek © Bayerische Staatsgemäldesammlungen)

Tobias Verhaecht (1561–1631), a distant relative. Later he moved on to Adam van Noort (1562–1641), and finally he became the pupil of the then celebrated Otto Venius (van Veen, 1556–1629). In 1598, Rubens was admitted into the Guild of St Luke as an independent master. His earliest known work, *Portrait of a Man* (1597, New York, Metropolitan Museum), is a small painting on copper, highly finished, in the van Eyck tradition. In 1600 Peter Paul left for Italy, following his brother Philip, apparently to Venice first. Tradition has it that it is by a fortuitous encounter in Venice that he was introduced to the Duke of Mantua. However, this remains unclear. It is possible that Peter Paul was introduced to the Duke, who was in search of fine portrait painters (in order to paint the portraits of beautiful ladies such as the great actress Isabella Andreini), during the Mantuan sovereign's visit to Flanders, where he went to take the waters at Spa in 1599. Indeed, the young Duke, who may have 'preferred painters to painting', as White suggests[5] – engaged Frans Pourbus during this trip. Before ascending to the throne of his Duchy, Vincenzo Gonzaga saved Torquatto Tasso (who was actually mentally ill and caused the Duke of Ferrara serious trouble with the Inquisition) in extracting him from the madhouse at Ferrara, where the poet was locked up by Alphonse II for seven years (1586).

Vincenzo Gonzaga, Duke of Mantua, on the eve of his departure on 18 July 1601[6] at the head of his troops to make war in Croatia, wrote to Cardinal Montalto, nephew and Secretary of State of Pope Clement VIII (Aldobrandini): 'The bearer of the present is Pietro Paolo fiamingo my painter, whom I am sending to copy on your side and execute a few paintings . . . ' The Duke, in writing to the Cardinal, and not to his official resident in Rome, Lellio Arrigoni, did most probably have something else in mind besides simply the copying of paintings by the young painter; indeed, why bother the Papal Secretary of State with such small a matter instead of the Mantuan permanent resident? The Duke must have entrusted Peter Paul with some verbal message: the tone of the Duke's letter as well as the Cardinal's reply hint at something which remains unclear. Was it already a special mission? Others were to follow, of which Rubens's mission in 1603–4 to the Royal court of Spain, where he painted the equestrian portrait of the Duke of Lerma (1603, Madrid, Prado), was the second. It was his first diplomatic experience, during which

5 ibid., p. 50
6 Rooses and Ruelens, op. cit., vol I (1600–08), p. 28

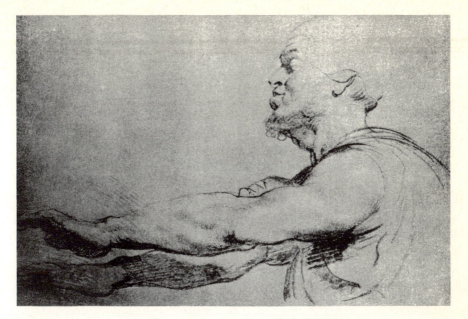

Rubens, *A Blind Man* (preparatory drawing for the *Miracle of St Fancisco-Xavier*, 1619–20), black chalk with white highlights on grey paper, 28 x 41 cm. (Vienna, Albertina)

he was to be given a sharp taste of the spite and petty jealousy of diplomatic behaviour, which in later years he was to know so well . . . He was aware of his worth and the correctness of his behaviour, and within the prescribed rules he was ready to fight for himself. He never stooped to use the weapons of the other side but had sincere belief in the triumph of justice. It took him thirty years to become disillusioned . . . [7]

In 1601 Peter Paul Rubens was twenty-four years old, and apparently already at ease with royalty as well as with the Muses. This was Rubens's first sojourn in Rome. He was soon to receive his first important commission, from the Archduke Albert, whose solemn entry into Antwerp in 1599 was witnessed by the Duke, Rubens's present patron. This first important commission was brought to Peter Paul by Jean Richardot, the Archduke's resident in Rome (the son of Jean Gruchet de Richardot, President of the Privy Council of the Spanish Netherlands whose private secretary was Philip Rubens, Peter Paul's elder brother). The commission, *St Helena Discovering the True Cross* (1602, Grasse, Chapel of the Municipal Hospital), is not a great

[7] White, op. cit., p. 27

masterpiece, but neither was it due to one of those master strokes of knowing the right person at the right time as was often said. It was actually more a result of Peter Paul's upbringing from the cradle, which gave him that social ease and poise by which all gates opened before him. The only astonishing fact was that he was allowed to become a painter . . . It is true that Peter Paul Rubens was so to speak 'well-connected', but his connections and lifelong friendships were in harmony with his nature. After Rubens's first experience of castle life at the age of fourteen at Audenarde, it is at the court of Mantua that he served his apprenticeship in court-life politics. He had among his colleagues Claudio Monteverdi, the best theatre group in Italy, the 'Gelosi', which meant the best in the Western world – apart from Shakespeare's theatre in London – and the finest orchestra and chorus – Monteverdi's *La favola d'Orfeo* was first produced there (1607). Besides, some of the most stunning female beauties could be met at the court of Mantua. All this expenditure eventually brought down the Duke's finances to the point of precariousness.

II

Travelling from Mantua, the young painter arrived in Rome during the second half of August 1601. The Western World's artistic capital was in the midst of a 'big bang' in the arts: the Mannerist legacy, i.e. the priority of style over truth, to which some were still clinging, was collapsing, yet not completely, it was still hanging, by more than a hair, on the Platonic ideal, on proportion and propriety. Artists from all over Europe concentrated in Rome where Annibale Carracci was still working on the Palazzo Farnese cycle; Caravaggio, who 'preferred truth to beauty' (something he was later condemned for by Giovan Pietro Bellori), had just finished the *St Matthew Cycle* at S. Luigi dei Francesi, and was now painting the *Conversion of St Paul* and the *Crucifixion of St Peter* at the Cerasi Chapel, S. M. del Popolo. The impact of these works must have been colossal. It is apparently through them that Rubens gives the impression of drawing from Michelangelo. We can sense his passionate reaction to the masterpieces, old and modern, in the Eternal City, from the numerous copies he made of them during this first stay, thus unknowingly constituting his data base which was to serve him in the future. 'On some occasions he maintained a scrupulous regard for the detail and character of the original, while on others he remained as close as Beethoven did to Diabelli,' says White.[8] A good example would be, I think, Rubens's

[8] ibid., p. 28

copy of Raphael's *Portrait of Castiglione*, still in Mantua until 1609, though it is not clear when and where Rubens painted it (Madrid 1629?); anyhow, Rubens added the hands in full (maybe thinking that Raphael's painting has been cropped – but it is intact, Raphael intended it that way, using, as he often did, the fragmentation of the hands as a compositional device).

White thinks that 'in everything, Rubens was deliberate and his habit of copying had a specific purpose. Although a number were carried out on commission from such patrons as the Duke of Mantua, by far the largest number were made for himself. In the first place they provided an artistic education . . . '[9] But one should point out the fact that copying, at least in drawing, is a sort of perpetual act of deference, a tribute living artists pay to the dead masters in the hope of piercing their secret. 'Like most great artists, Rubens was an avid student of the past, above all of antiquity and the Renaissance; he was also attentive to the works of the Italian masters of his own time . . . '[10] On the other hand, 'building up a record of works of art to supplement the available reproductive engravings'[11] constituted for Rubens an archive, a mining ground for his own work.

'Rubens was criticized by some of his competitors for borrowing whole figures from the Italians,' wrote the Dutch painter, etcher, poet, writer and theoretician Samuel van Hoogstraten (1627–78), adding that Rubens, 'answered that they were free to do likewise if they could benefit from it. But he indicated that not everybody was capable of deriving benefit from these copies.'[12]

After all, it is true that Rubens used his 'documentation' quite often in his history-painting compositions, as in the case of the figure of *Bounty* in the Whitehall Banqueting House ceiling (1629–34) which is derived from a copy Rubens made from Michelangelo's *Ignudo* (Sistine Chapel); but his greatest works were picked directly from life. Sometimes he had, in his life drawings, his models take a pose reminiscent, consciously or not, of a similar pose in this or that masterpiece. It would be naïve and wrong to give corporeal attitudes an importance which they actually don't have: a female nude seen from the back or in foreshortening in a similar attitude by different artists is no proof of derivation. Indeed, Rubens is a *force de la nature* of unequalled amplitude. But

[9] ibid., p. 16
[10] Held, op. cit., vol I, p. 17
[11] White, op. cit., p. 18
[12] Samuel van Hoogstraten, *Inleyding tot de hooge schoole de schilderkonst: Anders de Zichtbeare Werelt*, Rotterdam, 1678, p. 193

the foundation of his vast pictorial output, as I see it, is in his line, founded on his superb draughtsmanship. His drawings are sensitive and sensual, moving and powerful, free and exact. The secret of his brush was in his crayon, albeit colour played an important part. Colour, like sound, requires a sharp sense of sight, and a particular intelligence in order to be able to grasp by a fraction of tone which one of the pigments on the palette will seize the tone in nature. Rubens was blessed with this sense as well, although his colour is sometimes higher by a fraction than it should be. Compared with Titian, or with Velazquez, Rubens is sometimes a bit shrill.

In December 1605 Rubens received the ducal permission to go to Rome for a second visit 'in order to continue his studies', and was granted wages of three hundred ducats. His brother Philip, recently appointed librarian and secretary to Ascanio Cardinal Colonna, shared lodgings with him. His talent was soon recognized by such patrons as Scipione Cardinal Borghese, nephew of Pope Paul V, and Jacobo Cardinal Serra, Grand Treasurer of the Papal States. It may be through them that Rubens was to receive his first highly significant commission and paint one of his first outstanding masterpieces: *St Gregory the Great Surrounded by Other Saints* (1607–8, Grenoble, Musée des Beaux-Arts). The work was destined for the high altar of the new church Santa Maria in Vallicella, belonging to the Oratorian order. Rubens received this commission in preference to such celebrated Italian artists as Caravaggio, Cavalier d'Arpino, Guido Reni and Barocci. But just before the unveiling, Rubens realized that because of the direct reflective light on the high altar, the picture would become almost invisible. It was a disaster. Rubens hoped to sell the painting to the Duke for 800 crowns (10 jules to the crown) when he wrote on 2 February 1608 to the Mantuan Secretary of State, Annibale Chieppio:

> Since you have always shown an interest in my affairs, due to your affection for me, it does not seem to me inappropriate to inform you of a strange thing that has happened to me. I do this all the more willingly since I believe that this personal misfortune may turn out to the advantage of His Most Serene Highness. You must know, then, that my painting for the high altar of Chiesa Nuova turned out very well, to the extreme satisfaction of the Fathers and also (which rarely happens) of all the others who first saw it. But the light falls so unfavourably on this altar that one can hardly discern the figures, perceive the colours, heads and draperies executed from nature with great precision, and completely successfully, according to the judgment of all. Therefore, seeing that all the merit in the

work is thrown away, and since I cannot obtain the honour due to my efforts unless the results can be seen, I do not think I will unveil it. Instead I will take it down and seek some better place for it . . . [13]

Rubens painted a second work, a triptych representing Saints Gregory, Maurus and Domitilla adoring the Virgin, executed on slate, which is non-reflective. It still decorates the high altar of the Chiesa Nuova. But the Duke did not buy the first painting. Rubens hung it over his beloved mother's tomb in St Michael's Abbey in Antwerp, from where it was taken away by Napoleon's armies and brought to France with all the other looted Flemish masterpieces, and never returned.

III

Rubens returned from Italy in October 1608, because of his mother's illness, only to find her dead and buried. He wished to go back to Italy. But the Archduke Albert and Isabel the Infanta wished to retain him, and succeeded: 'they made him a member of their court and bound him with golden fetters'.[14] By *lettres patentes,* dated 23 September 1609, Rubens was granted an annual pension of 500 livres de Flandre of 40 gros payable in two instalments (because of the financial difficulties of the Spanish Crown and its dependencies, they were often late) [15] and 'the rights, honours, liberties, exemptions and franchises enjoyed by the members of the archducal household.[16] He was absolved from the obligation of living at court (Brussels), and was free to teach art without being subject to the Guild regulations. In 1609 Rubens married Isabella Brant, the eldest daughter of Jan Brant, who, in company with Philip Rubens, was one of the four secretaries of the city of Antwerp, and whose wife's sister Philip married. Rubens entered a phase of high creativity, of building his superb house, of becoming a father.

[13] The original – in the Archivio Gonzaga, Mantua – is addressed: To My Most Illustrious Sir and Esteemed Patron, Annibale Chieppio, Secretary and Councilor of His Most Serene Highness, in Mantua.

[14] Philip Rubens, *Vita,* p.38

[15] cf. Jules Finot, *Documents Relatifs à Rubens – Extraits des comptes de la Recette générale des Pays-Bas,* Anvers, 1887

[16] ibid., p. 55

Roger de Piles (1677) describes Rubens as having 'a tall stature, a stately bearing, with a regularly shaped face, rosy cheeks, chestnut brown hair, sparkling eyes but with passion restrained, a laughing air, gentle and courteous'.[17] His patrons included virtually all the enlightened monarchs and all the 'who's who' who could afford a Rubens. The demand was higher than the possibility of his being able to supply the large cycles he was commissioned to paint, among which were the *Decius Mus* for Genova, the Jesuit Church of Antwerp, the Marie de Medici and Henri IV cycles for Paris and the twelve *Constantin* tapestries for Louis XIII – whence the workshop, mainly between 1615–25, with Anthony van Dyck, Frans Snyders and Jacob Jordaens as principal collaborators. A 'production line' ensued, essentially for the large history painting cycles, which was to become, to my mind, detrimental to Rubens's posterity. Indeed, a collaborative work of three or four different hands cannot achieve the organic structure needed in a painting, which one hand only can possibly attain. A collaborative painting is not a chorus singing the music written by one composer, but rather several composers trying to make a chorus with one voice singing it. Unfortunately, many of the collaborative pieces tend to fall apart, although they are interesting for art-history students as exercises in connoisseurship: we can easily recognize which hand is which, especially those of van Dyck, Snyders and Jordaens (van Dyck was in the studio only briefly around 1616 to 1619, Snyders from 1611 to 1616 and Jordaens was Rubens's assistant from 1620 to 1640). But Rubens had other assistants as well, especially for the decoration of the Banqueting House in Whitehall.

IV

'I have never failed, in my travels, to observe and study antiquities, both in public or private collections, or missed a chance to acquire certain objects of curiosity by purchase,' wrote Rubens to his friend Peiresc on 18 December 1634. His collection of antique sculpture and Italian painting was the most significant one in northern Europe. Besides the collection of sculpture, which he acquired from Sir Dudley Carlton in the 1620s, and later sold , after his first

[17] Roger de Piles, *Conversations sur la connoissance de la peinture et sur le judgment qu'on doit faire des tableaux*, Paris, 1677, p. 73; *Dissertation sur les ouvrages des plus fameux peintres*, Paris, 1681, p. 27

wife's death in 1626, to the Duke of Buckingham, Rubens possessed nine Titians, among which was the last *Self-portrait* (Madrid, Prado), five Tintorettos, four Veroneses, one Raphael, as well as paintings of the northern schools by Jan van Eyck, Hugo van der Goes, Quentin Massys, Jan van Scorel and Frans Floris; but his favourite was Pieter Brueghel the Elder; he also owned works by Dürer and Holbein, as well as works by contemporaries: ten by van Dyck, five by Snyders, eight by Cornelis Saftleven, eight by Adam Elsheimer and seventeen by Adriaen Brouwer. In his *Life* of Rubens (1672), Giovan Pietro Bellori describes the master's private museum: 'He had a circular room built in his house in Antwerp, with only a round skylight in the ceiling, similar to the Pantheon in Rome, so as to achieve the same perfectly even light.' To complete his 'museum', Rubens built a rectangular room in which to hang his collection of paintings, lit by northern light – thus following not only Vitruvius's concepts but also observing what was common knowledge to all painters: northern light alone is stable and permits the viewing of colours in their right hue.

According to the English Ambassador to the King of Denmark, Sir Thomas Roe, Rubens was 'full of resource and marvellously well equipped to conduct any great affair . . . he had grown so rich by his profession that he appeared everywhere, not like a painter, but a great cavalier with a very stately train of servants, horses, coaches, liveries and so forth . . . he had two advantages, great wealth and much astuteness. He was extremely alert in everything . . . '[18] But this was Rubens's public image of a *mens sana in corpore sano,* as read the inscription above the archway leading into his garden. It is impossible to know the private Rubens. Of his surviving correspondence there are practically no private letters. Was he really as balanced, as Stoic? Probably not always. Although a follower of Justus Lipsius in neo-Stoicism, when faced with the sudden death of his wife Isabella Brant in June 1626, he wrote (15 July 1626) to his friend, the great French humanist, Pierre Dupuy (1582–1651), Royal Librarian in Paris:

> You do well to remind me of the necessity of Fate, which does not comply with our passions, and which, as an expression of the Supreme Power, is not obliged to render us an account of its actions. It has absolute dominion over all things, and we have only to serve and obey. There is

[18] Gregory Martin *The Flemish School c.1600–c.1900*, National Gallery Catalogues, London, 1970, p. 122

nothing to do, in my opinion, but to make this servitude more honorable and less painful by submitting willingly; but at present such a duty seems neither easy, nor even possible. You are very prudent in commending me to Time, and I hope this will do for me what Reason ought to do. For I have no pretensions about ever attaining a stoic equanimity; I do not believe that human feelings so closely in accord with their object are unbecoming to man's nature, or that one can be equally indifferent to all things in this world . . . [19]

That he was in accord with his object, feeling it closely, is what we grasp, to my mind, from Rubens's work. The intensity of feeling conjugated with his power to distil truth from life, his high intelligence in his compositions, the logic with which he solved, as if in a flash of lightning, contradictions between content and form, make up the syntax of his paintings.

For example, the *Self-portrait with Isabella Brant* (1609-10, Munich, Alte Pinakothek): the composition is, as I see it, dictated by the placing of Isabella on the right-hand side of the canvas, thus setting it off balance; etiquette and symbolism imposed it – the left, *sinister*, being malefic and inferior. But in placing Isabella on the right, Rubens certainly knew that his composition would seem to be tilted to the right, thus having the figure of Isabella 'fall out'; his brilliant invention was to seat himself higher, with his hat cut off, 'hanging' his composition from the angle thus created; it is this angle which sets off the circular movement in a rhythm of 1, 2, 1, with Isabella's yellow hat as an accord, continued by her light stomacher echoed in reverse, upwards, by his dark right sleeve, pulled down and left by his two (red) crossed legs as a counterpoint. Isabella's collar plays an essential role in summing up the circular, clockwise movement around the crossed hands (the picture's focus) which are placed on the Golden Ratio intersection: his hand in hers, and one free; her hand in his, and one free – whence the rhythm. Our eye is driven there, and starting from there we are pulled, clockwise.

The key to a painting is not easily found: unlike music where the key to a piece is given first, the key in painting remains hidden. Sometimes there are several keys.

But White gives us another view, or more precisely, a 'reading', of the picture:

[19] Rooses and Ruelens, op. cit., vol. III, pp. 444–5; and Ruth Magurn, *The Letters of Peter Paul Rubens*, Cambridge, Mass.,1955, pp. 135–6

'In a bower of honeysuckle Isabella, wearing an embroidered stomacher, sits at Rubens's feet, her hand resting affectionately on her husband's . . . The perfect harmony between them is expressed by the interlocking flow of movement from one figure to another. He portrays himself not as an artist but as elegantly dressed as his wife . . . his yellow stockings creating a colourful accent in an otherwise dark-keyed painting. The painting is an unmistakable statement about social position . . . '

For the sake of history, the art historian often tends to disregard pictorial formulation, because it is ahistorical in its essence, but also because it is never taught. Hence the insistence on iconography, which is frequently the result of deciphering a picture rather than seeing it.

V

The years 1628–30 were hectic and filled with travel, during which Rubens had to make art and politics concord. He spent considerable time travelling, with long sojourns in Madrid (1628–9), and then in London (1629–30), where he was sent to re-establish diplomatic relations between Spain and England. The amazing thing is that these activities did not stop him from painting. In Madrid he even managed to paint the equestrian portrait of the king, and copied a number of Titians. In London, besides the complete success of his mission, he did not abandon his brushes and painted among other things a portrait of Thomas Howard, Earl of Arundel (London, National Portrait Gallery), but strangely enough, not a portrait of Charles I.

The last ten years of his life were years of happiness and fulfilment during which he painted the Ovid cycle for the Torre de la Parada (which remained unfinished) and most of his greatest masterpieces. Spending most of his time in his town-house and his castle, Het Steen, he retired from politics (but was involved in the granting of asylum in Flanders to Marie de Medici). After his return from England, Rubens remarried.

He wrote on 18 December 1634 to his friend Peiresc:

. . . I have taken a young wife of honest but middle-class family, although everyone tried to persuade me to make a court marriage. But I feared pride, that inherent vice of the nobility particularly in that sex, and that is why I chose one who would not blush to see me take my brushes in hand.

Hélène Fourment, whom he married on 6 December 1630, was sixteen years old. She filled the last ten years of his life, and was his muse, and constant model. The drawings and paintings he did with her, are the greatest masterpieces of his life; 'he was intoxicated by her,' says White. One feels it. However, after his death she blushed about the brushes, and preferred to consider herself the widow of the knight of Het Steen rather than of one of the greatest painters of her time. Of all time. She also destroyed some paintings showing too much of her nudity. But what remains – the numerous drawings and paintings, culminating in the fabulous *Het Pelsken* (Vienna), reverberate with his passion and her sensuous femininity.

Already in 1607, while working in Rome on the Chiesa Nuova altarpiece, Rubens was considered a great master. By 1611 he was referred to as 'the Apelles of our age'. By royal decree and *Lettres patentes* dated 27 April 1629, Rubens was made by Philip IV, King of Spain, secretary in his Privy Council, and later knighted (created 'chevalier') by a royal document dated 20 August 1631,[20] after his return from his successful diplomatic mission to England. With the conclusion of peace, signed on 15 November 1630, the King of England had a patent of Rubens's knighthood drawn up 'for the peace concluded between Us and the King his master'. Charles I also 'presented him with the jewelled sword used for the accolade, and a ring from his finger and a hat cord ornamented with diamonds';[21] Rubens was made Knight of the Golden Spur and given the privilege of using in his coat of arms a quarter of the royal blazon, namely the gules with a lion rampant, which Rubens made his chief canton.[22]

But his ascendancy and growing fame paralleled the decline of his city, Antwerp, especially after the end of the Twelve-Year Truce (1609–21), and the renewal of the war between Spain and Holland. Amsterdam replaced Antwerp as the most important port, thus destroying its commerce. Rubens's great dream was to achieve peace between the sister provinces, the Spanish Netherlands and the Dutch Republic. He was to play in it a role, starting in

[20] Rooses and Ruelens, op. cit., vol. V, pp. 420–2; not 16 July 1631 (White, op. cit., p. 244, note 18), which is the date of the Infanta's proposal, in the name of her Supreme Council, to elevate Rubens to the dignity of Knight of Santiago (following the Emperor Charles V who bestowed upon Titian that knighthood). The request was approved by the King – but apparently not by the Council of the Military Order of Santiago. The knighthood bestowed on Rubens one month later by Philip IV is not the one of Santiago.

[21] Rooses and Ruelens, op. cit., vol. V, p. 228

[22] ibid., pp. 347–8

1624, as the mediator between the Archduchess Infanta Isabel, the marques Spinola, Commander of the Spanish army in the Netherlands, and Prince Henri van Nassau, the Stadthouder of the Dutch Republic. But Rubens never saw the end of the war. He died eight years too early – but not for dealers – on 30 May 1640.

In a letter from Brussels dated 2 June 1640, Balthasar Gerbier, agent for the Court of England in Brussels, wrote to the Earl of Arundel:

May it please yr Excelency:

Sr Peeter Rubens deceased three days since; all his rarities of Pictures, Statues, Agates, Ivory cut workes, and drawings will be sould outt off hand. If his Majty, or yr Lod, would have any of his said rarities baought, bills of credit would be necessary to make good paymt; since wth out monney notting can be made sure. I thought fitt to notice ye same, ceasing giving more trouble to yr Excel. I remaine, Etc.[23]

[23] ibid., pp. 447–8

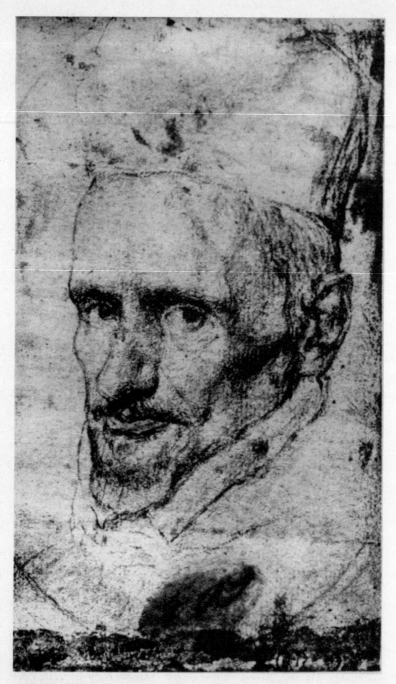

Velázquez, *Portrait of Cardinal Borja,* 1643, black chalk, 19 x 12cm.
(Madrid, Academia San Fernando)

VELAZQUEZ, *PINTOR REAL*[1]

Velázquez was one of the first artists to understand the importance of painting directly from life, and he did so from the start. His knowledge of geometry, philosophy, scientific theory and even medicine (suggested by what we know of his library) didn't get in his way when he turned to the canvas. It is as if all his accumulated knowledge was stored up in order to propel him out of his own time and allow him to paint what he saw. This is how a painter's eye still sees him.

It is essentially thanks to Pacheco (1649), Lazaro Diez del Valle (1656, 1659) and Palomino (1724) that we can imagine bits of Velázquez's life, and our assumptions are further nurtured by documents and commentaries such as Jusepe Martinez's (1675), known to Palomino, and more so, by the research pioneered by such historians as Carl Justi (1888) and continued by Lopez-Rey, Elizabeth Trapier (1948), Enriquetta Harris (1982) and Jonathan Brown (1986) among others. Though art historians are usually at variance with artists, being more attentive to *what* is painted than *how* it's painted, and tend to be carried away by cultural history, they are a great help in reconstructing the missing facts of an artist's time and, eventually, of his life. Indeed, the facts of Velázquez's life remain scarce – we have only the court documents published in *Varia Velazqueña*.[2] There is no remaining correspondence, as in the case of Rubens or Poussin; nothing is left in writing about Velázquez's ideas, and almost nothing about his character – except the report that he was witty. But his activities at the court of Philip IV and the principal events of his life are well documented. His interests can be guessed at from the listed contents of his library, which contained virtually all the books a seventeenth-century humanist could have wished.

[1] Originally written as a book review for *The New York Review of Books,* vol. XXXIII, no. 17, 6 November 1986, on *Velázquez: Painter and Courtier* by Jonathan Brown, Yale, 1986, under the title '*Pintor Real*'; Spanish translation published in *Diario 16 – Culturas*, Madrid, 30 November 1986). Subsequently expanded and modified.

[2] *Varia Velazqueña,* Madrid, 1960

Few of Velázquez's paintings can be dated with precision and some attributions remain questionable. From the 226 works listed by Stirling-Maxwell,[3] and attributed to Velázquez, the number of authentic works was gradually reduced, attaining a rough 125 works in the second edition of the José Lopez-Rey *catalogue raisonné* (1979).[4] No other drawings attributable with certainty to Velázquez are extant but the *Cardinal Borja*, which is one of the greatest drawings of all time: the purity of its line, more connected to Holbein than to any Italian, the space, the shading, the rhythmic line, last but not least, the expression and unmistakable likeness of the sitter, all reveal a great draughtsman, i.e. an incessant practitioner of drawing. There must have been many drawings but none is mentioned in the *post mortem* inventory. They all vanished.

Although Velázquez's painting gives the impression of a simple transcription of nature, this apparent simplicity is both misleading and enormously difficult to analyse or describe. Blessed by nature with extraordinary talent, he was fortunate to benefit from royal opportunities, but these opportunities, favourable to his creation, restricted his audience to the king and his immediate entourage, with few exceptions – this was his exclusive public. In spite of the fact that he became, as Brown puts it, the only Spanish painter of his age whose work was to equal and even surpass the best works of Flanders and Italy, his painting was not considered of any importance in France or Italy during his lifetime. He remained unnoticed by the principal European commentators of the seventeenth century, such as the Italian classical art

[3] William Stirling-Maxwell, *Annals of the Artists of Spain*, London [1848], 1891, vol. IV, pp. 1575–95

[4] Without venturing into the intricacies of a *catalogue raisonné*, Brown reduced this figure in his checklist to ninety-eight authentic paintings, seven collaboration works, nine possibly by Velázquez, and three drawings: *Cardinal Borja*, and the recto-verso sheet of the study for the *Surrender of Breda*, of which only the portrait-drawing of *Cardinal Borja* seems certain. Rejecting such works as the *Kitchen Scene* (Chicago, Art Institute), accepted by Lopez-Rey, and all the 'self-portraits', Brown fully accepts *La Tela Real* (c.1640, London, National Gallery), better known as the *Royal Boar Hunt*, rejected by Lopez-Rey and most scholars, thus reverting to Carl Justi (1888) who described this picture at length. Badly damaged in the 1734 fire at the Madrid Royal Palace, *La Tela Real* underwent successive restorations even before its acquisition in 1846 by the National Gallery. Independently of its bad condition it was chiefly questioned because of its uniqueness in Velázquez's oeuvre. Brown also accepts one of the two extant versions of *Prince Baltasar Carlos in the Riding School* (c.1636, the Duke of Westminster), which is generally disputed, also reverting to Justi, who saw in it a foretaste of the *Meninas*.

theorist Giovan-Pietro Bellori, or the French theorist Roger de Piles. He is mentioned with contempt by the French historian and critic André Félibien, who writes that 'Velasque' lacked the '*bel air* of which only the Italians were capable . . . ' Putting Velázquez together with the minor landscape painter Francisco Collantes, Félibien concludes that 'they had the same qualities which we find among others who were not first-rate.'[5]

In Spain itself, no other Spanish artist of the seventeenth century was written about so much during his own lifetime, yet he had scarcely any influence on other Spanish painters. He left no immediate followers. Except in the realm of court portraiture, there is scarcely a trace of his impact on the painters who succeeded him. His successors at court and the other painters in Madrid turned to other models, notably Rubens, and painted almost as if Velázquez had never existed. In the history of Spanish art, he is alone. One could argue that he was isolated because he was a gentleman and, much later, a knight of Santiago (a knighthood he enjoyed only six months), and that his colleagues were craftsmen, dependant on commissions, an argument some social historians (like Brown) put forth; or that he was isolated because of his exceptionally rare talent. His unique qualities as a painter and the fact that he was, so to speak, at the centre of power, enabled him to follow his inclinations as none of his contemporaries could. All this, thanks to Philip IV, a discerning, passionate admirer of painting, but an unlucky, melancholic and superstitious monarch, five years younger than his painter. Actually, one of his painters. The others were: Vicente Carducho (1576–1638), Eugenio Cajés (1575/6–1634), Angelo Nardi (1584–1664) and Juan Battista Mayno (1578–1641). Incidentally, they were all of Italian descent. A competition among them and the young Velázquez in 1627 on the subject of 'The Expulsion of the Moors' was judged by Mayno and the architect-painter Giovanni Battista Crescenzi (also of Italian descent) who proclaimed Velázquez the winner. This is the symbolic date of the beginning of the Spanish 'Golden Age' of painting. Velázquez was to become the king's favourite painter and illustrated his unique position in the portrait of *Philip IV in Brown and Silver*, by putting a sheet of paper into the king's hand which reads: Señor (Diego Velazquez) Pintor de V. Mg.

Spain is a peculiar place. The Iberian peninsula is indeed part of Europe but faces Africa. The Renaissance hardly got there. It did affect sculpture and

5 André Félibien, *Entrentiens sur les vies et sur les ouvrages des plus excellens peintres anciens et modernes*, Paris, 1688, vol. V, p. 14

architecture, but not painting, which remained stagnant and provincial. There was little significant patronage for Spanish artists other than from the Church, and ecclesiastical patronage went chiefly to architecture and sculpture; the king and court patronized the famous artists of the European centres.

Things started to change in the sixteenth century during the last years of the reign of Philip II, with the construction of El Escorial between 1563 and 1584. Italian artists made the trip to Spain to work for the king, and some of them, such as Bartolomé (1554–1608) and Vicente Carducho (1576–1638), even remained there. They brought with them the *buon maniera* of history painting based on proportion and perspective, which aimed at fidelity to nature. Still, those constitutive parts of a picture named *disposition* and *decor* (the positioning of figures and propriety) were dictated by the Church. Thus, the painter was a mere practitioner rather than a creator. Medieval rules still governed sixteenth- and seventeenth-century artists in Spain, who were considered craftsmen, not artists, on the same level as carpenters, masons and butchers.

That was the prevailing situation when Diego Rodriguez de Silva y Velázquez was born in Seville on 6 June 1599 to parents of the minor nobility (of Portuguese origin), and when he entered the studio of Francisco Pacheco (1564–1654) in 1610. Pacheco's studio and academy were described by Palomino (1724) as a 'gilded cage of art, the academy and school of the greatest minds of Seville',[6] which was seemingly dominated by idealist theory. Pacheco, whose daughter Juana he married on 23 April 1618, and who was to become his first biographer (1638), was versed in technique rather than theory, although he apparently was a believer in the ideal manner of painting, mixed with Catholic propriety and Jesuit overtones. He was aware of the importance of drawing and encouraged its constant practice, but he was not a believer in painting from life. He recommends in his *Arte de la Pintura* (1649) the use of a print rather than a live model for painting the female nude, and he must have been an opponent of Caravaggio. But after Velázquez was granted the 'licence' to practice painting as an independent master, on 14 March 1617,[7] his works were all painted from life. They were definitely anti-idealist, not anti-Caravaggesque. He followed Caravaggio's example, at least in adhering to working only from observation. This was more a matter of attitude than of style: truth before beauty.

[6] See Jonathan Brown, 'Theory and Practice – The Academy of Francisco Pacheco', in *Images and Ideas in Seventeenth-Century Spain*, Princeton, 1978
[7] cf. *Varia Velazqueña*, op. cit., vol. II, p. 217

Velázquez's relation to Caravaggio and to Caravaggism has been much debated. The great Italian art historian Roberto Longhi saw in the early work of Velázquez a direct link to Caravaggio. But Benedict Nicolson pointedly excluded Velázquez from his catalogue *The International Caravaggesque Movement*,[8] and Jonathan Brown rejects the connection with Caravaggio on stylistic grounds, even though the example of Caravaggio was exciting to most of the young artists in Western Europe for at least a decade up to the 1620s. It can be argued that Velázquez did not see any original painting by Caravaggio in Seville. The *Crucifixion of Saint Andrew* (now in the Cleveland Museum of Art), brought to Spain from Naples in 1610 by Don Juan Conde de Benavente, was hanging in the palace of Valladolid. The young Velázquez may have seen a copy, but there is no evidence that he did so.

It is possible that Velázquez was more influenced by northern painters, such as the Flemish artists Pieter Aertsen (1508/9–1575) and Joachim Beuckelaer (1530–74), as was first suggested by Carl Justi in his pioneering biography of the master (1888). Some historians mention the Cremonese painter Vincenzo Campi (1525/30–1575) as another model. It is plausible that works by such northern and Cremonese artists could have been seen in Seville, a rich international port where goods from all over the world were exchanged, and trade was principally in Flemish hands. Velázquez must have seen not only prints by Jacob Matham after Aertsen, but originals as well of his *Keuken*, or kitchen scenes with still life, called in Spain *bodegones*. Jonathan Brown also mentions as a possible influence the 'subspecies' of northern Italian genre painting called *pittura ridicola*, 'a type of scene in which the antics of the lower orders were turned to moralizing purposes.'[9]

Frequently, these pictures display still-life objects as tokens of vicious behaviour, employing a form of symbolism which had long been in existence, depicting familiar objects symbolizing the vices, gluttony, sexual licence or drunkenness. Pacheco had written of this type of painting, of which one Spanish example may be found in the obscure Andalusian painter Juan Esteban de Úbeda, in his satire of gluttony dated 1606, as suggested by Jonathan Brown. Velázquez's early genre painting may convey a moralizing message. Even such works as *Old Woman Cooking* (1618, Edinburgh, National Gallery) or the *Waterseller* (London, Wellington Museum) may, according to Brown, contain cryptic messages.

[8] Benedict Nicholson, *The International Caravaggesque Movement. Lists of Pictures by Caravaggio and his Followers throughout Europe from 1590 to 1650*, Oxford, 1979
[9] Jonathan Brown, *Velázquez: Painter and Courtier*, Yale, 1986, p. 15

These early paintings, which seem to me rather hard, are nevertheless extraordinary achievements for such a young painter – Velázquez was nineteen years old when he painted the *Old Woman Cooking*. The early works gained him increasing attention, which, with the backing of his former teacher, now father-in-law and admirer, brought him to Madrid, where he was commissioned to paint the portrait of the young King Philip IV (now lost?). Pacheco relates that Velázquez was summoned to Madrid by the royal chaplain, Don Juan de Fonseca, at the order of Olivares. Velázquez was given lodging in Fonseca's home where he painted his portrait, which received great acclaim at the palace, thus convincing the young king to sit to Velázquez for his own portrait. Velázquez painted the king, five years his junior, on 30 August 1623, 'to the pleasure of His Majesty, the infantes and the Count-Duke . . . '[10] On 6 October 1623, Velázquez was appointed by royal decree a royal painter, *pintor real*.[11] For the next thirty-seven years, until his death on 6 August 1660, he lived at court, rose in its hierarchy, and produced the great works that probably wouldn't have existed had he remained in Seville, where he was settling down to a comfortable life with his young wife and two daughters (Francisca, born in 1619, and Ignacia, born in 1621). The move from cosmopolitan Seville to Madrid must have been something like a move from Paris to Versailles. Madrid was a small, dull place centred around the palace, its cost of living higher than Rome, but as its citizens boasted, *Sélo Madrid es corte*, 'Only Madrid is the court': the nobility, abandoning Toledo or Valladolid, built its palaces there.

The artificial town Philip II built around the palace was chosen as the kingdom's capital because it lay geometrically at the peninsula's centre. The Habsburg court there was one of the most complex and hierarchical in Europe; its organization can be traced to the requirements of the etiquette of the Burgundian court, which had been introduced into Spain by the Emperor Charles V. The various positions held by Velázquez in the King's service must be measured against this background, becoming clearer and clearer, although in reverse image, because delineated by the austere surroundings. Velázquez certainly shared that style. His royal portraits were born in these surroundings. Opulence and gravity which were at the heart of Philip's court style were also the background to his portraits. Subsequently, the empty rooms of the Alcázar

[10] Pacheco, *Arte de la Pintura, sua antigüedad y grandezas,* Seville, 1649. Edited from 1638 Ms. by Sánchez Cantón, 2 vols, Madrid, 1956

[11] Archive of the Palacio Real, Madrid, Felipe IV. Casa. Leg. 139

palace, dimly lit and without much ornament, have, as I think, their counterpart in Velázquez's conception of space in his middle and late paintings: simplicity, modesty and limitation to an austere palette.

Portraiture was indeed Velázquez's main interest. Starting with the early portraits painted in Madrid, such as the one of the poet *Luis de Góngora* (Boston, Museum of Fine Arts) or the very expressive *Portrait of a Gentleman,* presumed to be Juan de Fonseca (1623, Detroit, Institute of Arts), his style is his own; it is not Titianesque and resembles nothing but life, as expressed by the minimal means of brush and pigment. The greatness of Velázquez's painting is achieved by the reduction to the means at his disposal, by the equation between accuracy and painterly diligence. There is no story to tell, there is actually no room for art-historical comment. Arcimboldo's 'portraits' are much more suitable for such discourse, but it is the former which procure an everlasting delight.

Was there a distinctive Habsburg style of portraiture, beginning with Titian's 1548 portrait of Emperor Charles V (Munich, Alte Pinakothek), as some art historians suggest? I tend to think that there is a Titianesque style which became identified with the House of Habsburg. But the problem of royal portraiture was: should a royal face be painted as it is or as it ought to be? This Aristotelian question had an answer in antiquity: Augustus did not allow his actual appearance to be sculpted (he was rather ugly), and preferred idealization to likeness: an ideal head. Philip IV, however, did not hide his face, at least not his right profile (his left profile was rarely painted by Velázquez).

Velázquez made two long visits to Italy (1629–31 and 1649–51), and while his portraits of Pope Innocent X (1649/50, Rome, Galleria Doria-Pamphili) and of Juan de Pareja (1649/50, New York, Metropolitan Museum) had some impact on artists working in Rome in the 1650s, he was soon forgotten there. This can be explained by the dominance in Italy of the *classical ideal*, which did not admit such straightforward painting from life as Velázquez's, and imposed instead the neo-Platonic conception of idealizing or 'improving' nature, in order to obtain Ideal Beauty.

It is against that background that Velázquez painted his portrait of *Innocent X,* the greatest portrait painted in Rome, as Reynolds thought, and many still do. Words really fail in front of it. One should go to the Galeria Doria-Pamphili and remain in front of it until the whisper of the two lives traced upon the canvas – the painter's and the sitter's – will resound in one's heart. Velázquez had a prolific year in 1650, painting the portraits of Dona Olimpia Maidachini (lost), Cardinal Astalli-Pamphili (New York, Hispanic Society), a chamberlain

to the Pope, and his barber, Signor Michel Angelo (New York, private collection), among others. He also painted the portrait of *Monsignor Camillo (né Carlo) Massimi* (1620–77),[12] a passionate art lover who was Poussin's friend. He was a pontifical *cameriere segreto d'onore* – the holder of this office wore peacock blue, whence the strange blue in the portrait. Velázquez first met Massimi in 1649–50. The prelate was, at the age of thirty-three, Patriarch of Jerusalem. He arrived in Spain in 1654 as Nuncio – but Philip IV refused to receive him (the Nuncio being too friendly to the French) for an entire year, during which his entry to Madrid remained forbidden. Massimi was forced to live in a small town between Valencia and Madrid. Nevertheless, he took pleasure in archaeology, deciphering Hebrew inscriptions for his learned friends in Italy. While waiting, he wrote to Velázquez, who replied on 28 March 1654 (BM) that he hoped ' . . . to see his former patron at court'. He did, at last, and one can imagine the range and depth of their conversations. Velázquez also painted four more works for Massimi: the King, the Queen, and two Infantas. Massimi was recalled in 1658 by Alexander VII and had no further job for the next twelve years. It is probably during these hard years that he had so much time on his hands to spend with Poussin, who gave him his last unfinished painting *Apollo and Daphnae*. In 1670, Clement X made him Cardinal and *Maestro di Camera*. By that time Velázquez and Poussin were dead. Cardinal Massimi, once painted by Diego Velázquez, was now painted by Carlo Maratta.

Ascending in the hierarchy of the court, Velázquez was appointed not only *Pintor Real* but also *Ugier da Camara* (1627), *Ayuda da Guardarropa* (1636), *Ayuda da Camara* (1643), *Veedor de las Obras* (1647), and finally *Aposentador Mayor de Palacio* (1652). In contemporary language, we would say he was royal painter, chamberlain of the palace, decorator, and curator of the royal collections. As such, he had to use his connoisseurship, which was evidently sharp. For example, Velázquez censured the acquisition of Correggio's *Education of Cupid* (1520/4, London, National Gallery) for the King's collection. The painting, once in the Gonzaga, Duke of Mantua collection, and bought by Charles I of England in 1628, was cut down on all four sides before 1639, when it was recorded at Whitehall as having measurements almost identical with its present ones. Velázquez's acute eye probably saw that there was something not quite right about it, an observation really rare for the period.

[12] The National Trust, Kingston Lacy (Ralph Bankes collection). Provenance: Marqués del Carpio (1682), acquired in Bologna for an ancestor of Ralph Bankes

Philip IV was born in 1605, the year of the publication of the first part of Cervantes' *El Ingenioso Hidalgo Don Quijote de la Mancha*, almost like an omen. His life was dominated by political and military defeat. He took refuge in theatre (also actresses) and art. He was among the greatest collectors of painting of the seventeenth century. Between 1623, when Velázquez became the King's painter, and 1660, the date of Velázquez's death, their relationship continued to grow and became a kind of friendship, within the limits of court etiquette. It is clear that the King was fond of his painter, that he admired his work and trusted his taste, and gave him every honour he could, culminating in the knighthood of the military Order of Santiago, which was immensely hard to obtain for Velázquez.

Velázquez's ambition to be knighted followed the examples of Titian (knighted by Emperor Charles V), Rubens (knighted by Charles I of England and Philip IV), and Anthony van Dyck (knighted by Charles I). But he had to struggle for his knighthood. Pope Innocent X, whom Velázquez painted in 1650 (Rome, Galeria Doria-Pamphili),[13] and Philip IV demanded that Velázquez be knighted because he was a great artist – not because he was of noble descent, which he was. He was finally accepted into the order (after a second intervention, *dispensia*, by the Pope Alexander VII)[14] on 28 November 1659, eight and a half months before his premature death. His entry into the oldest military order of Spain was seen as a victory for all artists – Zurbarán, Alonso Cano, Juan Carreño de Miranda, among others, who had testified for Velázquez. The order's rules excluded 'those who themselves, or whose parents or grandparents, have practised any manual or base occupation here described . . . By manual or base occupation is meant silversmith or painter, if he paints for a living.' Velázquez's colleagues testified that Velázquez did not practise painting for a living.[15] To demonstrate that art was a noble occupation remained for Velázquez as for other artists a central issue. This may help, as Brown sees it, to explain the iconography of Velázquez's two greatest paintings (both in the Prado), *The Fable of Arachne* (*Las Hilanderas* – 'The Spinners') and *Las Meninas* ('The Maids of Honour'), in both of which some historians see homage to painting as a noble art. In *The Fable of Arachne*,

[13] ' . . . the famous portrait by Velázquez which Sir Joshua Reynolds pronounced the finest picture in Rome', *Diary of Thomas Moore*, ed. Lord John Russell, London, 1853, III, 62, cf. Justi, 1888, vol. II, pp. 189–90

[14] cf. Varia Velazqueña, vol. II, pp. 375–6

[15] For all other testimonies see *Varia Velazqeña,* vol. II, pp. 301–67

Velázquez depicts the last moments of a competition to which Arachne had presumptuously challenged Minerva to show that she, Arachne, could weave like a goddess, and thus demonstrate that gods and mortals are equals. Velázquez ignores the horrifying conclusion of Ovid's text, the transformation of Arachne, who won the competition, into a spider by the jealous Minerva. The subject of Velázquez's painting has a double meaning: not only does he show the competition between common mortals and the gods, but the actual weaving of a tapestry based on Titian's *Rape of Europa*, a painting then in the royal palace. Arachne's tapestry, which uses one detail of Titian's painting, depicts Minerva's work, equating Titian with Arachne. Velázquez's homage to Titian had another connotation: Titian was Charles V's and Philip II's favourite painter, and as a knight of the Golden Spur he was a paradigm for the status-seeking artists of Spain. Very swiftly executed, *The Fable of Arachne* was the ideal of the Impressionists, who found in it the freedom of the brush they were longing for. It was not so much *Las Meninas* (1656) that fascinated them. The rigorous composition, in which speed and logic fuse, is a rapidly executed painting, with *pentimenti* here and there. We are not so much interested now in the interpretation of it as a monument to painting as a noble art. But as a painting. Palomino compared it to Titian's self-portrait holding in his hands the portrait of Philip II, or to Phidias who placed his own portrait on the shield of the statue he made of the goddess Athena. Palomino[16] regarded the Infanta Margarita (later Empress of Austria) as the 'protagonist' of the painting. He thought that as long as her fame lasted Velázquez would be valued too – he did not imagine that three centuries later, the Infanta Margarita would be remembered only because of Velázquez.

Las Meninas is no doubt Velázquez's most remarkable and most haunting masterpiece. It hits one's senses like nothing else and we don't grasp why. It is actually a huge genre scene and one wonders what Vermeer's reaction to this composition would have been. All frontal, like a stage with actors, the Infanta playing the principal role. The stage is the *cuarto bajo del Príncipe*, the apartment once occupied by the beloved and much regretted crown prince Don Baltasar Carlos (who died in 1646). The paintings on the walls are copies by Juan Bautista del Mazo (Velázquez's son-in-law) of Rubens's *Pallas and Arachne* and *The Judgment of Midas*, on the rear wall, and between and above the windows, other copies of Rubens by the hand of Mazo. The sitters are, from left to right:

[16] Palomino de Castro y Velasco, 'Don Diego Velázquez de Silva', in El Museo Pictórico y Escala Optica, Madrid 1724, II, ch.106

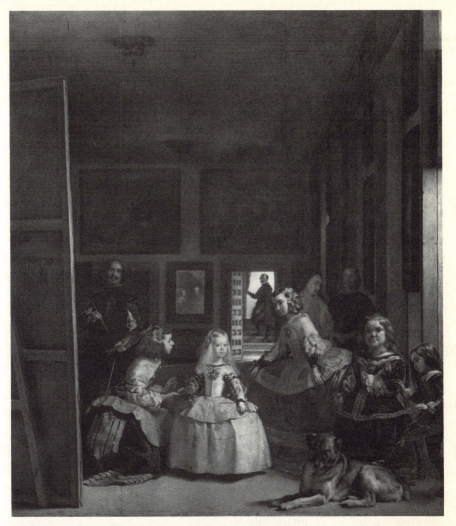

Velázquez, *Las Meninas*, 1656, 321 x 281 cm. (Madrid, Prado)

Diego Velázquez behind his canvas, painting the scene; the *menina* Maria-Augustina Sarmiento, handing a goblet of water to the future empress, the five-year-old Infanta Margarita; to her left, the *menina* Isabel de Velasco, curtsying; on the right hand of the picture, the dwarfs Marie Bárbola and Nicolásito Petrusato, and the sleeping dog; behind them, the ladies' governess (*guardamujer*) Marcela de Ulloa, and an usher; standing in the open doorway, Don José de Nieto Velázquez, the queen's chamberlain (*aposentador*); in the mirror, the reflection of the king and queen. One is deluded by the ideas one has of perspective, which is here multifocal.[17] The sensation we have of being pulled beyond the figures of the Infanta and her maids of honour is provoked, not really from the perspective's peculiarities, but from the tension between the two rectangles at the centre, between the deflecting figure of José de Nieto in the open doorway, and the reflected half-figures of the king and queen in the mirror. This positive-negative bond of light-on-dark (mirror) and dark-on-light (the open door), between reflection (mirror) and deflection (door), interlock, as if by a magnetic force into which our eyes are drawn. The multifocal perspective actually abolishes the illusion of depth, and brings the perspective lines back on to the plane. It was painted quite rapidly, with subsequent modifications: Velázquez's right hand, Maria-Augustina's profile, the position of Marcela de Ulloa (originally behind the usher, which was an affront to etiquette). There are some *pentimenti* here and there.

Velázquez seems not to have bothered much about perspective – which he actually mastered quite late, in Italy (in the *Forge of Vulcan*, which he painted there, perspective is dominant). The *Feast of Bacchus* (Madrid, Prado) which he painted before his first trip to Italy, retouching only the peasant figure on the extreme right upon his return in 1631, is all frontal. He tended to avoid perspective, although he must have studied it with Pacheco, and probably read the essential treatises on the subject, such as those by Vitelo, Alberti and Daniele Barbaro – all in his library. He did largely without conventional perspective, as is epitomized in the *Surrender of Breda* (1635, Madrid, Prado) but he is not the only painter of the seventeenth century to have replaced the perspective pyramid by a bifocal or multifocal perspective, which transforms depth into rhythm, bringing all perspective lines back to the flat plane. The understanding of the flat plane, the *piano,* was not a discovery of modernism.

[17] Bifocal or multifocal perspective constructions were used in studio practice before the laws of perspective were first described by Brunelleschi and Alberti, cf. Erwin Panofsky, '*I Primi Lumi*: Italian Trecento Painting and Its Impact on the Rest of Europe', in *Renaissance and Renascences in Western Art*, Norwich, 1970, pp. 115–61

Looking closely at his canvases, I think we can see that Velázquez painted directly, without drawing first, without 'calculating'; it seems clear that he started his painting directly with the brush, sketching with a burnt umber, going from dark to light often *alla prima* ('wet on wet'), and when possible finishing in one session – as in the portrait of the *Duke of Modena Francesco d'Este* (1638, Modena, Galleria Estense) or in the *Portrait of a Man* (presumably of José de Nieto, London, Wellington Museum). In most cases he did not finish a painting in one session, but often, even in *Las Meninas*, he completed most of the figures *alla prima*, and later retouched here and there (as in the shadow under the dress of the Infanta and her right arm). He retouched, changed, overpainted. The traces are visible to the naked eye – as in the splendid portrait of *Philip IV in Brown and Silver* (London, National Gallery),[18] where the shimmering silvery effect is obtained by overpainting white strokes on the already dried grey and brown; hence the scintillating hardness, due to the fact that the white strokes are not blended with the grey and brown underpainting, not wet on wet, but wet on dry, like in a gouache. The portrait was probably executed about 1631–2 (as determined by the *golilla*) and the overpainted strokes some time later.

Velázquez's technique of painting underwent a change in the early 1620s under the spell of Titian's royal portraits, as the first portraits of Philip IV demonstrate. But the most important event before his first trip to Italy was his encounter with Rubens, who arrived at the Spanish court in September 1628 and stayed there until April 1629. Rubens painted a number of royal portraits in Madrid and copied many Titians in the royal collection – such as *Diana and Acteon* as well as *Diana and Callisto* (Edinburgh, National Gallery) – which were intended to be given as a wedding gift to Charles I, then Prince of Wales, had he married Philip's sister, the Infanta Maria. When he didn't, the paintings remained in Madrid.

Rubens's copies of Titian must have had an important effect on the young Velázquez. The softening of form, freer handling of colour, and a certain change in the use of pigments, especially in the treatment of flesh, may well have been the result of seeing Titian by way of Rubens. Velázquez's first trip to Italy, just after Rubens's visit to the court, had an even greater effect in extending Velázquez's compositional range, as is demonstrated in the *Forge of*

[18] Apparently removed from a royal palace by Joseph Bonaparte and given by him in 1810 to General Dessolle (d.1828); sold by his daughter through Woodburn to William Beckford (d.1844) whose son-in-law was the 10th Duke of Hamilton, 1882; National Gallery, London.

Vulcan (1630, Madrid, Prado) and the astonishing *Joseph's Bloody Coat Brought to Jacob* (1630, Madrid, El Escorial). But his particular approach of capturing life directly by brush and pigment and leaving the stroke evident, still trembling with life, he learned from no one. It was his own language. As it is brought to a paroxysm in the very moving portrait of the jester *Calabacillas* (1630s, Madrid, Prado). Don Juan Calabazas, first in the service of the Cardinal-Infante, entered the service of the king in 1632. Velázquez must have painted him some time afterwards (and not in the 1640s, since Calabazas died in 1639). This work was probably painted quite rapidly, in one or two sittings – except for the gourds, the sitter's attribute (*calabacillas*), which are a later addition. The swiftness of the brushstrokes in this portrait, all in softness, is unsurpassed in its *morbidezza* but also in its incredible sureness of touch. The face and the wringing hands – simple brushstrokes – seem to pulsate, they are so true, so devastatingly true, holding in their minimal trace the feeling and vision of the hands and face painted while scrutinized. As if an imprint, something like the veil of St Veronica. Nothing more, but also, nothing less. The paintings that followed between his first and second voyage to Italy include such masterpieces as the *Lady with a Fan* (London, Wallace Collection) and *Philip IV as a Hunter* (Madrid, Prado). In both of them Velázquez used a diagonal as a 'starter' of the composition, the fan in the lower-left corner for the *Lady*, the rifle in the king's full-length hunting portrait. This formal invention illustrates the depth of Velázquez's spatial understanding. Indeed, the diagonal activates the shapes and space in both of them. A somewhat later example is the odd painting of *Mars* (1640s, Madrid, Prado), which was probably painted for the Torre de la Parada. Here, too, he used a diagonal, but differently: here it serves as a support and counterpoint. This canvas compared to a Guercino leaves the latter behind, although Guercino's brushwork is in itself marvellous. But Velázquez's depiction of the sitter, his formulation, colour, touch and brushwork, forms an incomparable entirety. Starting from the top: the helmet, its hardness and spark suavely expressed, overshadowing the sitter's face (of the jester Antonio Bañules?); the face hiding under and leaning on his left hand, in full light; a light falling obliquely on the nude body, the fleshtints of which are rendered with the sharpest sense of colour and breathtaking freedom of the brush. And the colour! This perfect harmony of blue and crimson – falling lightly reflected on to the inclined shield – underlined by white against the blackish background; the legs, one hidden and one revealed in echo to the arms; and last, but not least, the diagonal stick on the lower left, the trigger of the entire composition. Whether the 'intention' of this painting was satirical or linked to the defeat of the Spaniards at Rocroi

(1643), as suggested by some historians, is unimportant. Even now, three hundred and fifty year later and after the experience of modernism, the phenomenal single-figure composition remains somehow ahead of us. Another work, painted a few years later, is the *Rockeby Venus* (London, National Gallery). Probably painted before 1648 (Velázquez left for Italy in November 1648 and returned in June 1651), it surpasses any female nude painted in the seventeenth century or since. In a way, it was Velázquez's response to Titian. Although there are in this painting a few anomalies, such as the face in the mirror (which is not the sitter's face) and the somehow unreal Cupid, (probably a later, not lifelike, addition), the perfection of the figure – its flesh-tints are simply miraculous – all is just like a breath: as if there was no 'work' involved. And yet, this masterpiece attracted vandalism as well, having been slashed in seven places (hip and back) by a suffragette demonstrator in 1914, vividly illustrating the mis-seeing of painting: didn't the suffragette attack this picture for the same inappropriate reason that its first owner, Don Gaspar Méndez de Haro y Guzmán, Marqués del Carpio y Heliche, loved it – female nudity? The painting is mentioned in his 1651 inventory.[19] The depiction of the female nude was prohibited in Spain but Velázquez painted four other nudes: *Cupid and Psyche* and *Venus and Adonis,* painted for Philip IV and listed in the Alcázar inventory of 1686 as being in the Salón des Espejos. They were probably destroyed in the fire of 1734. Another female nude, an upright format of 210 x 167cm., is mentioned in a 1651 inventory as being in the collection of Domingo Guerra Coronel, and a recumbent Venus, *una Venus tendida,* is mentioned as being among Velázquez's possessions at the time of his death in 1660.

Velázquez's use of colour is based on his perception of the differences between cool and warm colours, and the possibility of modifying hues by contrast.[20] He rarely used primary colours: instead of using a brilliant red, he preferred to create an optical illusion of it. A good example is the red ribbon in the dress of the Infanta Margarita in *Las Meninas.* The pigment used by Velázquez is not vermilion, as one may think, but red ochre; the redness we

[19] Grand nephew of Olivares, the son of Don Luis de Haro, who succeeded to his uncle's titles and position as royal favourite 1645 (d. Naples 1682). The painting was sold after Don Gaspar's death to the Duke of Alba and remained in this collection from 1688 to 1802; it passed to Don Manuel Godoy in 1808; to Buchanan, London in 1813; to J. B. S. Morrit of Rokeby Hall, Yorkshire in 1905; then to Agnew and the National Gallery in 1906.

[20] These subtleties are invisible under artificial light – to exhibit Velázquez's painting under artificial light is, in fact, to distort its perception.

perceive derives only from the contrast: the cold grey surrounding it and the point of yellow in it enhance the redness, and so transform the red ochre into something redder than it is. On the other hand, vermilion was used in the Infanta's face, mixed with white, to produce the cool light pink of the cheeks. The chromatic modulation which is so masterly in Velázquez's mature and late paintings is, as in musical modulation, based on juxtapositions and reversals.

His pictorial idiom, essentially concerned with expressing the visible by means of the brush, is in fact anti-illusionistic in so far as the painting is reduced to a limited pictorial language of brush-strokes. This language of brushstrokes is not unusual in the seventeenth century. Guercino and Rembrandt used it. Old Titian used it before. Spontaneity in painting is as old as painting. Velázquez's brushstrokes are spontaneous and swift, and baffle because of their impeccable precision: a precise shot obtained through absolute freedom, as if the brush went its own way. It brings to mind the 'artless art' of *Zen in the Art of Archery*.[21] Velázquez let himself be carried along by his inner voice, which he may have perceived as his source of truth.

Few others had a chance to do so. Only a handful of artists and connoisseurs who had access to the Spanish royal court and to the king's quarters could see *Las Meninas*. Luca Giordano, who saw it there upon his arrival at the court in 1692, said to Charles II, '*esta es la teologia de la pintura*' ('this is the theology of painting'). He became more and more infatuated with Diego, though other painters did not follow. But the general public had no access to the royal collections. Velázquez remained private until the opening of the Prado Museum in 1819. Since then, and throughout the nineteenth century, Velázquez's work was finally revealed and had an enormous impact – among others on Manet, for whom Velázquez was '*le peintre des peintres*'. Through the enthusiasm of the Impressionists for his work, however, Velázquez became increasingly identified with the painterly loose brush-stroke, done with bravura, the source of which was essentially the brushwork in *The Fable of Arachne*; this sort of pictorial abbreviation (the hands for example), and the free composition, was held to be the mark of 'great painting' by such artists as Boldini and Sargent. This association reflected unfavourably on Velázquez for a time, and perhaps explains why Matisse (but not Picasso) preferred Goya and Murillo.

The wonder is that a king could have perceived his greatness.

[21] Eugen Herrigel (Bungaku Hakushi), *Zen in der Kunst des Bogenschiessens*, 1948 (in English, London, 1953)

ON NICOLAS POUSSIN'S
RAPE OF THE SABINES
(*the Louvre version*)
AND LATER WORK [1]

'. . . moy qui fais profession des choses muettes.'
(Poussin, in a letter to M. de Noyers, 20 February 1639)

Nicolas Poussin believed that virtue and wisdom could be taught to mankind through painting. All his work, especially of his later years, illustrates this conviction. His paintings illustrate sublime themes which obviously could not have been painted from one model since no such model existed in reality. They had to be drawn from different sources: partly from the antique, partly from lay figures, and partly from life. His paintings are composite pictures, which normally should have fallen apart in their heterogeneous compositions, but most of them do not. They work without grating, with the precision of a clock that always gives the right time. A precision in the treatment of his subject matter and an extreme rigour in his formulation combined to give his paintings the double aspect of the *fable* and the *form* which fascinated Bernini, who said about him 'un grand istoriatore e grande favoleggiatore'.[2] Cézanne also admired this quality, which he felt, however, as wanting, and as one to be redone entirely from life. 'Imagine Poussin completely redone from life, that is what I mean by classic.'[3]

Going through different phases, from the Titianesque, painterly, rather

[1] Originally written in French for the Louvre exhibition curated by this author (*L'Enlèvement des Sabines* de Poussin, 10 March–21 May 1979, *Petit Journal*, Musée du Louvre, Paris, RMN, 1979). The English version was written for the Museum of Fine Arts, Houston, and the Art Museum, Princeton University, 1982, exhibited there in 1983. Retranslated into French, and modified, for *Nicolas Poussin, Lettres et Propos sur l'Art*, Hermann, Paris 1989, *Peinture et Regard*, 1991, and revised again in its English version.

[2] Paul Fréart de Chantelou, *Journal de Voyage du Cavalier Bernin en France*, Paris [1885], 1981, p. 73

[3] Cézanne to Joachim Gasquet (1926) in *Conversations avec Cézanne*, Paris, 1978, p. 150; cf. Richard Verdi, *Cézanne and Poussin: The Classical Vision of Landscape*, National Galleries of Scotland, Edinburgh, 1990

Poussin, *The Deluge*, 1664, oil on canvas, 118 x 160 cm. (Paris, Musée du Louvre)

sensual and expansive style, to an increasing restriction, Poussin attained a unique form of conjunction between subject matter, colour and form. His compositions evolved with the years and attained mathematical precision, though his hand trembled more and more. In these late works rigour and frailty fuse to move us. But his work is not easily accessible. It does not simply reveal this or that corner of nature – no landscapes other than heroic, no portraits (except for his two painted self-portraits), and no still-life. Delectation was not his aim in spite of his statement. His conviction that painting, as mute poetry, could visualize wisdom and virtue better even than the word, made him paint exemplary thoughts and actions, drawn from the Bible, Virgil, Livy, Plutarch or Tasso, which he painted into interiors or surrounding landscapes of Tivoli or Pincio. As for example the Greek legend of *Pyramus and Thisbe* (1651, Frankfurt, Städelsches Kunstinstitut): he painted the Babylonian lovers[4] and their tragic end in successive episodes within a stormy landscape.

L'Istoria, which was considered 'the greatest work of the painter', had to be

[4] Ovid, *Metamorphoses*, IV, 55–166

Poussin, *The Deluge*, harmonic division

conducted with 'speed of execution joined with diligence'.[5] It had to be prepared with the most extreme rigour in respect of composition and subject matter. It was in fact a way of taking the vows, of leaving the secular world of minute pleasures, for the sublime, the heroic, the ideal. History painting was meant and believed to be able to visualize it all. Therefore it could not have been painted from one model, since the ideal models for it were invisible, but the actual *invisibility* of these sublime models had to be founded on the philosophical principle that 'everything that is good and fair is not without proportion', that disproportion 'convulses and fills with disorder the whole inner nature of man'.[6] History painting thus had to follow the 'pattern of the Universe', its measure, which is Divine Proportion. The history painter was, since Brunelleschi, Alberti and Piero della Francesca, more and more engaged

[5] Leon-Battista Alberti, *De Pictura*, III [1435], Basel, 1540 (Latin); Italian version: *La Pittura,* Venice, 1547, II, p. 23; English, Spencer, London, 1956
[6] Plato, *Timaeus*, 87 c and 88 c–d

in geometry, not only because he had to find a method to express depth (which was practised in antiquity)[7] and harmony, but also because harmony was the key to the universal. Geometry, i.e. proportion and perspective, separated the 'elevated' history painting, even if it was treated in a *modus humilis* (humble mode), from the common 'naturalist' copy of nature; history painting appears thus to become during the sixteenth century a metaphor for the universe, a visual metaphor reduced to human scale.

Contrary to sixteenth-century concepts, and in spite of his admiration for classical sources, Poussin does not apply ideal proportion to his figures, or seek, following Ficino's *Convito* (V, 6), regular features as criteria of perfect beauty. Poussin was chiefly interested in expression. (This is the basic difference between his work and what was to become of classical idealism in his name.)

'Just as the twenty-four letters of the alphabet are used to form our words and express our thoughts, so the forms of the human body are used to express the various passions of the soul and to make visible what is in the mind.'[8] In the overall harmony of his compositions Poussin followed Alberti: 'Beauty is a concordance of all the parts simultaneously achieving proportion and discourse, in such a manner that nothing can be added, or taken away, or altered, except for the worse.'[9]

On his arrival in Rome in 1624, Poussin was thirty years old. His probable masters: Noël Jouvenet (about whom nothing is known), Quentin Varin (1572?–1634)[10] in Normandy, the Parisian Fleming, Ferdinand Elle or Helle (*c*.1580–1649), and possibly Georges Lallemant,[11] whose studio Poussin left after one month. Poussin's formation was that of Northern Mannerism, Fontainebleau and the Flemish schools combined. Nothing of his earliest works survived, but, according to Félibien,[12] he was commissioned by the Jesuits to paint six paintings, which he executed within six days in tempera.

[7] cf. John White, *The Birth and Rebirth of Pictorial Space*, 1967

[8] Poussin quoted by Félibien in his diary, 26 February 1648, fol. 32, Mss. 15–19, Bibliothèque de Chartres; cf. Thuillier, 'Pour un Corpus Poussinianum', *Colloque Poussin*, CNRS, Paris, 1960, vol. II, p. 80

[9] Leon-Battista Alberti, *Di Re Aedificatoria*, VI, 2 [Florence, 1485], Milan, 1966

[10] cf. Jacques Thuillier, *Nicolas Poussin*, Paris, 1988, pp. 48–55

[11] ibid., p. 74

[12] André Félibien, *Entretiens sur les vies et les ouvrages des plus excellents peintres*, 5 vols, Paris, 1666–88, vol. IV, p. 245

These paintings were seen and admired by the Italian poet Gianbattista Marino (1569–1625), who lived in Paris, where he was celebrated, from 1615 to 1623. (Marino, who was influential, brought Poussin to Rome, introduced him to Cardinal Sachetti and other patrons, but died soon afterwards.)

These lost paintings, as well as Poussin's illustrations of Ovid's *Metamorphoses* for the Cavalier Marino (thought to be illustrations to Marino's *Adone)*[13] explain something about Poussin's inclinations: from the beginning he does not leave a negative space, or 'background': the blank spaces in the drawings participate in the composition, as forms or light. His approach to oil painting was to remain marked throughout his life by the tempera technique. And though he abandoned it for a freer and more painterly Venetian, even 'Rubensian' impasto, as in *The Death of Germanicus* (1627, Minneapolis, Minneapolis Institute of Arts),[14] Poussin came back to a rapid touch with a small bristle brush, generally round, which left its marks, as if the strokes had dried under his hand. Though his mythological landscapes of the 1650s and 1660s owe a debt to Annibale Carracci (*The Flight into Egypt*, 1604, Rome, Galleria Doria-Pamphili), they have this special tremor and personal approach to oil paint by means of which his heterogeneous, sometimes even discordant, elements, whereby he desired to attain verisimilitude, are transformed into one organically painted surface.

This formal justification of every square inch could not have been achieved on huge surfaces, such as those of Pietro da Cortona's frescoes, for example. Poussin never ventured into large-scale work; mostly he worked on medium-to-small formats, apart from very few exceptions painted in Paris between 1641 and 1642, such as *Time Saving Truth from Envy and Discord* (1641, Paris, Musée du Louvre), for Cardinal Richelieu. This restraint reflects Poussin's idea of *médiocrité,* which meant moderation, 'refraining from all excess'.

Poussin's painterly density, almost present in the Louvre version of *The Rape of the Sabines*, matured and dominated his 'illustrative compositions'[15] throughout his lifetime. It gained in severity with the years, culminating in his later work, such as the *Landscape with a Man Killed by a Snake* (1648, London, National Gallery) and *The Deluge* (*c.*1664, Paris, Musée du Louvre), the last of 'the four seasons'.

[13] Anthony Blunt, *Nicolas Poussin*, London, 1967, p. 39

[14] On the subject of this painting, see Pierre Rosenberg, *La Mort de Germanicus de Poussin*, Paris, 1973

[15] Blunt, op. cit., 1967, p. 40

Winter, or *The Deluge*, the fourth 'season' which Poussin painted for the Duc de Richelieu, can rightly be considered as one of Poussin's testaments. It is executed in a very low key and reduced colour-scale: green earth, umber, black, red ochre, yellow ochre, and white. Poussin drew the horizon-line after first dividing his plane into a square and a rectangle, at the centre of each a principal point: the praying figure's head at the centre of the square, the bending figure towards the uplifted baby at the rectangle's centre. Prayer and rescue, the human actions here depicted, are presented as questions: will the prayer be heard? Will the baby be saved?

The scene represents the last season of the year (winter), the last season of life (old age), the last hours of day (nearly night), and the end: the deluge. Noah's Ark is in the background. All sinks, all drifts downwards to its end. Ten men (as in the Jewish *minyan*),[16] one woman, one child and one horse are desperately clinging on. With them, a horse and a baby. All goes downwards, except for the ascending prayer suggested by the little twisted figure placed on the horizon line, lifting his wringing hands towards the dark sky, by the waterfall. The baby lifted upwards from the sinking canoe on the right will not be saved: placed on the same horizon-line, the outstretched hand will never reach the baby. In contrast, the only living being not to sink, is the snake creeping upwards. The snake illustrates not evil only, but eternity. The snake alone prevails in Poussin's composition. The lightning striking down is its echo. The snake is painted dark on light, and the lightning, light on dark. They are parallel, like voice and echo. Their form constitutes the key to the painting. The variations of this twisted line continue, throughout the composition: dark on light angular lines (rocks), light on dark spiral lines (trees). Hanging on the upper-right tree is another small snake. This one is the echo of the snake creeping upwards. The ascending snake and the lightning striking down uphold the praying figure, with another one clinging on to him, in a diagonal syncopation. Poussin painted the biblical Deluge as seen from the side of the doomed.

[16] Poussin seems to have had some knowledge of Jewish customs – Padre Ferrari, Professor of Hebrew at the College of Rome, was a friend of his.

These paintings were seen and admired by the Italian poet Gianbattista Marino (1569–1625), who lived in Paris, where he was celebrated, from 1615 to 1623. (Marino, who was influential, brought Poussin to Rome, introduced him to Cardinal Sachetti and other patrons, but died soon afterwards.)

These lost paintings, as well as Poussin's illustrations of Ovid's *Metamorphoses* for the Cavalier Marino (thought to be illustrations to Marino's *Adone*)[13] explain something about Poussin's inclinations: from the beginning he does not leave a negative space, or 'background': the blank spaces in the drawings participate in the composition, as forms or light. His approach to oil painting was to remain marked throughout his life by the tempera technique. And though he abandoned it for a freer and more painterly Venetian, even 'Rubensian' impasto, as in *The Death of Germanicus* (1627, Minneapolis, Minneapolis Institute of Arts),[14] Poussin came back to a rapid touch with a small bristle brush, generally round, which left its marks, as if the strokes had dried under his hand. Though his mythological landscapes of the 1650s and 1660s owe a debt to Annibale Carracci (*The Flight into Egypt*, 1604, Rome, Galleria Doria-Pamphili), they have this special tremor and personal approach to oil paint by means of which his heterogeneous, sometimes even discordant, elements, whereby he desired to attain verisimilitude, are transformed into one organically painted surface.

This formal justification of every square inch could not have been achieved on huge surfaces, such as those of Pietro da Cortona's frescoes, for example. Poussin never ventured into large-scale work; mostly he worked on medium-to-small formats, apart from very few exceptions painted in Paris between 1641 and 1642, such as *Time Saving Truth from Envy and Discord* (1641, Paris, Musée du Louvre), for Cardinal Richelieu. This restraint reflects Poussin's idea of *médiocrité,* which meant moderation, 'refraining from all excess'.

Poussin's painterly density, almost present in the Louvre version of *The Rape of the Sabines*, matured and dominated his 'illustrative compositions'[15] throughout his lifetime. It gained in severity with the years, culminating in his later work, such as the *Landscape with a Man Killed by a Snake* (1648, London, National Gallery) and *The Deluge* (c.1664, Paris, Musée du Louvre), the last of 'the four seasons'.

[13] Anthony Blunt, *Nicolas Poussin*, London, 1967, p. 39

[14] On the subject of this painting, see Pierre Rosenberg, *La Mort de Germanicus de Poussin*, Paris, 1973

[15] Blunt, op. cit., 1967, p. 40

Winter, or *The Deluge*, the fourth 'season' which Poussin painted for the Duc de Richelieu, can rightly be considered as one of Poussin's testaments. It is executed in a very low key and reduced colour-scale: green earth, umber, black, red ochre, yellow ochre, and white. Poussin drew the horizon-line after first dividing his plane into a square and a rectangle, at the centre of each a principal point: the praying figure's head at the centre of the square, the bending figure towards the uplifted baby at the rectangle's centre. Prayer and rescue, the human actions here depicted, are presented as questions: will the prayer be heard? Will the baby be saved?

The scene represents the last season of the year (winter), the last season of life (old age), the last hours of day (nearly night), and the end: the deluge. Noah's Ark is in the background. All sinks, all drifts downwards to its end. Ten men (as in the Jewish *minyan*),[16] one woman, one child and one horse are desperately clinging on. With them, a horse and a baby. All goes downwards, except for the ascending prayer suggested by the little twisted figure placed on the horizon line, lifting his wringing hands towards the dark sky, by the waterfall. The baby lifted upwards from the sinking canoe on the right will not be saved: placed on the same horizon-line, the outstretched hand will never reach the baby. In contrast, the only living being not to sink, is the snake creeping upwards. The snake illustrates not evil only, but eternity. The snake alone prevails in Poussin's composition. The lightning striking down is its echo. The snake is painted dark on light, and the lightning, light on dark. They are parallel, like voice and echo. Their form constitutes the key to the painting. The variations of this twisted line continue, throughout the composition: dark on light angular lines (rocks), light on dark spiral lines (trees). Hanging on the upper-right tree is another small snake. This one is the echo of the snake creeping upwards. The ascending snake and the lightning striking down uphold the praying figure, with another one clinging on to him, in a diagonal syncopation. Poussin painted the biblical Deluge as seen from the side of the doomed.

[16] Poussin seems to have had some knowledge of Jewish customs – Padre Ferrari, Professor of Hebrew at the College of Rome, was a friend of his.

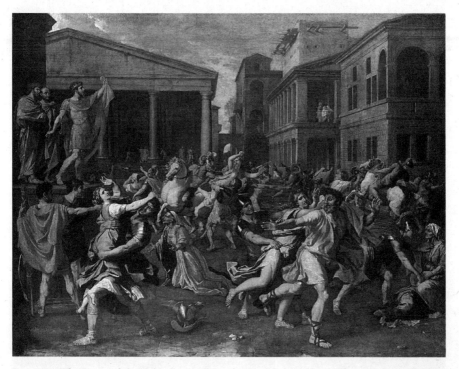

Poussin, *The Rape of the Sabines*, *c.*1638, oil on canvas, 157 x 203 cm.(Paris, Musée du Louvre)

THE RAPE OF THE SABINES

Poussin painted two versions of *The Rape of the Sabines*. One is in the Metropolitan Museum, New York (154 x 206cm.) and the other is in the Louvre.[17] Grautoff (1914) dates the two versions 1637–39; Blunt (1966) dates the Louvre version 1635 and the New York one 1637. Both Mahon (1962) and Thuillier (1974) date the Metropolitan version 1634–5, and the Louvre version 1637–8; Friedlaender, Sterling and D. Wild consider the Paris version

[17] Paris, Musée du Louvre, INV.7290, oil on canvas 157 x 203 cm. Addition of 1.8 cm. along the entire upper width, and of 2.7 cm. along the entire left length. In 1685, a painter named Geslin received 250 livres for 'having restored the paintings of Albano and the two Poussins from Rome' (cf. Thuillier, op. cit., 1960, p. 103). Restretched and probably revarnished in 1749 by Godefroid and Colins. Backed and restretched again in 1789 by Delaporte. Slightly restored in 1931.

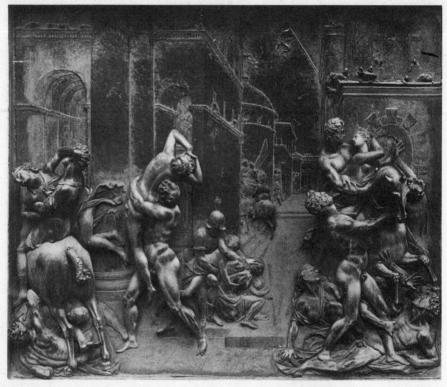

Giovanni da Bologna, *The Rape of the Sabines*, 1583 (Florence, Loggia dei Lanzi)

the first, and the New York one the second. Jane Costello (1947), and again Mahon (1965), as well as Pierre Rosenberg (1982 and, in an unwritten opinion, 1978) and myself (1979), consider the Paris version to be the later one (1637–8), probably painted between *The Golden Calf* (1633/7, London, National Gallery) and its pendant, *The Crossing of the Red Sea* (1639, Melbourne, National Gallery of Victoria), and *The Israelites Receiving the Manna in the Desert* (1639, Paris, Musée du Louvre). The two versions of the *Rape of the Sabines* seem in fact to have been painted at different periods; in spite of the similar dimensions, they differ in conception as well as in execution. The New York version is barer, conforming more to the classical ideal as formulated by Sacchi at the debates of the Saint-Luke Academy in 1634–5. In the New York version, the subject is treated by *moti* and *affetti* (movement and expression), which was the conviction of the period. It has fewer figures than the Louvre version, and its composition is very close to Giovanni da Bologna's relief at the Loggia dei Lanzi (Florence). It is also close

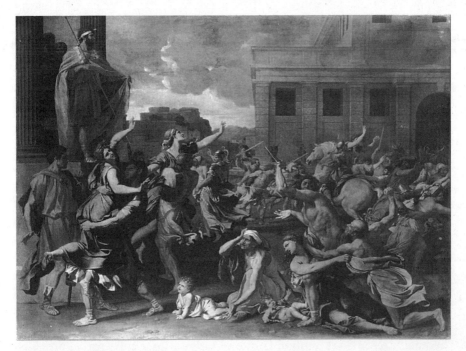

Poussin, *The Rape of the Sabines,* oil on canvas, 154 x 206 cm. (New York, Metropolitan Museum)

to the painting by Pietro da Cortona, on the same subject (1629, Rome, Galleria Capitolina). On the other hand, the Louvre version, which seems more 'baroque', is in fact more complex in composition, analogous to *The Capture of Jerusalem by Titus* (1638, Vienna, Kunsthistorisches Museum). It is also more freely executed within a more rigorous formulation.

Provenance

Painted for Cardinal Aluigi Omodei,[18] according to Bellori,[19] at an unknown date. The Cardinal proposed it for sale in 1655. But he did not sell it. The painting remained in his formidable collection until his death in 1685. Sent from Rome to Louis XIV in 1685, apparently along with *The Triumph of Flora* (Paris, Musée du Louvre) which had also belonged to Omodei, it was recorded by Le Brun in his inventory of the Royal Collection.

[18] Aluigi or Aloisio or Luigi Omodei or Homodei 1608–85
[19] Giovan Pietro Bellori, *Le Vite de' pittori, scultori ed architetti moderni* [Rome,1672], Turin, 1976, p. 465

Cardinal Omodei, Proveditor General of the Pontifical States Armed Forces under Urban VIII, was raised to the Purple by the new Pope, Innocent X, in 1652. About to send him to Dublin as his Legate, Innocent X named him instead General Commissioner of the Papal Armed Forces. Having lost the second 'war' of Castro (against the French), the Cardinal, forced to pay out of his own pocket for the losses, was thus obliged to sell some paintings in 1655. This explains the letter Abbé Louis Foucquet wrote to his brother Nicolas Foucquet, Louis XIV's still mighty minister of finance, on 2 August 1655, in which he announced, 'There are two which Cardinal Homodei wants to sell, being compelled to do so because of the losses our armies inflicted upon him in the Milanese.'[20] The Abbé means 'two' Poussins. They were *The Triumph of Flora* (1627/8?, Paris, Musée du Louvre) and *The Rape of the Sabines*. According to Bellori[21] Poussin painted the *Triumph of Flora* for Omodei; but this is doubtful according to Thuillier;[22] it was probably painted for Cardinal Sachetti as a pendant for the *Triumph of Bacchus* by Pietro da Cortona (1624–6). Cardinal Sachetti must have given the *Flora* to Omodei, since it was replaced by a copy (now at the Galleria Capitolina). As for the *Sabines*, there is no doubt that it was painted specifically for Omodei. Cardinal Omodei became, after 1655, Pontifical Legate to Urbino. As a collector he possessed works by Algardi, Pier Francesco Mola, Agostino Carracci, Cavalier d'Arpino, Il Cerano, Veronese, Salvator Rosa and many others. Cardinal Omodei was equally the protector of San Carlo al Corso (Rome) for which he designed the façade, executed by the master-builder Giovan Battista Menicucci (d. 1690). He had a reputation for being avaricious.[23] But this uniformed ecclesiastic was in fact an art lover in contact with many artists who worked in Rome, especially for San Carlo al Corso, including Pietro da Cortona. The list of his paintings, attached to his testament, is stunning.[24]

[20] cf. Thuillier, op. cit., 1960, p. 103

[21] Bellori op. cit., p. 457

[22] Jacques Thuillier, *Tout l'Oeuvre Peint de Poussin*, Paris, 1974

[23] cf. *Roma*, vol. 17, p. 510. I am indebted to Professor Francis Haskell for bringing this fact to my notice.

[24] The testament of Cardinal Omodei is dated 29 March 1682; it was opened on 26 April 1685. Cf. Luigi Spezzaferro, 'Pier Francesco Mola e il mercato artistico romano: atteggiamenti e valutazioni', in Manuela Kahn-Rossi, *Pier Francesco Mola*, appendix III, Milan, 1989, pp. 55–9

The subject
Because of the fact that the abducted ('raped') Sabine women became the mothers of the Roman patricians, this crime came to be considered by Roman men an heroic act. The name Talassius, one of the young Romans who abducted the most beautiful Sabine woman, became a wedding motto.

Written sources
Poussin combined the texts of Livy (1, IX, 14) and Plutarch (*Life of Romulus*, XIV) and followed Virgil's description (*Aeneid*, VII 1).

Iconography and visual sources
The background apparently represents the Temple of Jupiter Optimus Maximus.[25] Its Doric order is in contrast with the houses on the right which recall Sebastino Serlio's *Tragic Scene*. The colonnades seem to derive from Daniele Barbaro's commentary of his Vitruvius translation (1556).[26] Standing on the tribune is Romulus, his left hand raised, the figure partly derived from the *Apollo Belvedere* and *Augustus Caesar* (Palazzo dei Conservatori); the two senators behind him were probably painted from antique busts (Poussin possessed thirteen of them). The two lictors were seemingly painted from life, from one model, the two old women as well – the same old woman posed for both – and so were the three portraits of the prominent Sabines, possibly the portrait of Anne-Marie, Poussin's wife, painted three times. The head of the Sabine man running to the right was probably painted from an antique tragedy mask.

Analogy
The theme of the abduction of the Sabine women, popular in antiquity, vanished during the Middle-Ages, but reappeared in the quattrocento, with the Renaissance, on wedding *cassoni*. Among the artists who painted such *cassoni* were: Jacopo del Sellaio, Bartolomeo di Giovanni, Antonio Avelino (Filarete) and Amico Aspertini. The subject of the Sabines enters general iconography with the sixteenth century: Girolamo Genga, Giovanni Antonio Bazzi, Domenico Beccafumi, Polidoro da Caravaggio, Rosso Fiorentino, Latanzio Gambara, Luca Cambiaso, Taddeo Zuccaro, Francesco Bassano, Giovanni Bologna, Jacopo Palma (Giovine), Jacopo Ligozzi, Lodovico Carracci,

[25] Jane Costello, 'The Rape of the Sabine Women', in *Bulletin of the Metropolitan Museum of Art*, no 5, 1947
[26] Blunt, op. cit., 1967, p. 236

Leandro da Ponte (Bassano), Giusepe Cesari Cavalier d'Arpino, Giulio Cesare Procaccini, Francesco Allegrini, Alessandro Turchi and Pietro da Cortona, were among those who treated the subject before Poussin.

Copies

Copied (engraved) by Etienne Baudet (Andresen no. 316; Wildenstein no. 112). A painting said to be a copy after Poussin's *Rape of the Sabines* is mentioned in the *post-mortem* inventory of André Le Nôtre (1700), but there is no way of determining whether this lost painting was a copy after the Louvre or the Metropolitan version. The painting was copied by Degas: oil on canvas, 148 x 205 cm. – not in the same proportions as the original – (1870–2, Malibu, Norton Simon collection) mentioned in Degas' *Notebook CV* (Bibliothèque Nationale, Paris); Rouart sale 1912, no. 180; exhibited in the Degas exhibition of 1937, Paris, Orangerie, cat. no. 56; Biblio: Lemoisne no. 273, vol. II; Theodore Reff, 'New Light on Degas' copies', *The Burlington Magazine*, June 1964.

Preparatory drawings

The preparatory drawings for the Louvre version are at Chatsworth (Duke of Devonshire), Florence (Uffizi) and Chantilly (Musée Condé).[27]

Method and technique

The canvas is of medium density, 13 warp-thread by 11 weft for 1cm^2. The canvas is primed with a dark brown resinous substance (probably glue) on which there is a layer of light brown ochre plus white lead.[28] This brown ground (probably calcinated umber) is the *imprimatura*. Poussin's early work, marked by the tempera technique, as already mentioned, was modified under the Titianesque influence during the 1620s. This technique was mixed media. It consisted of an underpainting in tempera followed by oil painting and glazes. It required an imprimatura (coloured ground) which has to be lean, in order to permit the oil layers to follow. The recommended vehicle for the imprimatura was *vernice commune* (nut oil and mastic resin). The imprimatura was to serve as 'a bed for other colours' ('un letto cosi per cagione dell'ajuto degli altri colori').[29] On the imprimatura, Armenini recommends executing the drawing,

[27] Friedlaender/Blunt, *The Drawings of Nicolas Poussin*, 5 vols, 1939–74, nos 114, 115, 119
[28] cf. Delburgo and Petit, *Bulletin du Laboratoire des Musées de France*, no 5, 1960
[29] Giovanni Battista Armenini, *De veri precetti della pittura* (Mantua, 1587), Milan, 1820, II, ch. IX. p. 179; cf. also Ernst Berger, *Quellen für Maltechnik*, Munich, 1901.

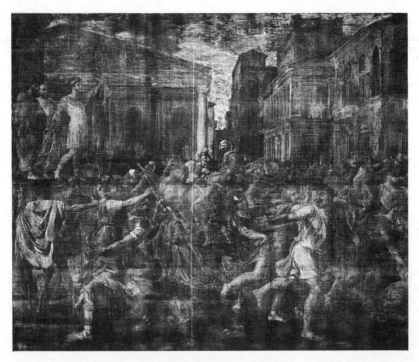

Poussin, *The Rape of the Sabines*, X-ray of the painting
(© Laboratoire de Recherche des Musées de France)

then the *abozzo* (underpainting). In the Venetian technique, the *abozzo* was done in oil-tempera in a proportion of 1:1 egg and oil mixed with white lead.[30] This technique permitted rapidity of execution, and as many layers of *velatura* (glazes) as one wished. Therefore Titian is quoted as having said, 'velatura, trenta o quaranta' ('glazes, thirty or forty'). Indeed, the lean underpainting (generally white on dark) permitted a heavier oil glaze on top of it, without adverse chemical effect. On the other hand, the white pigment on the dark ground illuminates all the colours, intensifying them. One could, as Titian did, paint swiftly over a white *abozzo*, thus combining meticulosity with spontaneity.

On top of the imprimatura, Poussin apparently incised his geometrical division (which I discovered in analysing the picture through the microscope) with a fine point. The microscope helped reveal parts of the chequerboard ground plane (floor) which contributed to set the perspective; he then drew, and then painted with white tempera on the dark brown ground. Having

[30] Max Doerner, *Malmaterial und seine Verwendung im Bilde* [1921], Stuttgart, 1954, pp. 308–9

73

finished his *abozzo*, he overpainted, probably section by section, quite quickly. His brushwork attests to the rapidity of his execution. The X-ray revealed a first underpainting, executed with that 'furia dell diavolo'[31] attributed to Poussin by the Cavalier Marino. The *Rape of the Sabines* is painted with a short, round hard, probably bristle brush. The rapid brushwork is remarkable, as well as the fact that nearly the entire composition is already present in the white underpainting. Very little was altered in the upper layers: one lictor on the left, with a helmet first, is repeated again without it; the Sabine male figure on the right was also slightly modified.

On top of the *abozzo* there is a rather fine layer of overpainting, not really a *velatura*. Poussin's palette in this painting is rather restricted: blue (azurite = copper carbonate) but also lapis lazuli; yellow ochre, red ochre (iron oxides); massicot (yellow monoxide of lead), umber, natural and calcinated (natural brown earth); vermilion (mercuric sulphide), minium (tetroxide of lead), green earth, black (organic carbon) and white lead. His chromatic harmonies are dominated by an equalization of intensities, as in stained glass. He shades, not with darker, but with warmer tones – for example, vermilion is shaded with red ochre, as in Romulus's coat. His chromatism is not based on *chiaroscuro*, but on cold-warm, or red-blue. When he modulates light-dark, it is done with moderation. For example, the armour breastplates of the Romans in the centre: a gentle accent of black, which is there only in order to underline the white spark; or the penumbra in the architecture, which is not dark but warm (umber), and the tonal contrast is due to the optical effect of colour saturation.

Lay figures: Sixteenth-century painters used lay figures, as had Gothic painters, even though the practice had been rejected by Leonardo. Indeed, a painting of 'noble and lofty' subjects from life not being feasible, painters were forced to have recourse to lay figures in order to surmount the problems of foreshortening, movement, the relation between figures, light and shade, and especially, in painting ceilings, to adjust the effect of space and of *di sotto in sù*. Barocci used dressed chalk or wax figures (according to Bellori); Titian's lay figures were of wax or wood (according to Lomazzo); Tintoretto made them in wax and chalk, dressed them and displayed them in a box (according to Ridolfi), as did El Greco (according to Pacheco). But there was a risk of uniformity, which Leonardo saw clearly: 'the lines of the muscles of an old man could not be distinguished from those of a young man,' he said, as it is reported by Armenini, who quotes *un suo allievo in Milano,* about

[31] From the Latin *furo*, as in 'furens' Sibylla, 'deliriously inspired'

Michelangelo.[32] Dead figures generated dead paintings.

Tradition has it that Poussin used lay figures. It was first reported by Bellori (1672), and Sandrart (1675)[33] who was in Poussin's company recurrently between 1627 and 1635. From Sandrart's testimony we understand that the board was chequered ('mit Pflasterstein ausgetheiltes Brett'), which suggests a black and white chequerboard, probably similar to the one designed by Lautensack.[34] He also mentions the horizon – that means the horizon-line, against which the lay figures were carefully set. In other words, Poussin may have used the board and box as a first step in the elaboration of a composition, which was the *dispositio*, i.e. the disposition of the figures in perspective.

Sandrart goes on to tell us that Poussin then went on working from life ('des Lebens bedienet') in his painting. Sandrart writes:

Er war sonsten auch von guten Discurss und hatte stets ein Büchlein, worein er alles nöthige, sowohl mit dem Umriss als auch Buchstaben afgezeichnet bey sich; wann er etwas vorzunehmen im Sinn gehabt, täht er den vorhabenden Text fleissig durchlesen und dene nachsinnen, alsdann machte er zwey schlechte Scitz der Ordinazie auf Papier, und so fern es einige Historien betroffen, stellte er auf ein glattes mit Pflasterstein ausgeteiltes Brett seinem Vornehmen gemäss die von Wachs darzu gemachte nackende Bildlein in gebührender Action nach der ganzen Historie geartet, denenselben aber legte er von nassen Papyr oder subtilen Taffet die Gewand nach seinem Verlangen um mit durchzogenen Fäden, das sie nämlichen

He was of good conversation, and always carried with him a booklet in which he marked all that he needed to, with outlines, or in letters; whenever an idea was in his mind, he would read the text thoroughly, and think about it, while making some sketches of the ordinance on paper, and for some histories, he would prepare a flat board, all divided and chequered, according to previous measurements, on which he would display undressed wax figures in the appropriate action, conceived in accordance with the history, which he dressed with humid paper, or fine taffetas, or a material according to need, and fastened them with threads, in such a way as to have them placed

[32] Armenini, *op. cit.*, II, ch. V, p. 139–40

[33] Joachim von Sandrart, *Teutsche Academie der edeln Bau, Bild-und Mahlerey-Künste*, [1675], Munich, 1925

[34] H. Lautensack, *Des Cirkels und Richtscheyts auch der Perspektiva und Proportion des Menscen und Rosse, kurze doch gründliche Underweisung des rechten Gebrauchs*, Frankfurt, 1564, p. 45

gegen den Horizont in gebührender Distanz stünden, und dene nach er seine Werk auf Tuch mit Farben untermalen konnte.[35]

in the right distance in relation to the horizon, and afterwards, he would sketch his work on canvas with colours'

Another testimony is that of a Bordeaux painter, Le Blond de La Tour, first discovered by Jacques Thuillier, dated 1669.[36] Poussin first prepared a rectangular board, 'une planche barlongue', in the desired form, in which he made holes, and by means of pegs fixed his lay figures. He then encased the board in a box, 'closed from all sides' except for one small opening from where the 'true appropriate ray' ('son véritable jour') would illuminate the lay figures. Then he made, in the front, an aperture, 'from where he could see all his composition from the point of distance, in such a way as not to affect the illumination coming from the small opening'.

Excerpts from Le Blond de La Tour

' . . . *on dresse une échelle de perspective pour disposer les figures dans leurs proportions; à quoi l'on adjouste la correction, dont je ne vous diray rien à cause de la longueur de ses circonstances, sur quyo notre Disciple pourra s'instruire dans le Traitté que le Docte Albert Duret a composé. Néanmoins parce que la chose est très-importante, je ne puis m'empécher de luy apprendre l'invention du fameux Mr Poussin, qui est presque le seul de notre temps qu'on peut comparer auc anciens pour ses belles inventions, qui lui ont acquis une estime immortelle parmi les sçavans. Car par le moyen de cette invention l'on vient à bout d'une des choses les plus difficiles de la Peinture.*

Cet homme admirable et divin inventa une planche Barlongue, comme nous l'appelons, qu'il faisoit faire selon la forme qu'il vouloit donner à son sujet dans laquelle il faisoit certaine quantité de trous où il mettait des chevilles, pour tenir ses mannequins dans une assiéte ferme & asseurée, & les ayant placés dans leur scituation propre et naturelle, il les habilloit d'habits convenables aux figures qu'il vouloit peindre, formant les drapperies avec la pointe d'un petit bâton, comme je vous ay dit ailleurs , & leur faisant la teste les pieds, les mains & le corps nud, comme on fait ceux des Anges, les élevations des Païsages, les pieces d'Architecture, & les autres ornemens avec de la cire molle, qu'il manîoit avec une adresse & avec

[35] ibid., p. 250
[36] Thuillier, op. cit., 1960, pp. 145–7

une tranquilité singuliere: Et ayant exprimé ses Idées de cette manière il dressoit une boëtte Cube, ou plus longue que large, selon la forme de sa planche, qui servait d'assiette à son Tableau, laquelle boëtte il bouchoit bien de tous costés, hoemi celuy par où il couvroit toute sa planche qui soutenoit les Figures, la posant de sorte que les extremités de la boëtte tomboient sur celle de la planche, entourant ainsi & embrassant, pour ainsi dire, toute cette grande machine.

Ces choses estant préparées de la façon, il consideroit la disposition du lieu où son Tableau devoit estre mis. Si c'estoit dans une Eglise, il regardoit la quantité de fenestres, & remarquoit celles qui donnoient plus de jour à l'endroit destiné pour le mettre, si le jour venoit par devant, par le côté, ou par le haut, s'il y venoit de plusieurs côtés, ou lequel dominoit davantage sur les autres. Et après toutes ces reflections si judicieuses, il arrestoit l'endroit où son Tableau devoit recevoir son veritable jour, & ansi il ne manquoit jamais de trouver la place la plus avantageuse pour faire des trous à sa boëtte, en la mesme disposition des fenestres de l'Eglise, & pour donner tous les jours & les demy-jours necessaires à son dessein. Et enfin il faisoit une petite ouverture au devant de sa boëtte, pour vaoir toute la face de son Tableau à l'endroit de la distance; & il pratiquoit cette ouverture si sagement, qu'elle ne causoit aucun jout étranger, parce qu'il la fermoit avec son oeil, en regardant par là pour dessigner son Tableau sur le papier dans toutes les aptitudes, ce qu'il faisoit sans y oublier le moindre trait ny la moindre circonstance; & et l'ayant esquissé ensuite sur sa toille il y mettoit la derniere main, après l'avoir bien peint & repeint.[37]

Poussin's method consisted, then, in preparing his composition step by step. The box described by Le Blond de La Tour confirms Sandrart's description, though the chequerboard is not mentioned by him. Another description of a later date (and therefore overlooked) is the *c.*1668 Gérard de Lairesse's 'machine' and 'poppetjes'.[38] Since no such box survives, various proposals for its reconstruction have been made, the latest of which is by Oskar Bätschmann, who relies on later sources such as Roger de Piles,[39] and remains debatable. In

[37] *Lettre Du Sieur Le Blond de La Tour, à Un de ses Amis, contenant Quelques Instructions touchant à la Peinture. Dédiée à Mr de Bois-Garnier,* A Bordeaux, par Pierre du Coq, Imprimeur & Libraire de l'Université, MDCLXIX, pp. 37–41

[38] Joseph Meder, *Die Handzeichnung Ihre Technik und Entwicklung,* Vienna, 1923, p. 554, quoting *Kunst und Künstler,* XVI (1917)

[39] Oskar Bätschmann, *Dialektik der Malerei von Nicolas Poussin,* Munich, 1982, p. 37–8 quoting *L'Art de Peinture de C.A. Du Fresnoy,* traduit en François Enrichi de remarques, revu, corrigé & augmenté par Monsieur de Piles, Paris [1683], 1751, pp. 180–1. But Roger de Piles does not mention the box, only a 'plan dégradé à

reconstructing the box in 1951, Lawrence Gowing[40] did not take into account the complete enclosure made so as not to affect the *jour*, and the small distant-point aperture in front, which was, in fact, a peephole, and proposed instead a sort of theatre-stage.

It can be assumed that Poussin probably did use lay figures and the box as a first step in working out a composition. The box was probably made of cardboard and remodelled for each composition, contrary to the stable chequerboard.

Poussin did sometimes use the articulated mannequin. This mannequin was probably of the same type as Fra Bartolomeo's (inherited by Vasari), the deadness of which left its mark on the Fràte's drawings. Poussin, following Leonardo, Verrocchio or Fra Bartolomeo, used the mannequin essentially for painting draped figures. Its deadening effect, however, remains fated, as for example in *The Lamentation over the Dead Christ* (Dublin, National Gallery) in which the hand of the Virgin Mary pops up woodenly, or in *The Death of Sapphira* (Paris, Musée du Louvre).

In his later years Poussin discarded these procedures for a painterly coherence unequalled in his time, such as in the *Landscape with Orpheus and Eurydice* (Paris, Musée du Louvre), the *Landscape with the Body of Phocion Carried out of Athens* (Cardiff, National Museum of Wales), *The Ashes of Phocion Collected by his Widow* (Liverpool, Walker Art Gallery) and the *Landscape with Hercules and Cacus* (Moscow, Pushkin Museum). Towards the middle and last periods of his life, Poussin painted his fables from nature, mostly from imagination, with the whole transformed by geometry.

Formulation

Scrutinizing the visible implies an innate sense of measure, but not of mechanical measuring. 'After all the eye must give the final judgment, for even though an object be most carefully measured, if the eye remains offended, it will not cease on that account to censure it.'[41] From its start,

proportion des Figures, qui sera comme une table faite exprès, que vous pourrez hausser & rabaisser selon votre commodité . . . ' and condemns the use of mannequins
[40] Blunt, op. cit., 1967, p. 243. Anthony Blunt, in a letter to this author, dated 28 December 1982: 'I fear you are right about the "Box". The model I reproduced was made by Lawrence Gowing & his students when the Sacraments were shown at Newcastle (in, I think, the early 50s) and I used it as the only thing available.'
[41] Giorgio Vasari, *Of Sculpture* [1550], *On Technique*, eds L. S. Maclehose and G. B. Brown, New York [1907], 1960, ch. I, 40, p. 146

painting was divided between the naïve and the more complex way of formulating the visible, in transforming tangible size into pictorial measure, and the three-dimensional reality into a two-dimensional painting. The question of how to represent depth or space on a flat surface, how to render the concave and the convex, the distant and the near on the plane in relation to the viewer, brought both perspective and proportion to the centre of the act of painting. Proportion was revealed through mathematics, and perspective through optics. Poussin wrote about this:

> . . . there are two ways of seeing objects, one of them is simply to see them, and the other one is to consider them attentively. Seeing simply is nothing other than the natural reception by the eye of the form or likeness of a thing which is seen. But in seeing an object and considering it beyond this natural reception, one seeks and strives particularly to get the means of knowing this very object well: so one can say that the simple aspect [of the object] is a natural operation, and what I name as *Prospect* is the function of reason, which depends on three things: the knowledge of the eye, of the visual ray, and of the distance from the eye to the object.[42]

Although Poussin appropriated this entire passage from Daniele Barbaro,[43] he nevertheless assimilated the theories of vision governing his time, Poussin opposes 'passive seeing' to 'active seeing', and continues further, throughout this very important letter,[44] unfortunately lost, in which he reveals his grasp of proportion and perspective.

Proportion and perspective coincided in one and the same activity. 'Only proportionality makes beauty,' said Ghiberti, and, 'the whole secret of art consists in proportionality,' wrote Daniele Barbaro.[45] It was part of the 'science' each artist had to possess, as Annibale Carracci or Domenichino did, 'who lacked neither art nor science' as Poussin put it.[46] 'Poussin had great esteem for the books of Albrecht Dürer and Leon Battista Alberti,' wrote

[42] Poussin, in a letter to Monsieur Sublet de Noyers (1578?–1645), Defence Secretary to Louis XIII (1636) before his disgrace in 1643, quoted by Félibien, to whom this letter apparently belonged, op. cit., p. 278,

[43] Daniele Barbaro, *La Prattica della Perspettiva*, Venice, 1569, ch. 2–4

[44] C. Jouanny, *Correspondance de Nicolas Poussin*, Paris, 1911, pp. 139–147d

[45] cf. Rudolph Wittkower, ' Brunelleschi and Proportion in Perspective', *Journal of the Warburg and Courtauld Institutes*, 1953, vol. XVI, 3–4, p. 279

[46] ' . . . qui ne manquèrent ni d'art ni de science', letter to Sublet de Noyers, ibid.

Félibien.[47] From Bellori,[48] Passeri[49] and above all from Jean Dughet's letter to Chantelou of 23 January 1666,[50] we can know something about some of his sources – Dughet had copied 'some laws' ('certaines règles de perspective') from Vitelo. On the other hand, Poussin studied the writings of the Theatine Father Matteo Zaccolini, who is mentioned by Passeri, Félibien and Mancini as having been Domenichino's teacher of perspective. But Matteo Zaccolini (1590–1630), who had access (at Cassiano dal Pozzo's) to some of the original manuscripts of Leonardo (still unpublished then), was nine years younger than Domenichino – whose friendship he must have enjoyed; Domenichino was a cultivated man, but could the Theatine father have been his teacher?

Jean Dughet (Poussin's brother-in-law), in his letter to Chantelou, mentions that he also copied for Poussin excerpts from 'Father Matteo', on 'lumi e ombre, colori e misuri', before 1640. This refers most probably to the second and fourth volumes of Zaccolini's writings which remained in manuscript form and were lost until their rediscovery by Carlo Pedretti in the Biblioteca Laurenziana.[51] Jean Dughet refers to two different works,[52] one of which is *Della descritione dell'Ombre prodotto da corpi opachi rettilinei* (II) and the other probably *Prospettiva da Colore*. In the French translation of Dughet's letter 'colori e misuri' is omitted. The evidence for Jean Dughet's statement was also given by Carlo Pedretti, who discovered a note attached to the Leonardo H.267 manuscript in Montpellier, which states: 'Monsù Poussino dove restre uno dell'ombre/e lumi/con figure appartate' ('Monsieur Poussin has to return the one/on light/and shade with detached plates').[53] However, there is no confirmation in it about the manuscript *Prospettiva da colore*, which is treated in both the third and fourth volumes. In them, Zaccolini explains Leonardo's theories on perspective ('prospective, ombre lontanenze, altezze, bassezze, da presso/e da discosto e altro . . . ') and deals with colour-gradation (the manuscripts were described by Cassiano dal Pozzo).[54] Zaccolini's theories

[47] Félibien, op. cit.,vol. II, p. 319 and VIII, p. 15

[48] Bellori. op. cit., p. 412

[49] Gianbattista Passeri, *Vite de' pittori, scultori e architetti che hanno lavorato in Roma* [1673], Rome, 1772, pp. 351–2

[50] Félibien, op. cit., vol. IV, p. 312, original lost, and *Correspondance*, pp. 483–6

[51] cf. Carlo Pedretti, *Scritti inediti di Leonardo da Vinci*, Geneva, 1956; and *The Zaccolini Manuscripts*, Bibliothèque d'Humanisme et Renaissance, Geneva, 1973

[52] Laurenziana, Ash. Ms.121, I, II, III, IV.

[53] cf. Pedretti, op. cit., 1973, p. 46

[54] Pedretti in appendix to K.T. Steinitz, *A Bibliography of Leonardo da Vinci*, Copenhagen, 1958

derive from such sources as Euclid, the pseudo-Aristotle (on colour), Ptolemy, possibly Alhazen, Vitelo, Peckham, Leonardo, Serlio and Kepler. In studying the Zaccolini manuscripts, especially the one on *light and shade*,[55] Poussin continued to struggle with the perpetual problem of *contrast*, which includes not only light and shade, but also the opposition between straight and curved lines, vertical and horizontal, in short, the old concern of harmonizing curves and angles through volume, light and shade on a flat surface. It is through practice and not through theory that it could have been accomplished.

But what did Poussin learn from Zaccolini? Did he accept and assimilate some of Leonardo's ideas after having illustrated his treatise – a fact contradicted by his letter to Abraham Bosse, as published in *Le Traité des pratiques géométrales et perspectives* (1665, p. 128), or was this lost letter (of 1651) contrived by Bosse? The question is evidently not whether or not Poussin was influenced by Leonardo's ideas – especially in the use of colour to create perspective; he most probably was – but rather what the exact role Zaccolini's writings play in Poussin's evolution, besides Leonardo's influence. It is certain that a profound change occurred in Poussin's work from the late 1630s–early 1640s onward. Geometry played a certain role in this evolution, which took Poussin away from a spontaneous painterly (Titianesque) brushwork, to a more frontal and ever more rationalized composition, in which the 'furia dell diavolo' gave way to strict form. The 'furia' of execution was replaced gradually by the tremor of Poussin's hand.

Proportion and perspective

Poussin retains three of the five 'things' on which perspective depends, as formulated by Dürer (who took them, possibly via Lucca Paccioli, from Piero della Francesca's *Da Prospectiva Pingendi*).[56] The 'five things' were: 'The first is the eye that perceives things. The second is the object seen. The third is the distance between them. The fourth is that everything is seen by means of straight lines, i.e. shorter lines. The fifth is the division between what is seen (surface) and the object.'[57] Dürer, who apparently met Luca Paccioli in

[55] cf. Elizabeth Cropper, 'Poussin and Leonardo: Evidence from the Zaccolini Ms.', *The Art Bulletin*, December 1980

[56] Piero della Francesca, *De Prospectiva Pingendi*, Edizione Critica a cura di Giusta Nicco-Fasola, Florence, 1984; cf Panofsky, *The Life and Work of Albrecht Dürer*, Princeton, 1943, p. 249

[57] Walter L. Strauss, introduction to Dürer, *Unterweisung der messung* [1525], *The Painter's Manual*, reprint, New York, 1977

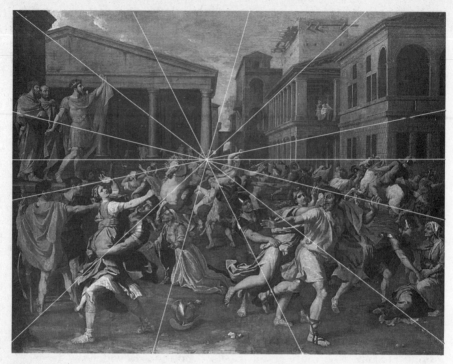

Partial reconstruction of the division of *The Rape of the Sabines*

October 1506, never mentions the term 'Golden Ratio' ($\sqrt{5}+1:2=1.6180$) but *Maß* and *Messung* only, though he must have been convinced by its veracity. The interesting fact about the Golden Ratio or Golden Mean is that it is innate. 'As [is] the saying of Pythagoras that Nature is sure to act consistently and with a constant analogy in all her operations,' says Alberti, in adding that 'the numbers by means of which the agreement of sounds affects our ears with delight are the very same which please our eyes and our minds.'[58]

Poussin does not mention it either. But there is no doubt that he used it, intuitively, or even consciously, along with other means, such as the old ratio of 3, which was an ancient studio practice. The Neo-Platonists and Neo-Pythagoreans established ten types of proportion: the first three corresponded to the arithmetical, geometrical and harmonic proportion, respectively 1-2-3, 1-2-4 and 2-3-6.[59]

[58] Alberti, *Di Re Aedificatoria*, IX, 5; cf. Wittkower, 'Alberti's Approach to Antiquity in Architecture', in *Journal of the Warburg and Courtauld Institutes*, vol. IV, nos 1–2, 1940–1, pp. 1–18

[59] Matila C. Ghyka, *Essai sur le Rythme*, Paris, 1938

Detail showing traces of Poussin's division

Pursuant to Alberti's concept of 'painting as the intersection of the visual pyramide', painters of the cinquecento were obsessed with perspective[60] and proportion. 'The intention of discovering the ideal in order to define the normal',[61] at the root of cinquecento theory of composition, gave way during the seventeenth century to a freer, more painterly approach (which ultimately stemmed from late Titian). The 'visual pyramid' was not really Caravaggio's concern, nor later Velázquez's. It was apparently not Poussin's either during the 1620s, while he was still under Titian's influence. But by the late 1630s

[60] Lomazzo divided perspective into two parts: *ottica* (optics) and *sciografia* by which he meant light and shade, although the Greek meaning of *skyagraphia* is shadow-drawing, outline. It may be interesting to note that Lomazzo had access to Leonardo's manuscripts, before his sight failed, at the time still kept by Leonardo's pupil and heir, Francesco Melzi. Was that the origin of the link between perspective, light and shade? On the significance of *skyagraphia*, see J. J. Pollitt, *The Ancient View of Greek Art*, Yale, 1974, pp. 247–54

[61] Panofsky, 'The History of the Theory of Human Proportions as a Reflection of the History of Styles' [1921], in *Meaning in the Visual Arts*, New York, 1955, p. 94

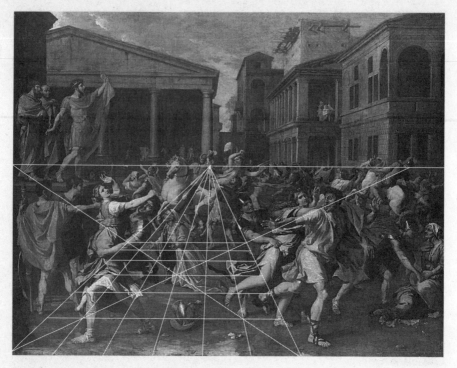

Partial reconstruction of Poussin's pyramid

(for Georg Kauffmann it is rather from 1641 onwards),[62] Poussin's painting changes, and his compositions appear to be freely executed on a strict and cautiously elaborated geometrical construction in which perspective and proportion coincide. This proportion in perspective is reminiscent of Piero della Francesca's method,[63] although it is not based on a module.[64]

Perspectiva naturalis was a codified compendium of various concepts from different sources: Babylonian, Egyptian and Greek, accumulated during the three centuries preceding Euclid, and codified by him. *Perspectiva artificialis* is an abstraction and a rational organization of space, subjecting height and depth to distance.

[62] cf. *Colloque Poussin*, CNRS, Paris, 1960, vol. I, pp. 141–50

[63] cf. Wittkower and B.A.R.Carter, 'The Perspective of Piero della Francesca's *Flagellation*', in *Journal of the Warburg and Courtauld Institutes*, vol. XVI, 3–4, 1953, pp. 292–302

[64] The bifocal system was an old studio practice (cf. Robert Klein, 'Pomponius Gauricus on Perspective' in *The Art Bulletin*, XLIII, 1961, pp. 211–30). It was used for the chequerboard construction of the ground plane, without which it would have been impossible to place the figures correctly, according to their relative distance.

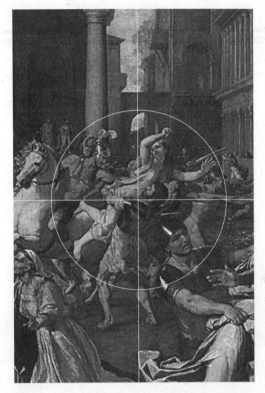

The turning circle

What the microscope reveals in the *Rape of the Sabines* is an unusual division, incised with a sharp point, in the imprimatura, as already mentioned. Within the incised orthogonals, transversal lines and various other traces of straight lines (ultimately constituting the architectural background) the actual pyramid can be approximated: its inclination is of 87°, its apex is placed on the helmet of the Roman rider on the left; the distance point can be located on the helmet of the Roman rider on the right, and the point of view on the left edge of the painting (part is missing).

All three points are situated on the horizon line, traces of which are visible to the naked eye. But what is singular in this construction is the fact that the division continues beyond the perspective pyramid, upwards, creating a turning circle. Its centre is the point on the helmet of the Roman rider (on the left). This circle generates the dynamics, abolishing the illusion of depth, bringing all tremor to the surface in a whirlwind. It is set off by the four bursts

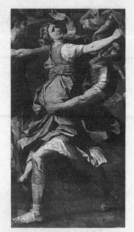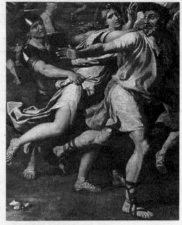

The couple running on the left rhymes with the couple running on the right

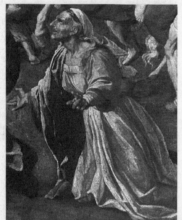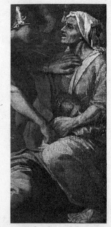

The old woman kneeling rhymes with the old woman seated

The two lictors rhyme with the two senators

The Roman horseman centre-left rhymes with the horseman on the right

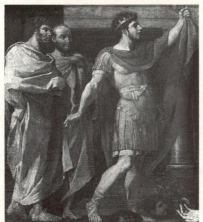

The group formed by Romulus on the tribune rhymes with the group on the balcony

The helmet fallen to the ground rhymes, contrariwise, with the arch of the gate

of white, inscribing themselves in a helix, from point to point, from helmet to helmet, armour to armour, of the three Romans lifting the beautiful Sabine destined for Talassius. She is inscribed in a perfect circle, turning clockwise, giving the horse its jolt, and so serves as a starter of the whirlwind, in which our eye is caught between the old woman praying and the Roman rider, his face painted in red ochre, according to custom, before battle.

Our gaze is arrested, as if from within the space, by the back of the Roman soldier holding the beautiful Sabine in his arms. He is seen from the back in a slight foreshortening, the ground reflected in his armour: red ochre against a hint of black. It is the essential counterpoint in the painting.

The entire composition seems to be founded on the musical principle of *proposta, riposta, contraposta*, expressed by rhymes in a rhythm of 1, 2, and counterpoint.

The motion is accentuated by the outburst of the arms – hands – swords - variations on one single form, thrown into that vacuum where the old woman kneeling is imploring Romulus.

The Rhymes

Each point has its retort, each form its rhyme. As in a poem, everything in this painting rhymes: the couple running on the left rhymes with the couple running on the right. The group formed by Romulus on the tribune rhymes with the group on the balcony. The two lictors rhyme with the two senators. The old woman kneeling, with the old woman seated. The Roman horseman at centre-left rhymes with the horseman on the right. The temple steps rhyme, in counterpoint, with the colonnade on the right. The helmet fallen to the ground rhymes, contrariwise, with the arch of the gate . . . and we can hear its fall.

THE CLASSICAL IDEAL

The classical ideal was the quest of the Golden Age through the Golden Mean, through proportion. It was a quest pursuing the invisible, where, as in stark darkness, no step was possible without support. And these supports were: the six principle of Vitruvius (order, arrangement, symmetry, eurythmy, economy, propriety),[65] the six principles of Aristotle, governing tragedy (plot, character, diction, thought, spectacle, song)[66] and the three basic principles of rhetoric (soul, gesture, expression).[67] It was an abstract vision expressed by means of the real and subjected to harmony: to Ideal Beauty. But it was also subjected to Christian doctrine. Theology was combined with rhetoric. 'A dead letter in pagan culture, the art of oratory was vivified by Christian spirituality, through which it became a power of incomparable efficacy.'[68] After one century of search for Beauty and Grace, the tide began to turn, around 1545, during and after the Council of Trent, in favour of decorum (propriety) and expression. The Counter-Reformation wave was allied to a reformative tendency in the arts, bringing Art back to Nature and Religion simultaneously. Daniele Barbaro, translator of Vitruvius and author of *La Pratica della Perspectiva* which appeared in Venice in 1569, published in 1547 a *Dialogo della Eloquenza*, in which Nature, Art and the Soul unite under Eloquence for the triumph of Reason.[69] The 'beautiful manner', which was believed by Vasari, Palladio and Armenini to reign only in Italy (whereas the 'barbaric manner' prevailed north of the Alps . . .), was too weak to hold out against 'vice and ignorance' – as the ecclesiastic Giovan Andrea Gilio puts it, pointing out in his two dialogues, the 'errors' of painters in matters of decorum ('Errori ed abusi dei pittori nei quadri storici'),[70] castigating essentially Michelangelo's *Last Judgment*. Even Aretino, who venerated Michelangelo, did not hesitate to tell the master, in a letter dated November 1545, 'Michelangelo known for his wisdom, whom we

[65] Vitruvius, *The Ten Books on Architecture*, I, ch.II, 1
[66] Aristotle, *Poetics*, 1450a
[67] Cicero, *Orator*, III, 220–1
[68] Marc Fumaroli, *L'Age de l'Eloquence*, Geneva, 1980, p. 147
[69] cf. Fumaroli, ibid., pp. 119–20
[70] Giovan Andrea Gilio, *Due dialoghi, nel primo de' quali si ragiona de le parti morali e civili appartenenti a'letterati cortigiani... nel secondo si ragiona degli errori de' Pittori circa l'historie, con molte annotazioni fatte sopra di giudizzio universale dipinto dal Buonaroti*, Camerino, 1564

admire, wanted to show the world as much impiety in religion as perfection in art.'[71] The great artist, seen as a great sinner, was condemned in the name of 'decorum' (which could only be Catholic) to have the more audacious nudes of his *Last Judgment* repainted by the order of Pope Paul IV. They were hewn out of the wall and repainted by Daniele da Volterra. The radical Counter-Reformation of Catholic Italy was an answer to Nordic iconoclasm. However, iconoclasm in the name of decorum was seen as appropriate, as well as judgments such as the one which Veronese had to suffer from the tribunal of the Inquisition (1593).

But with it all came a sudden need for naturalness. Painters discovered Titian's greatness. Annibale Carracci expressed it in the simplest way in a letter to his brother Lodovico, written in Parma on the 28 April 1580: 'Titian was my delight; without going to see his works in Venice again, I will not die contented. This is the truth, I say it for anyone; now I know him and I say that you were well right. However I know I am confused and do not want it: I like this sincerity and purity, which is true, not true-like; it is natural, not artificial, nor forced.'[72] The tendency for naturalness, combined with the prudish mood, did not discard the interest in antiquity and in nudity. The cold nudity of antiquity evolved from modesty into understated sensuality, illustrated by Giambologna's *Rape of the Sabines*. Half a century later, a cardinal did not hesitate to commission a painting on such a subject.

Certain ideas discarded by the Renaissance, such as scholasticism, reasserted their influence, along with the encyclopedic trend of such theoreticians as Palladio, or his master Giorgio Trissino, inherited from Alberti. Although the Platonic idea of Beauty remained in vigour, its interpretation varied.

According to Alberti, 'Art does not imitate Nature in its final product, but in its mode of construction, which is organic', and compares the natural to the architectural organization.[73] The key to this organization would appear to be concealed in the relationship between *effect* and *aspect*, as the relationship between sound and the string producing it was for Pythagoras. Hence the importance of musical harmony in the visual arts and architecture. The ratios of small whole numbers determining musical consonances was to become the key to visual harmony during the sixteenth century.

[71] *Les Lettres de L'Arétin*, translated by André Chastel and Nadine Blamountier, Paris, 1988, pp. 443–5

[72] cf. G. G. Bottari and S. Ticozzi, *Raccolta di Lettere sulla pittura, scultura, ed architettura*, Milan, 1822–5, vol. I, pp. 121–5

[73] Alberti, *De Re Aedificatoria*, preface

There was also a reversion to a certain intellectualism, to an ideal standard, to Virgil, his *Aeneid* in particular, which is an analogy of an individual's life with world history. On the other hand, and this is essential, the notion of decorum as expressed by Dolce (1508–68) and Castelvetro (1505–71) was reaffirmed. The return to the Aristotelian formulation and classification of tragedy, drama and comedy hinges on Castelvetro's new outlook on Dante, his translation of and commentary on Aristotle's *Poetics*, and his literary criticism.

Classical idealism is essentially anti-mannerist, anti-naturalist and anti-metaphysical. It is a return to Aristotle, a confinement to reduced means of expression. Aristotle explains the craving for an imitation which 'tries to imitate anything and everything is manifestly more unrefined' (1461b); in another connection he states that 'art attains its ends within narrower limits; for the concentrated effect is more pleasurable than one which is spread over a long time and so diluted' (1462b). Classical idealism is founded on Aristotle also in that it advocates ideal imitation which, while reproducing the distinctive form of the original, makes 'a likeness which is true to life and yet more beautiful' (1454b). For Aristotle 'beauty' is defined both by the subject matter, which has to be 'elevated'(1448b), and by the form, which has to be appropriate.

The 1630s

The 1630s were stamped by a sharp theoretical debate at the Academy of Saint Luke in Rome. From the time of the presidency of Federico Zuccaro (1543–1609) in 1593 the debates had actually never stopped. They concentrated on the conflict between drawing and colour. But by drawing, *disegno*, what was meant was rather the idea, and not necessarily the line. Federico Zuccaro divided drawing into *disegno interno* and *disegno esterno*. He wrote: 'Disegno interno in generale è una idea'[74] and the external design is subordinated to concept: '. . . la linea è simplice operatione a formare qual si voglia cosa, e sottoposta al concetto.'[75] Zuccaro follows the Platonic concept of subordinating execution to idea, but also painting to drawing. This mistaken hierarchy was to last.

Those who took the side of *disegno* were called 'formalists'. They insisted on strict composition as against the free painterly appearance attributed to the 'colourists'. These debates became intensified under the presidency of Pietro da Cortona (1634–7). Another element was added to the long controversy between the partisans of drawing and those of colour, and that was: expression.

[74] Federico Zuccaro, *Idea de'pittori, scultori e architetti*, Turin, 1607, I, p. 5
[75] ibid., II, p. 2

The thought that expression, gesture, *moti* and *affetti* alone were able to render the subject, the idea, was not thrown into doubt. The certainty in which this was held was parallel to the observation of the fundamental principles of *invention, disposition, decor and costume* or *invention, drawing and colour* . . . The argument was disputed essentially between Pietro da Cortona (1599–1669) and Andrea Sacchi (1599–1661). It revolved around the question of whether painting had to be epic, following Tasso's *Discorso del Poema Epico* (1594) – hence, one unique theme with multiple episodes, a point of view defended by Cortona – or, on the contrary, the reduction to a minimum of figures, as in tragedy, a point of view defended by Sacchi, and so well illustrated by his fresco *La Divina Sapienza* (1629–31, Palazzo Barberini).

It is probable that Sacchi, a believer in the classical ideal, influenced Poussin in the early 1630s.[76] The black cloud in Sacchi's *Divina Sapienza* appears in Poussin's *The Crossing of the Red Sea*, painted two or three years later. This threatening black cloud is one of Sacchi's obsessive forms; it appears as a tree, in the *Preaching of St John the Baptist* (1641–9, Rome, Lateran Palace), or again as a black cloud in *St Francis of Sales and St Francis of Paula* (c.1640, Camerino, S.Maria in Via). Sacchi's influence on Poussin ended abruptly. Their relationship is not documented, but by 1640, 'Poussin had scant respect for Sacchi's work.'[77]

What did Poussin think at that time? An interesting fact is that Pietro da Cortona's painting *Aeneas Meeting Venus* (1630–5, Paris, Musée du Louvre) is nearer to the point of view defended by Sacchi, whereas Poussin's *Rape of the Sabines*, looks closer to that defended by Cortona. Indeed, Cortona's style, still exuberant during the 1630s, becomes restrained in its turn, and increasingly classical during the 1650s. Guercino took the same path under the influence of Monsignor Agucchi (1570–1632), the great admirer of Domenichino, and the first theoretician of the classical ideal in painting.[78] 'Moderation' spread rather quickly to the north (in the 1640s) and became transformed into academicism. 'Moderation', the limit Poussin imposed upon himself, beyond which he was not to go, was, after Poussin's death, set up as dogma by the Académie Royale in Paris.

[76] Denis Mahon, 'Poussiniana', *Gazette des Beaux-Arts*, July–August 1962, pp. 1–138
[77] Ann Sutherland-Harris, *Andrea Sacchi*, Princeton, 1977, p. 7
[78] cf. Denis Mahon, *Studies in Seicento Art and Theory* [London, 1947], Westport, 1961

The belief that Beauty is perfectible through Idea, identifying truth with verisimilitude, governed this concept. 'This way the idea constitutes the perfection of natural beauty, uniting truth to verisimilitude, of what is submitted to the eye.'[79] It was basically a simplified conclusion of the Platonic idea that 'the senses are not clear and accurate',[80] and that absolute beauty cannot be seen with our eyes. That basically 'the soul is contaminated with its imperfection' (66b) and has to be perfected. Hence the belief that there is no way 'without electing the better parts',[81] since Nature in itself is inferior to Art ('*Anzi, la natura, per questa cagione, e tanto inferiore all'arte*'),[82] imposed on classical idealism the eclectic approach. Its paradigm was Zeuxis' composite portrait of Helen, painted from the five most beautiful nude maidens of Agrigentum, from whom he selected the most beautiful parts.[83] Selecting parts, the better ones or not, inevitably created a major problem: it disorganized the painting, creating something as artificial as a leaf composed of other leaves: a dead leaf.

The Hierarchy of Genres

The seventeenth century accepted Aristotle's division of poetry into 'lofty' or noble subject matter and 'low' or vulgar subject matter, according to whether the poet's 'soul' was beautiful or ugly, as though the theme or subject was a mirror reflecting the author. Under such conditions who would not have hesitated to paint a 'vulgar' subject, or have refused to paint a 'lofty' theme? Curiously, Aristotle's insistence on 'execution'[84] was overlooked. Caravaggio was judged 'vulgar' because of his subject matter. According to Félibien, 'for, whereas Poussin looked for nobleness in his subject matter, Caravaggio allowed himself to be carried away by natural truth, as he saw it; hence, they were opposed'.[85] It is, then, for the 'elevated' quality of his themes that

[79] '*Cesi l'idea constituisce il perfetto della bellezza naturale, ed unice il vero al verisimile delle cose sottoposto all'occhio'*, Bellori, op. cit., p. 14

[80] Plato, *Phaedo*, 65b

[81] Bellori, *op. cit.*, p. 15

[82] Bellori, ibid.

[83] '. . . *impexerit virgines eorum nudas et quinque elegerit, ut quod in quaque laudatissimum esset pictura redderet*', Pliny XXXV, 64–5

[84] Aristotle, *Poetics*, 1448b–12

[85] '*car si le Poussin cherchoit la noblesse dans ses sujets, le Caravage se laissoit emporter à la vérité du naturel tel qu'il le voyoit: ainsi ils étaient opposés l'un à l'autre*', Félibien, op. cit., 1725, VI, p. 194

Poussin was praised and not for his moving execution (it is like praising a person for what he has and not for what he is). From this time forth, Poussin's painting had a veil of academic dogma thrown over it, while for Caravaggio's it was that of the anathema of vulgarity. Félibien states: 'Poussin could not stand Caravaggio, and said of him that he had come into the world to destroy painting.' Indeed, after Caravaggio, Caravaggism as a formula set in. As after Cézanne, Cézannism did.

No Caravaggist had Caravaggio's genius; few of his followers, with the exception of Terbrugghen and Valentin de Boulogne (who sometimes surpasses him), could imitate him, or seize life as he could. For most of his followers, his genius became an incitement, as if it were a political party, it was 'tenebrism' in this case, as the cause to fight for, with its emphasis on vulgarity. Félibien's comparison between Poussin and Caravaggio is not based on execution, which is qualitative, but on subject matter, which is quantitative (nor did he realize that Poussin in his youth was influenced by Caravaggio).

The quantitative angle is the one from which painting has been seen, with some exceptions, for the last five hundred years, because contemplation was replaced by decoding. Thus, lofty subject matter was granted hierarchical supremacy. Consequently, still life or genre painting were to remain inferior subjects until the nineteenth century, while 'heroic' but imaginary compositions were considered 'elevated'.

In our own time, the historical or mythological subject matter has become political or social, severe or trivial, perpetuating an old misunderstanding, mis-seeing, which has gone on since the Renaissance.

THE THEORY OF MODES

In a letter to Chantelou of 24 November 1647,[86] Poussin states his theory of modes. It was pointed out by Blunt[87] that most of his theory was copied by Poussin from Gioseffo Zarlino's *Instituzione Harmoniche*.[88] In spite of the rather confused way of presenting the theory of modes, Poussin does not seem to do it only in order to justify himself for having painted the *Finding of Moses* (1647, Paris, Musée du Louvre) for Pointel, and not for Chantelou. In fact Poussin seems to have implemented this theory in his painting from the end of the 1630s. His work suggests it, as well as a fragment of a letter to the painter Jacques Stella (1637?), quoted by Félibien,[89] in which he makes the distinction between the 'severe' and 'soft' manner ('sujet mol' and 'manière plus sévère'). In other words, Poussin composes according to a *key*, like in music. The fact that he 'stole' from Zarlino, an act in itself unjustifiable, was, alas, a plague of the time (not over yet . . .) Mersenne, in his *Harmonie Universelle* (1636), also copied passages from Zarlino without quoting his source or having to subdue, as Poussin had to, a patron's jealousy.

In his letter to Chantelou, Poussin maintained: 'This word Mode means properly, the ratio, or the measure and form which we apply to do something, which compels us not to go beyond it, making us work in all things with a certain middle course or moderation, and this moderation is simply a certain manner or determined order, which encloses the process by which a thing is preserved in its being . . . '

[86] *Correspondance*, pp. 370–375. Paul Fréart de Chantelou (1609–94) was a cousin of François Sublet de Noyers, Secretary of State to Louis XIII and close to Cardinal Richelieu. From about 1638 onwards, Chantelou became an admirer of Poussin, and assembled a large collection of his paintings, second to that of Cassiano dal Pozzo, and nearly as large as the one of Jean Pointel. Of the extant correspondence of Poussin, 136 letters are addressed to Chantelou (who had them bound in a volume, Paris, Bibliothèque Nationale, Ms. Fr. 12347). However, Chantelou was not, like Pointel, on intimate terms with Poussin, nor was he as erudite a patron as Cavalier Cassiano dal Pozzo.

[87] *Bulletin de la Société de l'Histoire de l'Art Français*, 1933, p. 125ff

[88] Gioseffo Zarlino, *Instituzione Harmoniche*, Venice [1558], 1573; cf. Rudolf Zeitler, 'Il problema dei Modi e la consapevolezza di Poussin', in *Critica d'Arte*, 1965

[89] *Correspondance*, pp. 3–4 – original lost

Poussin: *'Cette parolle 'Mode' signifie proprement la raison ou la mesure et forme de laquelle nous nous servons à faire quelque chose, laquelle nous abstraint à ne pas passer oultre nous faisant opérer en touttes les choses avec une certaine médiocrité et modération, et partant telle médiocrité et modération n'est autre que une certaine manière ou ordre déterminé, et ferme dedens le procéder par laquelle la chose se conserve en son estre.'*

Zarlino: *'Questa parola 'modo' . . . significa propriamente la ragione cioè quella misura o forma, ch'adoperiamo nel fare alcuna cosa, la qual ne astrenge noi a non passar più oltra, facendone operar tutte le chose con una certa mediocrità o moderatione . . . Imperocché tal mediocrità o moderatione, non e altro che una certa maniera ovvero ordine terminato e fermo net procedere, per il quale la cosa si conserva nel suo essere per virtù della proprtione ch'in essa si ritrova'* (*Instituzione Harmoniche*, IV, I p. 359)

Here, moderation (*médiocrité* in its old connotation) meant restriction: a mental construction of an obstacle not to be cleared, the bounds 'we should not go beyond'. This was for Poussin (his appropriation from Zarlino may be a proof of it) a restriction to pictorial means, lines and colours on a surface, as well as compliance with a 'mode' – or a dominant. The modes are defined by the dominant. *The Rape of the Sabines*, for example, is painted in the Phrygian mode, 'one that is vehement, furious, very severe, that expresses people's amazement'.[90]

The Origin of the Modes

The theory of modes – Ionian, Corinthian, Dorian and Phrygian – has its origin in music, but also in architecture. Vitruvius describes them in his Book II from an architectural point of view and in his Book V from a harmonic point of view. The Pythagoreans developed a theory of modes in music, seven in all. St Ambrose (340–97) transformed this scale into four modes (called 'authentic'). St Gregory the Great (*c*.540–604) elaborated the Ambrosian system by adding four more modes (called 'plagal'). There are certain doubts now prevalent regarding the authenticity of these attributions. It is very probable that the modal system developed naturally among musician-choristers. To these eight modes four more, two *Æolian* and two *Ionian*, the ancestors of the modern major and minor, were added by the great Swiss humanist (and poet laureate of Emperor Maximilian I, 1512) Henricus Glareanus (Heinrich Loris,

[90] Poussin, ibid.

1488–1563).[91] But it was Gioseffo Zarlino (1517–90) who grouped them in a coherent fashion. Zarlino divided the modes into two classes: 'very joyful and lively' (C, F, G) and 'rather sad' (D, E, A). The melodic intervals of the first class were without a semitone, and, for the second, with the semitone.[92] The first expressed 'harshness, hardness, cruelty, bitterness' ('asprezza, durezza, crudeltà, amaritudine'); and the second 'complaint, pain, lamentation, sighs, tears' ('piano, dolore, cordoglio, sospiri, lagrime').[93]

In a sense, the expression of the architectural mode through form leaves the chromatic expression suspended. Starting from the sixteenth century, there were numerous attempts to find analogies between musical harmony and chromatic harmony, comparing *ut ars musica pictura* with *ut pictura poesis*:[94] Arcimboldo's 'chromatic clavichord', described by Comanini,[95] is an example of how the legacy of Pythagorean musical theory was understood by cinquecento art theorists in regard to colour. Arcimboldo's chromatic clavichord is, of course, a curiosity, but he succeeded nevertheless in establishing a parallel between colour and sound, in a note system[96] which was possible to perform (and was actually performed). The common denominator of the analogy between music and painting on the one hand, and optics and drawing on the other, was mathematics. However, this analogy stops on the threshold of praxis. Though colour composition is achieved through logic and feeling and is not as immediate as drawing, it ultimately can never reach mathematical truth: there is no one truth in colour harmony. The *veramente maraviglioso*, the truly 'miraculous phenomenon' as Zarlino qualifies it, of consonances being determined both by arithmetic as well as by harmony[97] cannot completely apply to painting. However, musical theory helped painting by contributing both to theories of proportion and chromatic harmony, utilized to attain expressive value.

[91] *Dodecachordon*, Basel, 1547

[92] cf. D. P. Walker, *Studies in Musical Science in the Late Renaissance*, Leiden, 1978, p. 68

[93] Zarlino, op. cit., III, X, p. 182; cf. D. P. Walker, op. cit., 1978, pp. 68–9

[94] Gotthold Ephraim Lessing, in his *Laocoön*, was the first to oppose such views: '*Die Zeitfolge ist das Gebiete des Dichters, sowie der Raum das Gebiete des Malers*' ('The unfolding of time is the domain of the poet, and space the domain of the painter.') *Lessing's Werke in sechs Bänden*, Leipzig, n.d., vol. IV, p. 184

[95] Gregorio Comanini, *Il Figino*, Mantua, 1591

[96] cf. Jonas Gavel, *Colour – A Study of its Position in the Art Theory of the Quattro-Cinquecento*, Stockholm, 1979

[97] Zarlino, quoted by Wittkover, *Architectural Principles in the Age of Humanism*, London, 1973, p. 133

On the other hand, the concept 'modus' or 'mode', developed in the domain of poetry in the Middle Ages, could be applied directly to subject matter in painting. It followed the Aristotelian categories of *heroic* and *iambic* verse, *modus gravis* and *modus levis*, which influenced antique rhetoric. As stated by Vitruvius[98] each order of architecture was appropriate and devoted to certain divinities: the Corinthian order to Venus, Flora, Proserpina and the nymphs, because of their fragility; the Doric order to Mars and Hermes, because of their virility; the Ionian order was appropriate for the temples of Juno, Bacchus and Diane, because it combined Doric severity with Corinthian delicacy. The modes were also classified in the theatre in this precisely detailed way: Doric for tragedy – the stage dominated by columns, statues and tympani; Ionian for comedy – the stage dominated by private houses, balconies and windows; Corinthian for satire – with trees, grottos and mountains.[99]

The tendency during the Middle Ages to systematize resulted in a strictly detailed classification of the characteristics as *stilus humilis*, *stilus mediocris* and *stilus gravis*. In seventeenth-century rhetoric, these categories were defined as *stile sublime* (the sublime), *stile temperato* (the moderate), *stile tenue* (the grave), in a book by Agostino Mascardi,[100] which Poussin probably read as well.

For Agostino Mascardi , history is the 'angular stone of the art of oratory destined to correct the vices of our time'. Mascardi championed 'just measure' against the excesses of (sophist) ornamentation in rhetoric, and against the confusion between prose and poetry. Agostino Mascardi's theory of elocution is based on the five principles of clarity, purity, propriety, naturalness and order. He rejects Justus Lipsius' *obscura brevitas*[101] in order to build up from his *caracteres dicendi*, progressively amplifying them from their *stilus humilis,* higher and higher, until the attainment of the sublime style. This process is very similar to Poussin's way of composing his theme, gradually amplifying it till it reaches the sublime. The *moti* and *affetti*, of Poussin's figures are amplified through his formulation. They ascend from simplicity to solemnity, as in a Greek frieze. In this respect, Poussin's formal treatment of any subject transforms this very subject into something not unlike the orator's art, convincing by eloquence through just measure. The effect is, however, more complex, more hidden, but perhaps also more immediately magical.

[98] Vitruvius, op. cit., II, p. 5
[99] ibid., V, p. 6
[100] Agostiono Mascardi, *Dell'Arte Historica tratatti cinque*, Rome, 1636, quoted by Marc Fumaroli, 1980, p. 124
[101] Fumaroli, ibid, p. 224

POUSSIN'S DEFINITION OF PAINTING

We shall not discuss here Poussin's 'Observations on Painting', *Osservazioni di Nicolo Pussino sopra la pittura* – as published by Bellori in his *Vite*. The authenticity of the 'Observations' was studied and discussed by Anthony Blunt (1938)[102] and Jacques Thuillier (1969).[103] On the other hand, Blunt (1938 and 1967) dismissed Poussin's Principles relating to painting proper (as stated in his letter addressed to Roland Fréart de Chambray of the 1 March 1665),[104] as being 'a mere list of qualities which have to be sought in a painting' and which 'does not help us towards an understanding of what Poussin felt about art'. We shall try to comment upon them here, nevertheless, since they were guiding principles of the Classical Ideal.

Definition

It is an imitation with lines and colours on any surface of all that is
found under the sun. Its aim is delectation.
Principles that any man capable of reasoning can learn:
Nothing is visible without light.
Nothing is visible without a transparent medium.
Nothing is visible without boundaries.
Nothing is visible without colour.
Nothing is visible without distance.
Nothing is visible without instrument.
What comes after this cannot be learned.
These parts are the painter's affair.

But first about subject matter. It must be noble and not have taken on any common quality so that the painter may show his spirit and industry. It must be chosen so as to be capable of taking on the most excellent form.

[102] Anthony Blunt, 'Poussin's Notes on Painting', in *Journal of the Warburg and Courtauld Institutes*, vol. I, no. 4, 1938, pp. 344–51

[103] Jacques Thuillier, *Nicolas Poussin*, Novara, 1969

[104] Roland Fréart de Chambray (1606–76), brother of Paul Fréart de Chantelou, was an ecclesiastic mainly interested in geometry and perspective. He published the treatise on Leonardo in French, a treatise on architecture, and a book on painting: *Idée de la Perfection de la Peinture* (1662) in which Poussin is mentioned along with Leonardo, Raphael and Giulio Romano. The letter from which this definition is extracted, acknowledges the receipt of this book.

The painter must begin with disposition, then ornament, decorum, beauty, grace, vivacity, costume, verisimilitude, and judgment in every part. These last qualities spring from the talent of the painter and cannot be learned. They are like Virgil's Golden Bough which none can find or pick, unless he is guided by destiny.[105]

Définition

C'est une imitation faicte avec lignes et couleurs en quelque superficie
de tout ce qui se voit desoubt le Soleil, sa fin est la Délectation.
Principes que Tout homme capable de
Raison peut apprendre.
Il ne se donne point de visible sans Lumière.
Il ne se donne point de visible sans moyen transparent.
Il ne se donne point de visible sans Terme.
Il ne se donne point de visible sans Couleur.
Il ne se donne point de visible sans Distance.
Il ne se donne point de visible sans Instrument.
Ce qui suit me s'appprent point
Ce sont partie du Peintre.

Mais premièremt de la Matière. Elle doit estre prise noble, qui n'aye receu aucune qualité de l'ouvrier, Pour donner lieu au peintre de monstrer son esprit et Industrie. Il la faut Capable de receuoir la plus excellente forme, Il faut commencer par la Disposition, Puis l'Ornement, le Décoré, la beauté, la grâce, la viuacité, le Costume, la Vraysemblance et le Jugement partout. Ces dernières parties sont du Peintre et ne se peuuent aprendre. C'est le Rameau d'or de Virgile que nul ne peut trouuer ou cueillir sil n'est conduit par la Fatalité.[106]

[105] translated by Anthony Blunt
[106] *Correspondance*, pp. 461–4. The original of this letter is lost

Commentary

'*Imitation*': The word is here used in the Aristotelian sense of the word; that is to say of ideal imitation,[107] as well as of 'men who are above the common level'(1454b) and yet 'more beautiful'. And, especially, of representing things 'as they were, or are, things as they are said or thought to be, or things as they ought to be'(1460 b 7).

Plato subdivided imitation in art into two categories: *eikastiké* and *phantastiké*[108] – *eikastiké* meant likeness and *phantastiké* imaginary appearance. But for posterity this 'appearing or seeming without being'[109] was rather confusing. It gave birth to the misleading concepts of *pittori icastici* and *pittori fantastici*[110] perpetuated by Bellori in support of his anti-naturalist stand. For Mazzoni there is also some confusion.[111] Not so for Tasso, for whom the 'icastic can also fit in with the imagination'.[112]

'All art is but an imitation of Nature' (*Omnis ars naturae imitatio est*), said Seneca. 'The Stoics believe in one cause only: that of the maker; but Aristotle thinks that the word "cause" can be used in three ways: "The first cause," he says, "is the actual matter . . . the second, the workman . . . the third is the form – *idos* [*eidos*]." '[113]

' . . . *lignes et couleurs en quelque superficie* . . . ': Borghini's definition, 'One can say that painting is a plane covered with various colours on a surface'(' . . . Si possa dire la pittura essere un piano coperto di vari colori in superficie'),[114] which is probably, in part, one of Poussin's sources, goes even further than Poussin's because of the term *piano* (plane). Poussin follows the general definition of art as an intellectual activity (*ut pictura poesis*) versus a manual one; as Borghini before him put it: 'L'Arte non esse altro che un habito intelletivo,'[115] and Benedetto Varchi referred to it as 'un abito

[107] Aristotle, *Poetics,* 1451 a & b

[108] Plato, *Sophist*, pp. 235 *et seq.*

[109] ibid., p. 236

[110] Comanini, *Il Figino*, 1591; cf. Erwin Panofsky, *Idea Ein Beitrag zur Begriffsgeschichte der älteren Kunsttheorie*, Berlin [1924], 1960, pp. 212–15

[111] Manzoni, *On the Defence of the Comedy of Dante*, 1587

[112] Tasso, *Discoursi dell Poema Eroica*, 1594

[113] Seneca, *Epistle to Lucilius*, LXV, 3 and 5

[114] Raffaello Borghini, *Il Riposo*, Florence, 1584, p. 170

[115] Borghini, op. cit., p. 48

intelletivo.'[116] Federico Zuccaro, in a speech delivered at the Academy of St Luke on the 17 January 1594, stated: 'Painting, daughter and mother of drawing, mirror of nature's soul . . . by the power of lights and shades demonstrates on the covered plane with colours, all sorts of form and relief, without the body's matter.'[117]

'Principes': The first six principles Poussin talks about seem to follow the generally accepted idea on optics prevailing at the beginning of the seventeenth century but actually conceived during the Middle Ages. According to Blunt,[118] Poussin seems to have copied the theorem from Alhazen 'almost word for word'. Alhazen (Ali Al Hassan ibn al-Haytham, 965–1039) refuted, as did Avicenna, the extramission theory of vision. His *Kitab al-Manazir*, translated into Latin as *De Aspectibus* or *Perspectiva*,[119] probably by Gérard de Crémone (d. 1187), marked the works of Robert Grosseteste, Roger Bacon and Vitelo among others. Lorenzo Ghiberti copied passages from one of the Latin versions. It was translated into Italian by Risner and published in Basel (*Opticae Thesaurus*, 1572). But the first line of Poussin's 'principles', '*Il ne se donne point de visible sans Lumière*', appears also on Pollaiuolo's tomb of Sixtus IV (Rome San Pietro in Vincolo) and is engraved in the book held open by the allegorical figure of Prospectiva. It reads: *Sine luce nihil videtur*, and is taken from John Peckham (1240–92), *Perspectiva Communis*.[120] The remarkable interest which the Franciscan and Dominican theologians of the thirteenth century had in optics, especially in the Arab treatises on perspective, notably of Alhazen, was due to the belief that perspective was a science of light (following the erroneous optical theories of extramission and intromission). Alhazen distinguished between twenty-one categories of beauty, according to the variety of optical perception, such as *distance*, because it subdues irregularities of imperfection, *proximity*, because it permits refinements to be seen, *colour*, too, can be beautiful, and the most beautiful one for him was dark blue . . .

Light, colour, size, position, continuity, etc., are categories of optical

[116] cf. Paola Barocci, *Scritti d'Arte del Cinquecento*, Milan/Naples, 1971

[117] '*Pittura, figlia & Madre del Disegno, specchio dell'alma natura . . . per forza di chiari, e di scuri in piano coperto di colore, dimonstràdo do ogni sorte di forma, e di rilievo senza sustanza di corpo.*' Federico Zuccaro, *Scritti d'Arte* [Turin, 1607], Florence, 1961, p. 37

[118] Blunt, op. cit., 1938, and 1967

[119] Eleventh century

[120] L.D. Ettlinger, 'Pollaiuolo's Tomb of Sixtus IV', in *Journal of the Warburg and Courtauld Institutes*, XVI, 3, 1953, pp. 239–74

perception.[121] It was thought that one could learn through optics the laws which govern the distribution of light, by which God illuminates all beings. This light was essentially invisible light, to theologians. Science, metaphysics and theology were united in the research of optics. The various authors distinguished between *Lux* – understood to be the source of the nature of light, *Radium* – its ray, *Lumen* – the spherically diffused rays, and *Splendour* – the brightness of things illuminated. There were seven modes in optics. These terms found their way into the theory of painting.

'Mais premièrent de la Matière. Elle doit estre prise noble, qui n'aye receu aucune qualité de l'ouvrier': This principle – 'But first about subject matter. It must be noble, without laboriousness' – follows Torquato Tasso ' – Quella que non ha ancora ricevuta qualità alcuna de l'artificio dell'oratore'[122] – only replacing the orator by the labourer.

' la plus excellente forme': 'The most excellent form', deriving from Aresi, is, according to Blunt (1938) copied from *Dell'Arte Historica* (1636) by Agostino Mascardi ('Di alcune forme della Maniera Magnifica') who was actually against the ideas of Aresi . . . and does not make style depend on subject.

Poussin follows the six principles of Vitruvius – order, disposition, eurythmy, symmetry, propriety and economy.

'la Disposition': This concept stems from Vitruvius, as well as from the Greek term *diathesis*. '*Diathesis* refers to the order among a thing's parts . . . for parts must have some position or other . . . '[123] In the seventeenth century and previously in the sixteenth, the term '*dispositio*' was derived from Cicero's and Quintilian's rhetoric. The principles of rhetoric, *Inventio, Dispositio, Elocutio*, were converted into *Invenzione, Disegno e Colorito* by Lodovico Dolce (1557). In rhetoric, arrangement means preliminary sketch, in the sense of the relation of parts to the whole, which for Dolce becomes the term *disegno*. For Vasari it was: *Regola, ordine, mesuro, disegno*.

It is interesting to note that Poussin does not quote 'invention', and says that

[121] Panofsky, 'The History of the Theory of Human Proportions as a Reflection of the History of Styles' [1921], in *Meaning in the Visual Arts*, 1955, p. 90

[122] Tasso, *Discorsi dell'arte poetica*; cf. Blunt, 1967, p. 355

[123] Aristotle, *Metaphysics*, 1022b I; cf. Pollitt, op. cit., 1974, pp. 162–7, for further exegesis.

one must begin by disposition, which demonstrates his concern for composition and structure. In a letter of 15 March 1655, he writes: 'Jei aresté la disposition de la Conversion de St Paul'; and on 25 November 1658: 'Je faits une nouvelle composition sur La Chutte de St Paul.'

'Disposition is a suitable positioning of parts and an elegant effect arising from the composition, taking into account the work's qualitative effect.' ('*Dispositio est autem rerum apta collocatio, eleganque incompositionibus effectus operis cum qualitate.*')[124] 'Disposition is nothing other than an adequate act of positioning the objects, with an effect of suitability in the composition.' ('*La disposizione non é altro che un'atta collocazione delle cose e un convenevole effetto nelle composizioni.*')[125] '*Discrezzione*', discernment, for Lomazzo plays the leading part in painting. The second is *disposizione*, the third is *distribuzione* (order), and contains *ragione* (reasoning), *temperamento* (moderating) and *dispensazione* (suitability – which concerns mostly the recipient and destination of the work). *Commodo* (choice with certitude) is the fourth one.

'*l'Ornement*': (A term in the art of oratory.) 'The triumph of eloquence is in amplifying a subject by embellishments.'[126] Along with decor and costume 'which have to be particular to the case',[127] it was part of the theory of poetry, before governing the visual arts.

'*le Costume*': 'Is nothing other than the scrupulous observation of what is fitting for the characters represented.' ('*N'est autre chose qu'une observation exacte de tout ce qui convient aux personnes que l'on représente.*')[128]

'*la Vraysemblance*': Probability, likelihood, also forms part of the 'accuracy of the subject and chronology' ('la fidelité de l'Histoire et de la Chronologie') as it was later formulated by Roger de Piles (1699), deriving from Lomazzo's *simile ad vero*. It is probability as a result of the painter's skill, a concept stemming from Aristotle's *probability*[129] and from which 'likelihood or necessity' derive. These terms were taken up again by sixteenth-century literary criticism, notably that of Castelvetro. 'Probability' became more important for academic formalism, but in the sense of *fitness*.

[124] Vitruvius, I, 2

[125] Lomazzo, *Idea*, 1590, XVIII

[126] Cicero, *De Oratore*, III, p. 104

[127] ibid., p. 106

[128] Félibien, op. cit., 1688, preface

[129] Aristotle, *Poetics*, 1541b

Verisimilitude was of major concern to the history painter. It eventually led to the *pompiers* in the nineteenth century. Even in the sixteenth century its danger was understood, by some, like Annibale Carracci, as pointed out in his letter to his brother (28 April 1580), quoted earlier: ' . . . mi piace questa schietezza e questa purità, che e vera, non verisimile . . . '

'le Décoré': The basic principle of the decor theory is the unexceptionable idea that the form of a work of art should be appropriate to its meaning.'[130] 'Decorum more often implies propriety in an ethical sense, decor in an aesthetic sense.'[131] Decorum, one of Vitruvius's six basic principles, is the only one not to have a Greek equivalent, the nearest Greek term being *to prepon*, that is to say, 'appropriate' - 'seemly' - 'faultless appearance'.[132] It was praised by Aristotle, as one of the essential virtues of rhetorical style, and by Theophrastus (*On Style*). The term *Décoré* that Poussin uses is, therefore, *decoro*, 'propriety' (for Dolce 'convenevolezza').

'la Délectation': 'Instruct and delight . . . or better still: instruct and delight, that is the real poet's task.'[133] It is interesting to note that of the two terms *docere* and *delectare'* thus linked by Horace, Poussin only cites 'delight', in spite of his evident ethical convictions. Inversely, Pietro da Cortona holds *docere et delectare* as an example in his treatise on painting.[134]

'Delectation' was for St Bonaventura (1221–74), in his *Itinerary*, a principal key to the recognition of beauty, since, according to him, the 'path of God' is accessible through *immediate perception* (the Divine being present in his movement, in 'order, measure, beauty and disposition'). In his *Itinerary*, St Bonaventura multiplies the points of view, in order to open the eyes – 'The splendour of things reveals Him to us if we are not blind.'[135]

Blunt calls attention to the mystical connotation in the term *delectare*, as being St Augustine's *delectatio boni*. As for 'instruction', according to Alberti,

[130] Pollitt, op. cit., 1974, p. 69

[131] ibid., 1974, p. 343

[132] Vitruvius, I, 2, 5–7

[133] Horace, *The Art of Poetry*, III, 33

[134] Pietro da Cortona, *Tratatto de la pittura e scultura, uso e abuso loro, composto da un Theologo e da un pittore*, Florence, 1632 – published jointly with the Jesuit Father Gio Domenico Ottonnelli under the anagrams: *Odomenico Lelonotti da Fanano e Britio Prenetteri*

[135] cf. Etienne Gilson, *La Philosophie au Moyen Age*, Paris, 1947, p. 442

art leads to piety. But Castelvetro was opposed to Horace's interpretation of Aristotle – that poetry was to instruct and delight. For him it was meant only to delight.[136] Nor does Dolce (1557) use the term *docere*. But the Counter-Reformation impelled Armenini (1587) to say that 'painting contributes to the cause of Christianity', and Lomazzo (1595) to affirm that it was 'the right road'. It may seem surprising that Poussin omitted 'instruct'. However, for the Stoics nature was 'reason in action'. From there to the observation published by Bellori (1672) that 'painting is only the imitation of human action' ('la pittura altro non è, che l'imitatione dell'azzioni umane') is only one step. Albeit, this definition is copied from Tasso's *Discorso del poema eroico*.[137]

The notion of 'instruction' was taken up again by the Academy. Félibien did not take Poussin's more multifarious attitude into account, reducing it to '*instruction et plaisir*'. This notion of art as instructing and moralizing, at the service of State and Religion, was to be developed by the Academy, and was to last well into the nineteenth century. Curiously however, in a subterranean fashion, this notion has survived long beyond that time. Utopian belief in art's redeeming power, held by Malevitch, Mondrian and others, is evidence of this.

After having stated the six principles of optics, Poussin says that 'what follows is actually unlearnable' and 'part of the painter'. Yet, it is strange that Poussin should mention *Ornement* after the essential *Dispositio*. *Ornement* contradicts *gravitas*, which was the essential quality in Poussin's art. It contradicts his statement on moderation in his letter on the 'modes'.

In fact, out of the traditional definition of painting, as it stemmed from Vitruvius's definition of architecture, Poussin retains only *disposition* and *décoré*. There is of course, the inevitable verisimilitude accompanying *costume*. The terms, *beauté, grâce, vivacité*, mean little, but may signify proportion and expression. But the explanation for the use of 'beauty, grace and vivacity' is given in *le jugement partout,* the overall judgment, which is the key – the pass-key – for any painter, since all rules or theories stop in front of the canvas. Painting is not an implementation of a theory, or rules. 'There are as many rules as there are true artists,' said Giordano Bruno.[138] The 'true artist' has to

[136] cf. Renselaer Lee, *Ut Pictura Poesis: The Humanistic Theory of Painting* [1940], New York, 1967, p. 33

[137] cf. Thuillier, op. cit., 1969, p. 92

[138] Panofsky, op. cit., 1960, p. 73

obey his inmost rules, and follow his own path 'which cannot be learned'. Poussin knew it in giving the example of Virgil's Golden Bough, 'which none can find nor pick, without being guided by destiny'. In other words, it is the descent of Aeneas to Hades, impossible without the Golden Bough for Proserpina, which could not be cut from the golden tree (the mistletoe) since the tree could not be touched by iron – it had to be picked *gracefully*, by hand, without forcing. 'It will come to you by itself with ease if destined for you, otherwise there is no force which can vanquish it . . . '[139]

This last comparison to Aeneas's grasping of the Golden Bough was Poussin's inner rule, and remains his legacy to painters.

[139] Virgil, *Aeneid*, VI, 126, p. 73

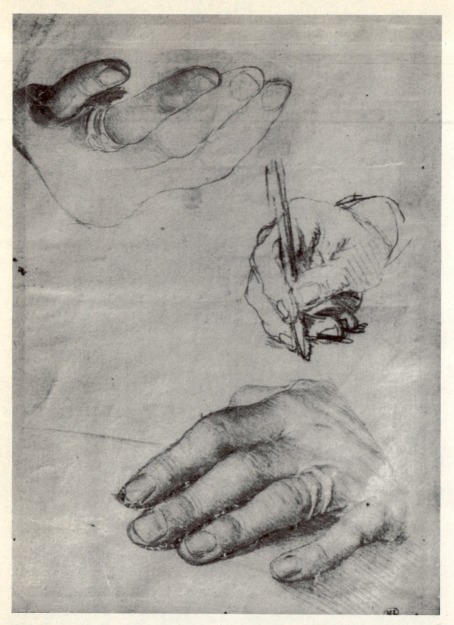

Hans Holbein the Younger, *Three Studies of Hands* (for the portraits of Erasmus), *c.*1521, metal point, red and black chalk (right hand), on primed paper, 20.1 x 15.3 cm. (Paris, Musée du Louvre)

ON DRAWING FROM OBSERVATION

I

Drawing from observation (or *prima* painting from observation, which is rare), when executed in a heightened state of intensive scrutiny, permits the recording of a sitter's living appearance by a stroke. 'The single stroke is the root of all representation,' said Shih-t'ao.[1] In this particular state of compressed time (instants) and reduced means (tracing), knowledge of how to draw comes second to scrutiny. There is indeed a process of unlearning without which true drawing or painting from observation fails. The battle launched against one's knowledge of how to draw a nose, an eye or a lip, has to be won in the process of observation, in order to draw this particular face and not simply a face, a general face – an invention. Thus, the act of drawing from observation is a dialectical one, supposing supreme mastery and the dismissal of such mastery at the same time. The 'method which consists in following no method is the perfect method,' as it was stated by Shih-t'ao.[2] To draw from life is, then, investigating by way of sight, and translating real size into graphic measure by means of line and blanks. The blanks or 'reserves' are as important in a drawing as the quality of a line. They are the lights – 'to draw the lights' was seen by Alberti[3] as most important. At the same time, it is from the 'single stroke' i.e. the masterly spontaneity, that a drawing draws its intensity. In China, where drawing and calligraphy were connected, this was implicit long before it was understood in Europe. Landscape, which cannot be recorded without its light, space and air, may have been the cause. On the other hand, although drawing from nature (*Xieshang*) was practised, its aim was not simply imitation or resemblance (*Xing*) but rather 'real nature'(*Qing*). The emphasis, however, was to go from the particular to the general for finding the *Li*, (principle) – a *concetto* with cosmic overtones.[4]

[1] Laurence Sickman and Alexander Soper, *The Art and Architecture of China.* Harmondsworth, 1956, p. 200

[2] cf. Pierre Ryckmans, *Shitao – Les Propos sur la peinture du moine Citrouille-amère,* Paris, 1984

[3] Leon Battista Alberti, *Della Pittura* (1435–6), London 1956, II, p. 94

[4] William Willetts, *Chinese Art*, Harmondsworth, 1958

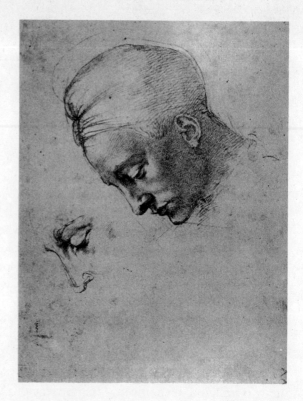

Michelangelo, *Studies for the Head of Leda*, c.1529, red chalk 35.5 x 26.9 cm. (Florence, Casa Buonarotti)

II

Drawing from observation did not vary as other art forms did and remained unaffected by technological progress: drawing someone's face presents the same challenge again and again. Drawing from observation seems to be an activity both within and without historical time. However, it was seen by most theorists, writers on art and even artists of the last few centuries up to the nineteenth, as a step towards a finished work, and not as a finished work in its own right.

Drawing from observation is immediate. It requires intense feeling, acuity, high velocity and instantaneous execution. It does not allow any mechanical help,[5] posterior modification or addition without it being noticed. Of the great masters not all were great draughtsmen. There are no drawings by

[5] From the glassplate device – invented by Leonardo, elaborated by Dürer, used, sometimes, by Hans Holbein, Clouet or Ottavio Leoni – to the photographic camera.

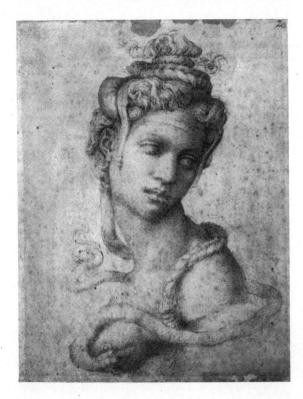

Michelangelo, *Cleopatra*,
black chalk, 23.2 x 18.2 cm.
(Florence, Casa Buonarotti)

Caravaggio, only one drawing from observation clearly by Velazquez, none unquestionably by Vermeer. But their absence may also be due to neglect.

Furthermore, the distinction between drawing from observation and drawing from memory or imagination was, and still remains, generally unclear to most art historians, although clear to artists and to every discerning viewer. Drawing or painting from observation, when truly picked from life, is immediately and distinctly convincing. Be it an apple, a figure or a tree. It is a true statement dictated by a sitter or a subject to the artist's hand. Its discernment is part of connoisseurship by which it is indubitably recognizable.

As an example one can quote two drawings by Michelangelo, one from life, and the other from the imagination: the life drawing, *Studies for the Head of Leda* (c.1519–20, Florence, Casa Buonarotti); the other, his 'presentation drawing' made for Tommaso di Cavalieri, *Cleopatra* (c.1530s, Florence, Casa Buonarotti). The sheet of studies is immediately convincing by its intensity. We are struck by the sitter's identity (probably one of the master's studio *garzoni*). This is, however, not the case with the *Cleopatra*, which is an invention, partly drawn from imagination and maybe also from different

111

sources (following the example of Zeuxis). The result is an ideal head which is nobody's likeness, giving the impression of artifice and uncertainty. This *testa divina* is mentioned by Vasari as being the gift Cavalieri offered Duke Cosimo di Medici.[6] It conformed with the neo–Platonic belief that the sublime can only be ideal and therefore cannot be anyone's likeness. It was a product of the *concetto*, believed to be of a higher order than drawing from observation,[7] in accordance with the neo–Platonic creed that Idea is superior to Nature. This *testa divina* cannot possibly be compared to the quality of the sheet of studies, but the ideal head was considered more elevated in the hierarchy of genres which governed art up to the Impressionists and somehow still seems to be present in the collective subliminal idea of art. Yet portraiture in Western art occupies the forefront of drawing from observation, including sporadic masterpieces from Leonardo or Dürer to Ingres, Degas, Matisse and Picasso. This sort of portraiture, by which not only a sitter's features but something beyond it is caught by the graphic medium, puts portrait drawing in the first rank as the quintessence of drawing from observation. As for example Dürer's portrait of his mother (*Barbara Dürer*, 1514, Berlin, Kupferstichkabinett) or the double portrait-sheet in silver-point of *Paul Topler and Martin Pfinzing* (1520, Berlin-Dahlem). The sitters' identities appear to be unquestionable. Such a trace of life couldn't possibly have been recorded from memory. It must have been seized at once, as fruit is from a tree. Instantaneous studies such as the reed-drawing by Rembrandt, supposedly of *Saskia III* (*c.*1640, Paris, Musée du Petit Palais), or *Isabella Helena* by Rubens (*c.*1636, Paris, Musée du Louvre) are examples of such drawings in which truth picked in a few instants holds those instants timelessly.

III

It is interesting to note that the earliest works of art were not done from observation, but from memory or from imagination. Not only were Magdalenian or Perigordian cave-paintings, sculptures or incisions, imaginary works; Sumerian, archaic Egyptian or Greek art were also mostly done not from life but from memory. Nor was the bulk of the prehistoric, tribal or the

[6] Giorgio Vasari, *Le Vite de più celebri pittori, scultori ey archetetti. Introduzione alle tre arti del desegno* (ed. Milanesi), V, p. 81
[7] cf. Erwin Panofsky, *Idea Ein Beitrag zur Begriffsgeschichte der älteren Kunsttheorie*, Berlin [1924], 1960

so-called 'primitive' art of Africa, Pre-Columbian America or New Guinea done from observation.

From the onset, the unquestioned creed was probably the surrogate for observation, as well as for any kind of aesthetic judgment. The creed, at first presumably rooted in magic, later in religion, couldn't be questioned: it was the cornerstone of the world, the standard of excellence underpinning the collective mental scheme of representation by which the head of a bison was judged good or bad. Iconography and colour symbolism were also closely connected in the earliest Perigordian artifacts, in terms of colour-significance, like in the bison's horn, the female figure or its essence – the vulva – the male figure and its essence – the phallus. They were everywhere. But, as in the case of the hand-imprints, most of them are graffiti, whether magical symbols, or deliberate scribbles. They were accepted formulas. These formulas evolved, through antiquity, into fixed models or patterns, the patterns mutated, but their formal essence sustained from generation to generation, as if fixed by eternity. It was best illustrated by Egyptian art. 'Painters and practitioners of other arts were forbidden to innovate on these models or entertain any but the traditional standards, and the prohibition still persists,' says Plato, and adds, 'If you inspect their paintings and reliefs on the spot, you will find that the work of ten thousand years ago – I mean the expression not loosely but in all precision – is neither better nor worse than that of today; both exhibit an identical artistry.'[8] It is notorious that Plato's hierarchical order rated Idea the highest and Art the lowest. This discrepancy gave birth to the notion that art ought to *docere et delectare* (instruct and delight),[9] to the moralizing aim of art, and finally to the erroneous notion of Ideal Beauty, another formula for a fixed model.

It can be assumed that the dawn of civilization was marked by a certain need for veracity, henceforth for art drawn from fact, within the respect for individual life, as we can see it mirrored at the dawn of portraiture. Not only Egyptian, Classical Greek, Hellenistic or Roman portraits (of the first and second centuries especially), but also their ramifications, such as the few outstanding portraits of the *Oni* of Ife (of an uncertain date, they all seem to be by one unequalled hand), convey a certain tremor. However, the greater part of art on this earth was not done from observation, but from imagination. Not from fact, but from fiction. Art entirely drawn from life is rare.

Primitive art is only done from imagination. Whence the confusion

[8] Plato, *Laws*, II, 656e–657a
[9] Horace, *The Art of Poetry*, III, 33

113

Head of an Oni from
Wunmonije compound, Ife,
*c.*thirteenth century, zinc
brass, height 31 cm.
(Ife, Nigeria, Museum of Ife
Antiquities)

between painting and image. Images are achieved without scrutinizing. They
are a representational memo, a by-pass by which sensing is avoided. Conven-
tional images were always done from memory. Image-making and image-
reading are thus complementary within a given coding system. The encoded
data of an image is decoded automatically by a common culture. Neither
intensity nor frequency are at its root – but in case of such a miracle, when
intensity and frequency coincide, it is a picture. Not an image any longer.

Most Palaeolithic images of a bison, a horse, or a woman were probably
drawn from common conventions governing how each part of a figure should
be done. (This 'how to' approach is, somehow, still alive.) Such incisions
seem to have been executed from point to point – as a totality – with a
beginning and an end in mind, unlike working from observation, which takes
place within a lesser clarity about where a figure starts and where it ends.
They were probably executed in the same way one draws conventional
symbols, signs or letters. This is denotation without depiction.

Drawings such as the ones on the walls of the Pech-Merle cave (Aurignaco-
Perigordian period) or stone incisions of the same period, in themselves

timeless and of great purity, hold within their lines the typical. Not the particular.

For tens of thousands of years the human need to capture, seize or imitate, dealt with the typical rather than with the particular – though in some Assyrian reliefs, there's a hint of an observing eye getting someone's likeness in spite of the rigid stylization. Representation was there from the dawn of art but it was subject to stylization, as in early Mesopotamia and Egypt. Albeit there are examples of exceptions all throughout time, such as the stylistic liberalization started by Amenhotep III and continued through the twenty-two-year-long reign of Amenhotep IV (Akhenaton) in the Eighteenth Dynasty.

The 'reserve' heads found at Giza, of an earlier age, such as the portrait of Sneferu-seneb of the Fourth Dynasty (Cairo Museum), seem at first glance contemporary with the plaster head of Amenhotep III (Berlin Museum) of a thousand years later, but a closer examination discloses the profoundly free and sensitive approach of the latter in contrast with the more stylized formulation of the former. Drawing, unlike sculpture, seems to have remained unaffected by this evolution. An intermediary stage, generally only a first step in wall painting and carving, ornament or in the illustrations for the *Book of the Dead*, it is unlikely that drawing was ever done from life.

IV

The Hellenistic world and China seem to have been the cradle of drawing from observation. In saying that drawing 'is the supreme refinement of painting', Pliny, writing about Parrhassius, also says that 'by the admission of artists themselves he won the palm in the rendering of outlines'. And he adds that through drawing 'outlines' ('liniis extremis') Parrhassius succeeded in suggesting what was hidden, 'ostendatque etiam que occultat',[10] presumably bringing the blanks to the fore, thus abolishing negative space. This is still the proper definition of a drawing.

Contrary to what is generally thought, Greek drawing was not only constituted by pure line. In stating that Telephanes and Aridices used only line and no colour, Pliny mentions a technique of 'sprayed lines', 'spargentes linias intus'.[11] This strongly suggests hatching. There must have been a variety

[10] Pliny, *Natural History*, Cambridge, Mass., 1968, XXXV, 67–9
[11] op. cit. XXXV, 16

impossible to guess, but was it drawing from observation or from memory? We shall never know the answer. Not a trace is left by Apelles, Cleantes, Pamphylus or Parrhassius. The conservation of drawings may be due to the perfect balance between the fragility of a line with that of an equally fragile support. The incongruous drawing supports used in ancient Greece and Rome did not allow it. The primed wood or parchment tablets used for drawing upon with the metal stylus [12] in ancient Greece and Rome, may have been one of the major causes of their decay. The legacy of drawing, its conservation, is largely indebted to the invention of paper.[13] Its appearance and generalized use in Europe about 1,200 years after its invention in China during the first century squarely coincides with the emergence of the conservation of master drawings.

Drawing as an activity in itself declined in the Western world into ornament with the decay of antique civilization. It certainly continued to be used in the creation of Byzantine mosaics, Ottonian and Mozarabic illuminated manu-scripts and Romanesque wall frescoes, but as preparatory outlines only. This fact by no means diminishes the aesthetic value of such medieval masterpieces as the Beatus Apocalypse of Saint-Sever (c.1028–42, Paris, Bibliothèque Nationale) or the Romanesque frescoes of Urgel and Saint-Savin. It was indeed an intensely expressive art, but had nothing to do with drawing from observation. Such seems to be the case with the later drawing pad by the master builder Villard de Honnecourt which contains 167 figures and 66 animals inscribed by him (in Picardian dialect) as having been done from life, 'contrefais al vif' (1220–40, Paris, Bibliothèque Nationale). Although it is possible that this master builder (who is known to have worked on the construction of the apse of Cambrai Cathedral) may have indeed tried his hand at drawing from observation (the animals at least), the result is a sort of schematic Romanesque shorthand.[14]

On the basis of extant Roman wall paintings such as the fresco portrait *Man and His Wife* – presumably the portrait of the law student Terentius Neo, *studiosus iuris,* and his young wife[15] – (from Pompeii, House VII, 2, 6) or *Theseus, Slayer of the Minotaur* (from the House of Gavius Rufus), both at

[12] Joseph Meder, *Die Handzeichnung – ihre Technik und Entwicklung*, Vienna, 1923, pp. 72–4, 164–8

[13] Dard Hunter, *Papermaking: The History and Technique of an Ancient Craft* [1943], New York, 1967

[14] Henri Focillon, *Art d'Occident – Le Moyen Age roman et gothique*, Paris [1938], 1955

[15] M. Della Corte, 'Case ed abitanti di Pompei', *Pompei Scavi*, 1954

Man and His Wife (presumed to be Terentius Neo, *studiosus iuris,* and his young bride), *c.*79, fresco, 65 x 58 cm., Pompeii House VII, 2, 6 (Naples, Museo Nazionale)

Naples, Museo Nazionale, we can ascertain the practice in antiquity of painting from life and from the nude. This practice was probably continued through to the end of the antique world. It seems to have vanished altogether in Europe for about one thousand years.

Presumably no life drawing from the nude (and no painting from life) was done in Europe before the early years of the fifteenth century.[16] The medieval concept of modesty excluded all nudity from art – Eve herself was represented robed. And if, for eschatological purposes, nudes were needed for the depiction of the damned or the Last Judgement, they were drawn from the imagination and were generally not larger than a thumb. Even Fra Angelico, in representing the naked souls at the Gates of Paradise, painted them dressed, leaving the sinners in imaginary nudity. Nudity was evil. Especially female nudity. But the quattrocento quest for measure, for ideal proportion, which was at the origin of their practice of measuring antique nude sculptures, led to the one for limbs and bodies. This preceded life drawing from the nude as a studio practice. It began during the early years of the fifteenth century. This didn't rule out the fear of temptation and consequently of sin, as far as the female model was concerned, whose pudicity, added to prejudice, led to the belief that only the male body was truly proportionate. 'I will give you the exact proportions of a man. Those of a woman I will disregard, for she does not have any set proportion,' says Cennino d'Andrea Cennini.[17] It is doubtful whether Pisanello read *Il Libro*. He may have shared the same belief, however, his studies from the female nude are among the earliest extant (*Four Nude Female Figures,* Rotterdam, Boyman's Museum). Pisanello drew whatever struck him: birds, deer, horses – see the *Studies of Dogs and Horses* (Paris, Musée du Louvre) or his portraits or the *Nude Studies* (Dresden)[18] or the harrowing sight of the *Two Hanged Men* (New York, Frick Collection) hanging from the gallows, rendered with veracity and deep feeling. Pisanello and van Eyck were among the first masters (after Giotto) to reconnect drawing to objective perception, leaving the imaginary behind. As was Masaccio. But no life drawings by him are extant, though they must have existed, at least as cartoons, for his frescoes at the Brancacci Chapel (Florence, Santa Maria del Carmine). It can also be

[16] Meder, op. cit., pp. 379–90

[17] Cennino d'Andrea Cennini, *Il Libro dell'Arte*, translated by Daniel Thompson Jr, *The Craftsman's Handbook,* New Haven, 1933, ch. LXX

[18] G. A. Dell'Acqua, *L'Opera completa del Pisanello*, Milan, 1974

Rubens, *Isabella Helena, c.*1636, black and red chalk, heightened with white, 39.8 x 28.7 cm. (Paris, Musée du Louvre)

assumed that Piero della Francesca used drawing from observation as cartoons[19] for his frescoes. But the most influential on further developments of art in the quattrocento was Andrea Mantegna. A superb draughtsman, he exercised a profound influence through his powerful engravings, disseminated throughout artists' studios, during his own lifetime as well as after. (Dürer, Raphael and Rubens, among others, were influenced by him.) His prints – only seven are genuine – more so even than his drawings, are marked by urgency probably due to the fact that an incised line is final and cannot be retouched.

V

Starting with Ghiberti, and even earlier, as testified by Cennini, drawing was transformed by mathematics into *disegno*. 'Design is cognizant of the proportion of the whole to the parts and of the parts to each other and to the whole,' says Vasari,[20] since *disegno* did not only mean 'drawing' but was also understood to be the translation of the Greek term *eurhythmia*. Lomazzo states it explicitly when he says, 'What the Greeks called *eurhythmia* we call *disegno*.'[21] *Disegno* continued to be understood as founded on this basis. It was also understood to be the 'parent of our three arts' and not only, 'the visible expression and declaration of our inner conception and of that which others have imagined and given form to in their idea'.[22]

This idea of inner and outer form, of *disegno interno* and *disegno esterno*, was carried forward by Armenini and further by Federico Zuccaro, who applied theology to aesthetics, interpreting *disegno interno* as 'segno di Dio', the 'sign of God'.[23] Prior to Zuccaro's 'divinization' of drawing,[24] speculation on the intellectual nature of drawing increased, with such theorists as Raffaello Borghini or Benedetto Varchi. Indeed, the aim of art was believed to be not a

[19] Meder, op. cit., p. 523

[20] Giorgio Vasari, *Vite*, op. cit.; 'Introduction to the Three Arts of Design', L. S. Maclehose and G. B. Brown, in *Vasari on Technique*, New York [1907], 1960, ch. 1 [15] 74, p. 205

[21] Gian Paolo Lomazzo, 'Idea del Tempio della pittura' [1590], in *Scritti sulle arti*, ed. R. P. Ciardi, Florence, 1973, vol. I, ch. X, p. 281

[22] Vasari, op. cit.

[23] Federico Zuccaro, *L'Idea de' pittori, scultori e architetti*, Turin [1607], in *Scritti d'arte*, ed. Detlef Heikamp, Florence, 1961, II, ch. XVI

[24] See Panofsky, *Idea*, op. cit., passim

Pisanello, *Two Hanged Men*, pen and brown ink on paper, 26.2 x 18 cm.
(New York, Frick Collection)

description but a definition of reality. 'Descriptions are as different from definitions as first sketches or quick sketches are different from pictures which are coloured and perfected. [This is] because the former derive from accidentals while the latter derive from essences.'[25] A drawing from observation was considered, then, to be an unfinished step towards *disegno*. No particular consideration was given to such life studies.

Since the early Renaissance, drawing from observation was, as the fourth stage in training artists, practised before the final stage of 'composition drawing' or 'modello', and after drawing from prints, drawings, paintings and from sculptures. Drawing from observation was practised in order to memorize. 'The best thing is to draw men and women from the nude and thus fix in the memory by constant exercise the muscles of the torso, back, legs, arms, and knees, with the bones underneath.'[26]

In opposition to this doctrine, Ingres is quoted (by Charles Blanc)[27] as having said to his pupils: 'Drawing is to feel – to discern and feel, and not to know nature by heart.' A statement which is in contradiction with Vasari's view that 'the artist must try with all possible diligence to copy from life if he does not feel himself strong enough to be able to draw on his own knowledge'.[28] It is Leonardo who understood, the way we do, the investigative nature of drawing: 'The painter who draws merely by practice and by eye, without any reason, is like a mirror which copies all things placed in front of it without being conscious of their existence.'[29]

It becomes clear that any visual subject has to be perceived in a state of urgency, but also reasoned. Drawing from life is not mere mechanical copying, but a complex process of transforming visual data (space and volume) into graphic data (lines on a plane). Alberti, Leonardo, Dürer, were perfectly conscious of it.

This concern with the purely optical aspect of perception was superseded not only by speculation inherent in the classical ideal, but also by formulas, mainly illusionistic, inherent in problems created by ceiling-paintings to be

[25] Benedetto Varchi, *Paragoni – Lezzioni sopra la pittura e la scultura* [Florence, 1549], ed. and trans. Leatrice Mendelsohn, Ann Arbor , Michigan, 1982, p. 112
[26] Vasari, op. cit. XV, no. 76
[27] Charles Blanc, *Grammaire des Arts du Dessin*, Paris [1867], 1880, p. 393
[28] Vasari, op. cit., XVI, no. 77
[29] *The Notebooks of Leonardo da Vinci*, compiled and edited by Jean-Paul Richter, London [1883], New York 1970, vol. I, no. 20, p. 18

seen *di sotto in sù*. Flying figures and putti demanded more than natural foreshortening. Such artifices had to be drawn from elsewhere.

Finally, the quarrel between the partisans of line and those of colour, between Florentine and Venetian, and later between 'Poussinistes' and 'Rubéniens' was actually not about drawing from observation in itself but about *disegno*. Structure versus brushstroke. Free as opposed to applied brushwork, the *non-finito* as opposed to the *finito* quality of a painting. It is interesting to note that Poussin rarely drew from life whereas Rubens constantly did. Furthermore, the *Poussinistes* in France (Le Brun, Testelin) were the founders of the academic doctrine, whereas the 'Rubéniens', for whom Roger de Piles was the principal spokesman, led up to Watteau, eventually to Chardin.

'Before dressing a man we first draw him nude, then we enfold him in draperies. So in painting the nude we place first his bones and muscles which we then cover with flesh,' wrote Leon Battista Alberti.[30] This tradition of undressing the model before drawing the folds was transmitted essentially through Raphael to posterity, since Ingres, who learned it from David, proceeded in that way. It was thus essential to have at one's disposal nude models, male as well as female. But women (with beautiful figures) ready to model must have been scarce. An unknown Pisanello follower most probably used the public bathhouse as a source in drawing the studies of a bathing young woman (Berlin, Kupferstichkabinett). So did Dürer (*Nude Woman Bather*, 1493, Bayonne, Musée Bonnat, or the later Louvre sheet of 1495). This subject of bathers, pagan and biblical, continued to thread through history up to Cézanne, who again used male models for his female bathers. However, he didn't meet the kind of obstacles in getting female models as did the artists three or four centuries earlier. For them, the availability of young male apprentices (who had to undress, *spogliare*), added to pious fear and prejudice, must have been the reason why Pollaiuolo, Signorelli or Verrocchio and also his pupils Lorenzo di Credi, Leonardo and so many others, used mostly male models. Moreover, according to Meder, the ideal body of the Italian quattrocento was seen to be the young lean male. Rejecting rigid Gothic attitudes, the gracious movement of the joints became increasingly important, as is expressed by Alberti and Leonardo, who codified movement into *moto locale, moto actionale, moti composti*. Proportion was at the root of it.

[30] Alberti, op. cit., II, p. 73

Dürer, *Heroldsberg*, 1510, pen and ink (Bayonne, Musée Bonnat)

But not only measure haunted painters.

It is a necessary thing for the painter, in order to be good at arranging parts of the body in attitudes and gestures which can be represented in the nude, to know the anatomy of the sinews, bones, muscles and tendons. He should know their various movements and force, and which sinew or muscle occasions each movement, and paint those only distinct and thick, and not the others, as do many who, in order to appear to be great draughtsmen, make their nudes wooden and without grace, so that they seem a sack full of nuts rather than the surface of a human being, or indeed, a bundle of radishes rather than muscular nudes.[31]

'Muscular nudes' is indeed the key to it all. By 1500 the ideal of the young lean male and with it the gradual harmonious movement from ankle to wrist (*composto*) were replaced by musculature. As strange as this may seem, the splendour of the female body was eclipsed by the increasing fascination with anatomy, with muscles. Later, Michelangelo, whose drawings are the most intense masterpieces of this 'muscular' phase, used male models instead of females for his Sibyls of the Sistine Chapel, of which one of the most outstanding examples is the study for the *Lybian Sybil* (New York, Metropolitan Museum). Was it for the same reasons, or because beautiful female models were scarce, 'carestia e de buoni giudici e di belle donne', as Raphael put it in his letter to Baldassare Castiglione?[32] Yet Dürer had female models in Venice, and also drew from the female nude in Nuremberg (*The Fall of Man*, 1496/7, Paris, Ecole des Beaux-Arts, and the engraving *The Four Witches*, 1497). Adversely, the drawing Raphael sent to Dürer, *Two Studies of Male Nudes* (1515, Vienna, Albertina), which is inscribed in Dürer's hand: '1515, Raphael of Urbino, who is so much admired by the Pope, made this nude study and sent it to Albrecht Dürer to illustrate his hand',[33] is a double study of a male nude. If we are to connect this to the above-mentioned letter by Raphael to Castiglione, we can deduce from it that the use of male models was due to the scarcity of female models – with or without ideal proportions. However, Raphael had the advantage of having the ravishing Fornarina as his model;

[31] Leonardo, op. cit., p. 488 [L.79a]

[32] Giovanni Gaetano Bottari and Stefano Ticozzi, *Raccolta di lettere sulla pittura, scultura ed architettura*, Milan [1822], Hildesheim/New York, 1976, vol. I, pp. 116–7

[33] '1515 Rafahell de Urbin, der so hoch beim Pobst geachtt ist gewest, hat diese nackete Bild gemacht und hat sie dem Albrecht Dürer gen Nornberg geschickt, ihm sein Hand zu weisen.'

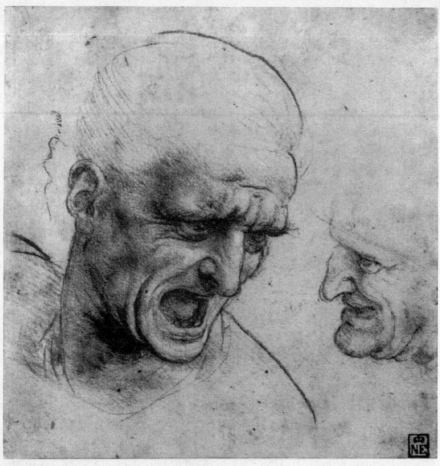

Leonardo, *Studies of a Man Shouting and of a Profile*, c.1503–4, black chalk, 19.2 x 18.8 cm. (Budapest, Museum of Fine Art)

Andrea del Sarto had Doralice, Fra Filippo Lippi had Lucrezia . . .

Scarcity was not the main reason. Marcantonio Raimondi had, according to Baldinucci,[34] male models as *salariati* – on a fixed salary. Professional models started to become available by the end of the fifteenth century and were plentiful throughout the sixteenth and seventeenth centuries with the proliferation of academies. Drawing from the female nude became a principal subject in art training and practice, in the north as well, in spite of puritan attitudes, as can be attested by the superb sheet of *Studies from the Female Nude*

[34] Filippo Baldinucci, *Notizie de Professori del disegno*, Florence [1681–1728], Turin, 1768, VI, p. 520

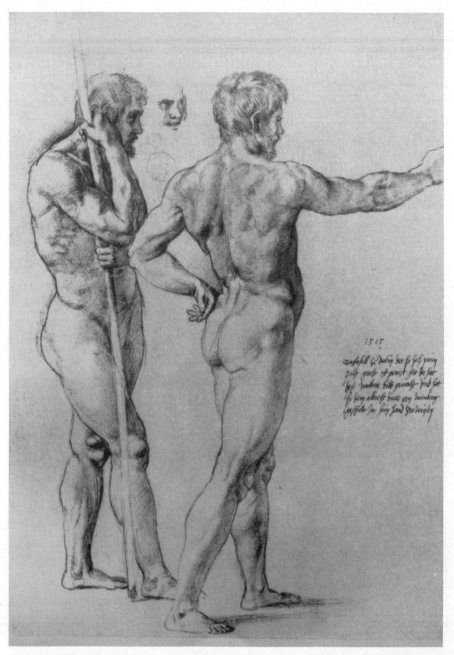

Raphael, *Male Nude, Double Study*, 1515, red chalk, 40.1 x 28.2 cm. (Vienna, Albertina)

Jacob de Gheyn II, *Female Nude Studies,* c.1603, pen and ink on black chalk,
26.2 x 33.5 cm.(Bruxelles, Musée Royal des Beaux-Arts)

by Jacob de Gheyn II (*c.*1603, Brussels, Musée Royal des Beaux-Arts).
Although available and admitted in private, female models were admitted in
Germany to pose in the nude 'officially' only in 1703, at the Nuremberg
academy, and in Paris at the Académie Royale first in 1759 (but dressed), and
exclusively for the *têtes d'expression.* This does not mean that one didn't
practice life drawing from the female nude in private. On the contrary: the
period of Louis XV was its apogee. The term *académie* which is applied to all
studies from the nude has its origin in France.

Dürer, *Female Nude with Staff from the Back*, 1495, brush and wash, 32 x 21 cm.
(Paris, Musée du Louvre)

VI

Slowly the professional model emerged from anonymity, like Caporale Leone, who modelled for Andrea Sacchi and Poussin, and was qualified by G.B. Passeri[35] as 'il miglior nudo di Roma'. At the French Academy, one century later, the principal model was a royal functionary wearing the royal livery and dagger who had his quarters in the Louvre and was paid between 200 and 500 livres, eventually revertible to his widow.[36] But professional modelling also had its drawbacks . . . for the artists: it lead to the academic pose. To the downfall of life drawing from the nude, which by the end of the eighteenth century became routine. Became 'academic'. In 1777 Claude-Henri Watelet, an enlightened member of the Académie de Peinture, wrote the following: 'A model named Deschamps posed for more than forty years at the Académie de Peinture. During this long period of time, nearly all the figures in the pictures of the French school featured Deschamps; sometimes Deschamps was Mercury, always young, at times he was the terrible Mars, then Neptune, Pluto, Jupiter . . . '[37] Jean Restout 'even boasted of using the male model of the academy for his Nymphs, Arianes, Venuses and for all other women of his pictures.' So did Taillasson, not only because female models 'were so expensive' but also because of decency . . . '[38] In this way male models were used for female subjects. (Did Masaccio use a male model for his *Eve?*) Annibale Carracci used one for his Magdalen (an 'ugly colour grinder', according to Malvasia),[39] and he used the back of his brother Lodovico for a Venus. This fiction went on for the sake of history painting,

However, the misuse of life drawing for painting did not affect drawing from observation as much as it harmed painting. A life drawing from a male model used for a female figure cannot diminish the eventual quality of such a drawing. Moreover, a painting drawn from a life drawing is necessarily twice removed from life (and one from a photograph even more) and will not contain the energy, the breath, a drawing from observation would. Compare,

[35] Giambattista Passeri, *Vite de'pittori, scultori ed architetti che hanno lavorato in Roma*, Rome [1673], 1772, p. 352

[36] Jean Locquin, *La peinture d'histoire en France de 1747 à 1785*, Paris [1912], 1978, p. 78

[37] ibid., p. 79

[38] ibid.

[39] Carlo Malvasia, *Felsina Pittrice, vite de pittori Bolognesi*, Bologna, 1678

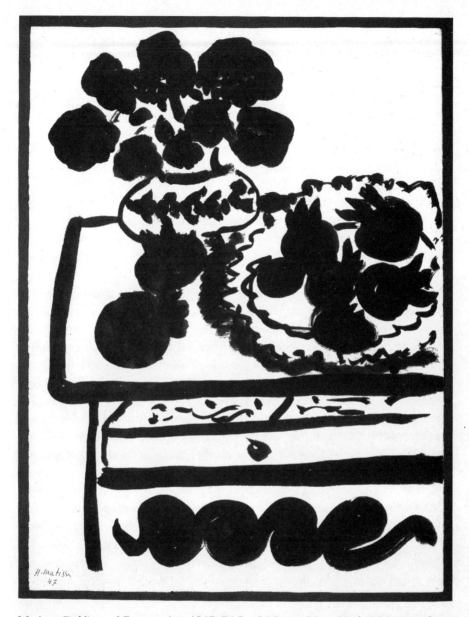

Matisse, *Dahlias and Pomegranites,* 1947, 76.5 x 56.5 cm. (New York, Museum of Modern Art)

for example, Michelangelo's drawing mentioned earlier of red chalk studies from a male nude, from which he copied the *Lybian Sibyl* (New York, Metropolitan Museum), with the Lybian Sibyl in his Sistine fresco: it is, in comparison with the drawing, although magnified and chromatic, much less moving than the drawing, which contains the breath of life. Or Ingres' study for the *Corpse of Acron* (New York, Metropolitan Museum) with the corpse in the painting *Romulus Vainqueur d'Acron* (Paris, Ecole des Beaux-Arts). No doubt is left. Paintings from drawings (or from photographs) contain the trace of their source, but not the trace of life, that breath their source contains.

This quality of 'breath', of vital force, which the Chinese, who named it *ch'i*,[40] early on understood and placed as the first of the principles governing art, seems also to have been understood, or rather felt, in the Western world by isolated artists rather than by 'schools'. That quality of breath, added to the one of accurate recording of the visible by the graphic or pictorial medium, has governed drawing and painting from observation up to now. Degas, (Menzel before him) was, after Ingres, one of the last repositories of the great tradition started in the quattrocento. But drawing from observation did not stop with him. There was, however, a decline in the quality of life drawing, which started with its conversion into an academic formula. The tendency of 'learning nature by heart', as Ingres put it, was essentially there to serve history painting. Its false equation triggered the decay. Reacting against it, Cézanne tried simply to seize an apple, thus making the apple into a heroic subject. The concept of a line as a line and nothing else then followed. Drawing turned back to ornament, to abstract design, then to outline again (Picasso, Matisse), away from the Renaissance and towards the Primitive or the Romanesque, with exceptions such as Schiele, in his last quintessential drawings of the years 1917–18, or Morandi in his etchings.

As a whole, art in the modernist era was an unprecedented inquiry into its own nature. The search for the transcendental, the invisible, in a way replaced the attraction of the visible, of nature. The term 'nature' in itself acquired an academic connotation; thus drawing somebody's appearance seemed not only absurd but doomed by the spell of kitsch. One tended towards an 'art by which non-optical impressions would become visible' (Paul Klee).[41] Although modernism disconnected seeing from drawing, nothing was uniform, as it was in other times of history. There was no longer a stylistic tyranny such as the Assyrian or Egyptian had been. However, a menacing veil hung between

[40] or *shih*, cf. Oswald Sirèn, *The Chinese on the Art of Painting*, New York, 1963, p. 154
[41] Paul Klee, *Das Bildnerische Denken*, Basel, 1956, p. 63

reality and art: transgressing it excluded the culprit from the avant-garde, from 'modernism'. André Breton is quoted as having said to Alberto Giacometti, who went back to working from life: 'Everybody knows what a head is.' The opposite is truer: each head is unique. The knowledge one can gain in drawing one head is useless in drawing another. Drawing from observation is an endless recommencement.

<p style="text-align:center">★ ★ ★ ★ ★</p>

In drawing from observation the line one draws is dictated by the sensorial-investigatory response to visual data. Thereby it escapes intentions rooted in previous experiences. Drawing from observation is precisely the process by which previously accumulated data is not applicable to a current subject. The previously accumulated data will prove to be a hindrance in drawing a new head. It will indubitably be noticed, as a parasite or an intruding virus is. The investigative observation of a given subject while drawing is a sort of a translation into lines following directions, i.e. angles. A grid can serve as an example, however simplified, of what actually happens between brain and hand, in transmitting – through the hand – visual data. In such a transmission any previous data will only be a 'bug', a disturbing parasite. The act of drawing from observation must therefore remain free of such parasites. This is why the perceptive investigation of how the forms of one head are consti-tuted will be of no help for another one. Only the sharpness of observation may increase, but so will the danger of interference. In other words, the accumulation of any previously acquired knowledge of a face or a figure has to be left behind the threshold of the present sitter.

The 'avant-garde' notion, which is a confusing factor in late twentieth-century art, perpetuates an old erroneous belief in the *Ideal*. It is a simplification of Plato's concept of the *Idea*, which held the highest rank, and Art the lowest. This discrepancy gave birth to the notion that art ought to *docere et delectare*, instruct and delight,[42] to the moralizing aim of art, and finally to the erroneous notion of Ideal Beauty, another formula for a fixed model. This belief in the Ideal still flows in the collective subconsciousness of the Western World. It is, although in disguise, subterraneously active: the very notion that art is there to 'instruct' rather than to move was dictated by the belief that Idea, i.e. ideology, is superior to feeling, the State (Church, Cause or Movement), superior to the individual. All of this is still at work within the

[42] Horace, *The Art of Poetry*, III, 33

prevalent confusion between modernity and innovation, uniqueness and novelty, experience and experiment. Innovation becomes obsolete but uniqueness remains timeless. Cézanne's *Apples* were never new, but unique. Mu-chi's *Six Persimmons* (thirteenth century, Kyôto, Daitokuji) appears new because it is unique. But inherited, fixed models are still haunting, because of an erroneous outlook on art, because of the confusion between painting and image. Has one forgotten that a painting or drawing is not simply an image? That its aim is to move, not to inform? Cézanne's *Quarry* (1895, Essen, Folwang Museum) wouldn't satisfy a topographer, a cartographer or a geographer. His tracking and tracing, his sifting truth by means of feeling and observation, exemplifies what working from observation is about. The result is a most subjective imprint – in a frequency which is as unique as saliva or fingerprints. Part of the mystery is due to the impetus by which all this occurs. Just like a grinder, the impetus transforms visual data by formulating it all inwardly, point by point, knotting together density, intensity, spontaneity, relative perfection of touch, coherence and veracity. This impetus ignites the frequency, the root of style, this hidden structure which I call *microform*. In painting the *Standing Peasant* (1895, Merion, Pa., The Barnes Foundation) or the *Bibémus Quarry*, Cézanne transformed man or mountain into painting, not by mere copying, but by his impetus, by what he called 'les sensations'. His main aim was to register them. His brushstrokes, his shapes, his 'plans colorés' are the idiom of his inner form, of his *microform* – the mark of his uniqueness.

The same pair of gloves painted by Velázquez or by Frans Hals are as different as the voices of two people uttering the same word. In order to achieve such a transformation a power is needed, not unlike the power of the wind rearranging sand into patterns. Such a power is scarce and not available at command. However, uniqueness does not necessarily provoke immediate recognition. Maybe because it cannot be recognized immediately because of mis-seeing.

It is interesting to note that the masterpieces of the past which stay constantly modern are those which were drawn from life. From the Pompeian double portrait of Terentius Neo and his bride to Titian's portrait of *Pietro Aretino* (1545, New York, Frick Collection), and from the portrait attributed to Domenichino of *Monsignor Giovanni Battista Agucchi* (York, City Art Gallery)[43] to Frédéric Bazille's *La Toilette* (Musée Fabre, Montpellier), for

[43] Attributed to Domenichino by Pope-Hennessy (1946) and dated by him 1621–3 (cf. Richard E. Spear, *Domenichino*, Yale, 1982, no. 76). But presumably painted earlier by Annibale Carracci; cf. Silvia Ginzburg, *The Burlington Magazine*, No. 1090, January 1994, pp. 4–14

example, there is a perpetually modern quality. A quality of uniqueness.

There are no rules in art. It is, like life itself, unpredictable, unless coerced into repeating a pattern. Drawing or painting from life, i.e. sensing and tracing while perceiving, is truly experimental when it is intensely subjective and sparked off at its highest velocity. However, it is a fragile quality which has no story to tell and vanishes, just as a spark does, if not recognized. Tyrannies (religious, political or of fashion) do not tolerate subjectivity. Such moments in history are recurrent and impose the *typical*, the collective style.

Should Plato reappear in our time, he would be struck by the fact that the notion of eternity has vanished. That instead of timeless Beauty, the notion of change masks the old hierarchy based on the old certitude that Idea is superior to Art, that Art should follow it. Now follows the idea of change which in its turn is the result of the constant multiplication of degraded replicas. The degraded replicas of art, of Velázquez or of Degas, distributed by the media, corrupted the gaze, weakened discernment and replaced timeless quality with the spark of change. The need for change is innate, so is that of permanent values, as long as the functions of the brain remain unchanged.

1987–9

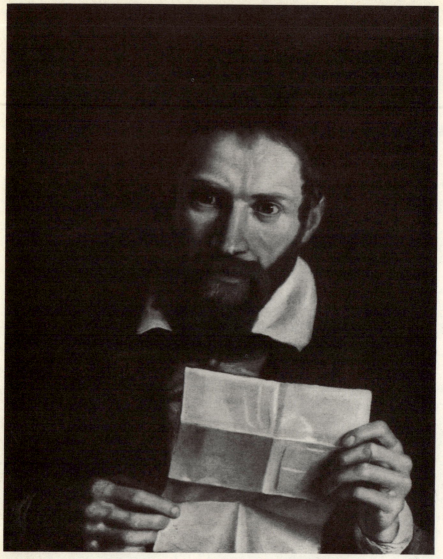

Domenichino(?), *Monsignor Giovanni Battista Agucchi*, 1621(?), oil on canvas, 60.5 x 46.5 cm. (York, City Art Gallery)

ON RED CHALK[1]

From Palaeolithic times onward, hematite [2] was used in art. In its amorphous state it was used for burials, or as a pigment for ritual make-up (Roman warriors powdered their faces with it before combat), as well as in fabrics, ships and architecture. But there is no extant drawing (except for *sinopias*) in red chalk prior to the fifteenth century. It is unknown whether there were red chalk drawings in antiquity. Hematite is frequently mentioned by the authors of antiquity,[3] but walls, boxwood, parchment tablets or papyrus, were not suitable for the conservation of drawings. Moreover, it is only after 1480 that fixative appeared. It ought to be emphasized that paper is doubtlessly the ideal support for red chalk drawing, permitting the extensive tonal possibilities of this medium.

The habit of scrawling, tracing and drawing with the tabular hematite on various supports probably began in the Western world in the workshops of goldsmiths, miniaturists, gilders and stained-glass craftsmen. Indeed, burnishers for gold were in antiquity, and still are, made of hematite, in the West as well as in the Far East. The value attached to a hematite burnisher was its age, because of its becoming smoother and more adhesive with time. Thus such a tool was precious and was transmitted, as in China, from father to son, from master to master or from one workshop to another. These burnishers, which Byzantine and Gothic painters used as well, for their gold backgrounds, were rare and expensive. We can imagine the disaster a broken burnisher represented. But it is undoubtedly in this way that this graphic medium was born: in point of fact, illuminated parchment manuscripts baring traces of guide-lines or inscriptions in red chalk, prior to the first drawings on paper, exist. The use of hematite in drawing follows the introduction of paper, and appears

[1] Notes for lectures given to the curators of the Cabinet des Dessins, Musée du Louvre, 1971

[2] Iron oxide, Fe^2O^3, tabular, reniform or amorphous. Ruddle, the most earthy variety of hematite, red in colour, is the one used in art.

[3] cf. Horace, *Satires,* II, 7, 88; Pliny, *Natural History,* XXXV, 31, 33, 36 and XXXIII, 115; Vitruvius, VII, 7

in the fifteenth century in Italy and in the sixteenth century north of the Alps. Up until then, what was used was the gessoed drawing tablet, *tabula busuli*, called *tavoletta*, derived from the *tabulis* of antiquity on which Greek children, pupils of Pamphylus, exercised. On these *tavolette* masters and apprentices drew with the metal stylus. It was customary for an apprentice to practise drawing on such a *tavoletta* – drawing and wiping off – for one entire year. Cennini tells us[4] how to prepare the tablet with bone white, as does Jehan Le Bègue in his manuscript dated 1431 (which gives a formula identical with that of Cennini),[5] but none of them mentions hematite as a drawing medium.

The metal stylus demands a perfectly smooth surface. The characteristic of lead, zinc, silver and gold stylus drawing consists in their pure, fluid and sharp line. Red chalk, on the contrary, doesn't leave a trace on an overly smooth support like that of wood or parchment. Its trace is apparent solely on rough paper surfaces like that of *carta bambagina,* which Michelangelo had such a predilection for, and which was later refined.

The first paper mills in the Western world go back to 1150 (Xativa, Spain); its usage in official documents was forbidden because of its fragility by Emperor Frederick II in 1221, but the paper mill Fabriano is mentioned in 1276, and 1293 marks the beginning of paper manufacturing in Bologna. But it was still not used by painters. Paper was not considered as noble a material as vellum. Cimabue and his followers, Fra Angelico and Jacopo Sellajo, only drew on parchment, considered durable and noble. It must also be added that pen drawing on *carta pecorina*, a thick and unsized paper, in fact blotting paper, was practically impossible. Parchment was more appropriate or, at least, *carta pecorina* primed with bone white. But the next generation, the one following Masaccio, already used paper. It was rag-paper, sized from 1400 on, notably with fish glue. This paper, which didn't blot, was ideal for drawing. But the new material demanded something other than the sharp metallic outline; it offered new graphic possibilities. The appearance of this drawing paper coincided with the first use of red chalk in drawing, driving drawing towards the painterly rather than the graphic quality. The sharp and wiry line-turns give place to a broad and tonal one. It hints at colour and nuance. It is actually this excess of nuance which will later bring about the *sanguine*'s decadence, a result of too much *pastosità, dolcezza* and *morbidezza*. But in the meantime –

[4] Cennino d'Andrea Cennini, *Il Libro dell' Arte*, ch. V
[5] Quoting Johannes Alcherius (1398), BN Ms. Lat. 6741; published by Mary Merrifield, in *Original Treatises on the Arts of Painting* [London, 1849], New York, 1967, vol. I, p. 274

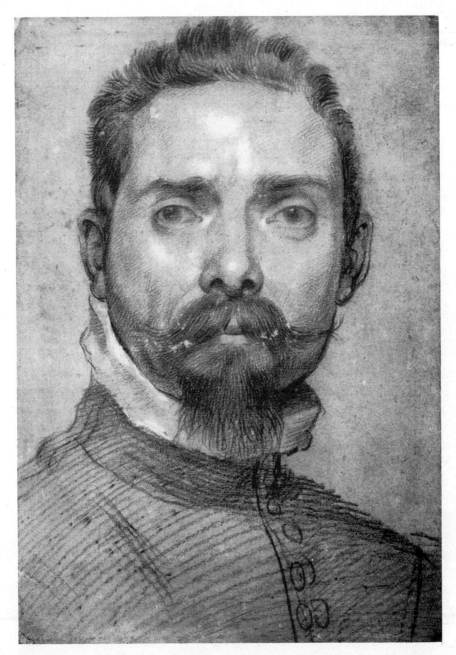

Annibale Carracci, *The Lute Player, Mascheroni,* before 1595, red chalk with white highlights on grey-pink paper, 40.7 x 28.1 cm. (Vienna, Albertina)

for three centuries – it was an inexhaustible drawing medium.

The paternity of *matita rosa* (red chalk) drawing is traditionally attributed to Leonardo.[6] In 1475, when his first red chalk drawing appeared, he was still in the studio of Verrocchio, who was also a goldsmith. It can be conjectured that a hematite burnisher fell and broke, and that its splinters were used by Leonardo in his drawing. His first red chalk drawings date from 1475–80. The use of red chalk was already widespread in Florence and its vicinity about 1503. Not in Umbria, though. In the Netherlands, as in Germany, *Rötel* was introduced after 1500, via stained-glass artists. However, it was not adopted by Venetian painters, although as colourists they should have used it. Titian and Tintoretto preferred *matita nera*, black chalk. Introduced into France by Primaticcio and other Italian artists working at Fontainebleau, as well as by Andrea del Sarto, who visited France in 1518, *sanguine* had Martin Fréminet and François Clouet among its first French adepts.

The manufacture of artificial red chalk *pierre rouge, pierre sanguine*, or even *vermilion* started in France about 1635. This artificial red chalk differs from the genuine tabular hematite by its mat and dry mark. Tabular hematite, on the contrary, leaves a dense and glossy mark.

Red chalk drawing accords with humanist ideas, going beyond the old concept of line as outline. It was then a new medium not turned towards antiquity but towards the immediate. It was a medium for drawing from life. It contradicted Cennino Cennini's notion that 'the poet . . . is free to compose . . . In the same way the painter is given freedom to compose a figure, standing, seated, half-man, half-horse, as he pleases.'[7] It is therefore no longer a question of drawing or painting pebbles in the studio and later enlarging them and calling them a mountain. Now it was the real rock and the real mountain that called. The living subject. The applied metallic line no longer held the attraction from which stemmed Pisanello's power. It was a new, spontaneous line which replaced it, doing away with the medieval craftsman's mark. This new anti-graphic medium, soft and saturated, gave birth to a new line, to new means of expression. However, the temptation of mixed media like pen-chalk, two-crayons, three-crayons, or red chalk-wash did away with the restrictive purity of the metal line. It was practised by Procaccini, Carlo Cigniani, Passari, then by Bloemart and Jacques Bourguignon. But the technique, mixing red and bistre chalk and wash, practised by

[6] Joseph Meder, *Die Handzeichnung ihre technik und Entwicklung*, Vienna, 1923, p. 122
[7] Cennini, *op. cit.*, ch. I

Leonardo, Carpaccio, Piero di Cosimo, Fra Bartolomeo and others, was inherent in the means, whence its purity.

Stylistic purity inheres in the singleness of the means, as for example Michelangelo's red chalk drawing called *Studies for the Head of Leda* (Florence, Casa Buonarroti) or Dürer's black chalk portrait of Erasmus (Paris, Musée du Louvre). This purity is a voluntary impoverishment, a restriction to a single means, pursued to its logical end, which then gives all its amplitude.

But the tendency to mix medias induced by the praxis of the possibilities red chalk offered, gave way, after the second half of the sixteenth century, to a more-than-drawing, a painting almost. It is with the technique of the three crayons, reaching the pinnacle with Rubens and Watteau, that its autonomy was imposed, as well as its divorce from the simple sketch, but also from stylistic purity.

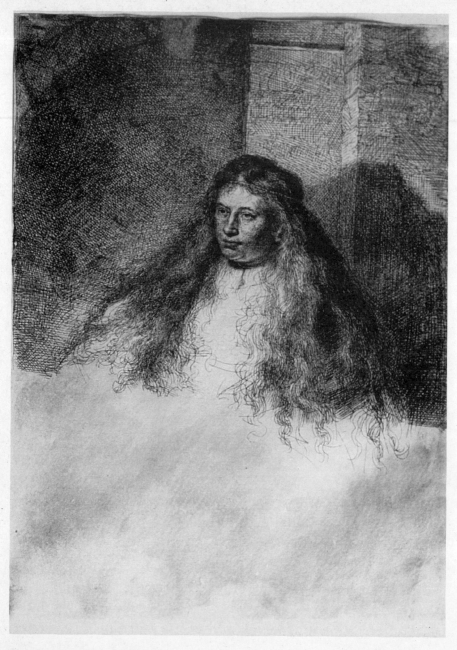

Rembrandt, *The Jewish Bride,* 1635, etching, 21.8 x 16.4 cm., second state of five (Paris, Musée du Louvre)

ON PRINTS[1]

Must one say it again? Art is not necessary if not needed. It is the urge to capture and, eventually, to communicate one's feeling for something seen in a perfect form, without which art is but artifice and whim. Without that need, all form-invention is only cerebral relocation. Need and urge are the two conditions without which a gifted painter cannot be a painter. A head, an apple, a tree or a piece of bread, can strike, command, and make the hand follow, by tracing and communicating the visual.

Mantegna's engravings, such as the first state (without halos) of the *Virgin and Child* (c.1485–91), Dürer's drypoint *Saint Jerome* (1512), Rembrandt's *Bush* (1652) or the second state of his *Jewish Bride* (1635), Degas' monotype *Le Foyer* (c.1880) move and stir us. Are they so stirring because of their linear language, stemming from the primordial incisions, which are the origin of drawing? They vibrate without artifice, in spite of the transfer from plate to paper. In fact, the art of the print is not simply a report from plate to paper: there is loss and inversion. Every engraving, etching or tracing on the plate, is modified by loss and inversion, which will ultimately determine a print's fate. But whereas the inversion can be foreseen, what cannot be foreseen are the modification by the bite, the nature of incision, the fullness or dullness of a lithographic line.

Modification, the factor of hazard, can be miraculous or disastrous – it gave birth to the devices and technical deeds which often jeopardized that direct expression which had been made possible by simplicity and purity of line. Without pure line, the trace of pure feeling, a print, being a multiple, wouldn't have much to multiply; but without the specific qualities of each technique, there wouldn't be any definite graphic language for engraving, etching or lithography. However, the particularity of the graphic language was recognized late. In Mantegna's time the print was seen only as a multiple, as a reproduction and no more. Slowly, the specific quality of the engraved line, as an idiosyncratic means of expression, attracted more and more painters. The connoisseurs followed after, developing the taste and

[1] Originally written in French for *Nouvelles de l'Estampe*, on the occasion of its 100th issue, Paris, October, 1988, p. 9

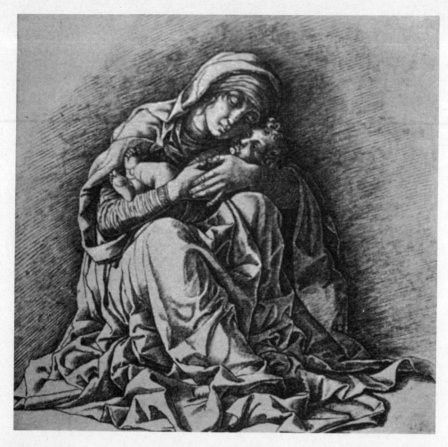

Andrea Mantegna, *Virgin and Child*, c.1480–5, engraving and dry point, first state of two, 21 x 22.2 cm. (Vienna, Albertina)

'connoisseurship' in prints, with an eye to the quality of impression, paper and state. At that time, it was improbable that a print collector would go to the print dealers of the rue Saint-Jacques without possessing the needed eye, taste and knowledge. Taste, flair and erudition need maintenance, in the same way a lawn needs continuous care.

ON DAVID'S *BRUTUS*[1]

I

A whole generation, among whom were Ingres, David d'Angers, Drouais, Fabre, Gérard, Girodet, Granet, Gros, Daguerre, Abel de Pujol, Riesner, Rude, Tieck, Wicar and others, was taught by Jacques Louis David (Paris, 1748–Brussels, 1825), the pictorial language such as it was was transmitted from master to pupil, from Raphael and Titian onwards. They were not, for all that, followers of a particular manner, but they carried on an encyclopedic vision of the world through art, which broke down after the 1830s, became routine know-how, and ultimately academicism. Thus, a betrayal of David's art and teaching.

David's natural inclination was portraiture and figure painting. But his ambition, ensuing from the belief in the hierarchy of genres, was history painting. His greatest portraits such as *Madame Trudaine* and *Madame Récamier* (both in the Louvre) or *La Marquise de Pastoret* (Chicago, Art Institute) are considered 'unfinished', in contrast with his more 'finished' history paintings. Indeed, David painted his portraits in one or only a few sittings. But he must have, as in the case of the portrait of *Madame Récamier*, or better, of his daughter *Emilie, baronne Meunier* (c.1810–13, San Francisco Fine Arts Museum), considered them as completed as *prima* paintings, in which the freshness and 'single stroke' execution is essential. David's pictorial idiom is marked by a minimal colour scale (inspired by Roman wall paintings) by which he attained an immense chromatic variety, expressed by a powerful and free brushwork. He was never slick, even in his 'finished' pictures, such as the *Sériziat* or *Monsieur et Madame Mongez* portraits (all three in the Louvre), or in his more ambitious compositions, of which *Brutus*[2] is probably the most moving.

[1] Originally written in French (without the introductory note) for *Rendez-vous en France*, December 1988; published in *Connaissance des Arts*, November 1989; translated into English by Anne Atik, in collaboration with the author, for *The Journal of Art*, vol. 2, no. 1, September–October 1989

[2] *Les licteurs rapportent à Brutus les corps de ses fils*, oil on canvas, 3.23 m. x 4.22 m. signed and dated on the lower left: *L. David f. bat parisiis anno 1789*. Exhibited at the Salons of 1789 and 1791. Collection Louis XVI, acquired in 1789. Paris, Musée du Louvre, INV 3693

The circumstances that led to the creation of this work and its subsequent critical fortune due to the role it played during the Revolution, especially after 1790, have been amply described and studied.[3] It was believed, as the Goncourt brothers (1858) summarized it, that this sombre subject of sacrifice for the State's sake had been chosen by David to express his revolutionary ideas. A belief still shared by some ingenuous Marxists best illustrated by Plekhanov's exhorting his pupils to go and bow before David's *Brutus* in the Louvre.[4] But, nothing is less certain. Did David attend the only performance of Voltaire's play *Brutus* on 25 January 1786? This play was revived in 1790 with its sets inspired by David's painting.[5] The subject was in the air, although the theme was quite rare in painting.[6] The Italian playwright Vittorio Alfieri published his *Bruto Uno* and *Bruto Secundo* in early 1789. The first of these plays was dedicated to Washington.[7] Hence David's choice is neither esoteric nor random. Its political significance was not yet evident at the outbreak of the revolution. The inscription on the verso of the canvas *ce tableau a été fait dans le tems* [sic] *de la révolution de l'année 1789* is without any doubt posterior. Does this reveal a desire to catch up? It was only after 1789 that David's revolutionary convictions were asserted. On the other hand, David's long letter to his pupil Wicar, then in Florence, dated 14 June 1789, proves that David saw his theme as only grave and noble, only as an *exempla virtutis*; there was not yet anything of political consideration. 'I am engaged in doing a new picture, wretched as I am . . . of my own invention', adding about the tragic subject of Lucius Junius Brutus which he had begun to paint: 'he is distraught with chagrin, at the feet of the statue of Rome, by his wife's screams and his eldest daughter's fright and fainting fit. It is beautiful to describe, but as for the painting I don't dare say anything.'[8] When it was exhibited at the Salon of

[3] cf. R. L. Herbert, *Brutus* ('Art in Context'), London, 1974. Thomas Puttfarken, 'David's *Brutus* and Theories of Pictorial Unity in France', *Art History*, vol. IV, no. 3, September 1981, pp. 291–304

[4] cf. Hugh Honour, *Neo-Classicism*, Harmondsworth, 1973, p. 71

[5] Antoine Schnapper, *David témoin de son temps*, Paris, 1980, p. 92

[6] It also inspired a drawing by Charles Eisen (engraved by L.C. Legrand), and a drawing by J.B. Wicar (1788, Lille, Musée des Beaux-Arts), after having been treated by, among others, Antonio Campi (before 1591, fresco, Rome, Museo Capitolo, Salla di Capitani), Rembrandt (1626, oil, also thought to represent 'Titus', Leyden, Stedelijk Museum), Paul Juvenel l'Ancien (1579–1643, oil, Nürnberg, Town-Hall).

[7] Schnapper, op. cit.

[8] J. L. J. David, *Le Peintre Louis David 1748–1825, souvenirs et documents inédits*, Paris, 1880

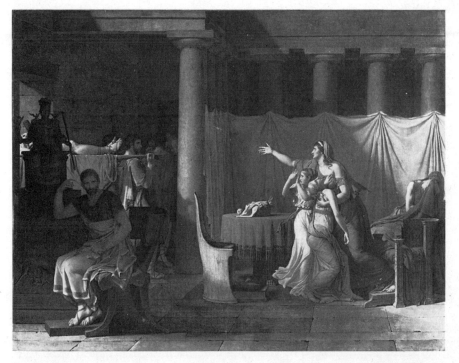

David, *Lictors returning to Brutus the Bodies of his Sons,* 1789, oil on canvas, 323 x 422 cm. (Paris, Musée du Louvre)

1789 neither his admirers nor his critics saw in *Brutus* the republican manifesto it later became, especially after its second exhibition at the Salon of 1791 and after the revival of Voltaire's play.

II

The Crown having commissioned a painting for the Salon of 1787, David proposed two subjects: *Coriolanus* or *Regulus.* The Count d'Angiviller's choice was *Coriolanus.* But David did not present anything at the Salon of 1787 and changed the subject to Brutus[9] – with or without d'Angiviller's

[9] Lucius Junius Brutus (Livy II: 4–5; Plutarch VI: 6) was the nephew of the last Roman king, Tarquinius Superbus, who raped Lucretia. She killed herself in the presence of her father and Brutus, with her knife put an end to the monarchy. With the founding of the republic Brutus was its first Consul. His sons, Titus and Tiberius, conspired to re-establish the monarchy. Brutus had them condemned and executed.

agreement. In a letter to Vien dated 10 August 1789, Cuvillier, the Count's clerk, does not express any regret that David's work will not be ready for the Salon.[10] The painting was none the less exhibited. The *livret* of the Salon specifies that 'this painting 13 by 10 feet is for the King; it will appear only at the end of the exhibition'. What a surprising reversal of circumstances: the King acquires a non-commissioned painting the subject of which will later become symbolic of the revolution. Moreover, David charges and obtains payment from the Crown.[11] Four years later, at a session of the Convention of 27 March 1793, it was stated: 'The citizen David illustrated Liberty with his brush with two masterpieces: *The Oath of the Horatii* and *Brutus*. The price of these two paintings composed for the Government was very inferior to their value because of royal avarice . . . Republics should be more generous toward truly republican works.' A supplement of 11,000 livres was asked for. But David had the good taste to refuse this offer.[12]

It is significant that in 1789 as well as in 1793 it is 'liberty' and not 'the republic' which is seen in David's *Brutus*. And yet, the image one had of this work evolved with events, notwithstanding David's original idea, which, apart from its meaning, looked for a subject which would permit him in terms of composition to leave the *Horatii* behind. But it is the 'mis-seen' rather than the misunderstood which hovers over this work. Delécluze,[13] at the end of his book, doesn't count *Brutus* among David's masterpieces (but only the *Horatii, Marat, The Sabines* and *The Coronation*). Tastes change. Although it was a revolutionary image for some, *Brutus* was relegated to the rank of anecdotic image by most of the modernists (with the exception of Matisse and Picasso), considered as academic and rejected by them together with all history painting. (And yet, *Guernica* is a history painting.) It's true that history painting as such calls for deciphering and decoding, not simply looking in delight as at a Chardin or a Cézanne fruit. It presupposes knowledge, which is

[10] Schnapper, op. cit.

[11] 'Memorandum of a painting made for the service of the King under the orders of Monsieur le Comte d'Angiviller, Directeur & Ordonnateur des Bâtiments de sa Majesté, by Le sieur David, the King's painter, during the years 1788 and 1789. This painting is 13 x 10 ft. It represents *Brutus, First Consul*, returning to his house after having condemned his two sons who had conspired against Roman liberty, and the lictors bringing back their bodies for burial. Estimated cost . . . 6,000 livres' (Archives Nationales, 01 1931)

[12] Fernand Engerrand, *La Chronique des arts et de la curiosité*, 1897, pp. 15–16

[13] E. J. Delécluze, *Louis David, son école et son temps, souvenirs*, Paris, 1855, p. 401

part of connoisseurship and which often doesn't take pictorial qualities of execution exclusively into account. Ultimately, history painting was appreciated less for its pictorial qualities and inventiveness than for the loftiness of its subject. Hence it was seen less as a source of visual emotion than as a moral lesson: Horace's *docere*. In getting rid of these ambitions under the false equations between subject-matter and painting, which resulted in bad history painting, in 'pompier', modernism's great sweeping-out left painting with its only attribute, which is painting. But *Brutus* is great history painting, in the true sense of the term: it is a complex and 'savant' composition. Now, history painting's aim was to instruct, to instruct and delight. What's curious is that *Brutus* doesn't instruct us as much as it moves us. It also fascinates us. By its economy, its logic, its harmony, its modernity. In spite of the fact that it is of a less free, less modern brush-work than, for example, the portrait of *Madame Trudaine* (*c*.1791–2, Paris, Musée du Louvre), *Brutus* is not less modern regarding its composition. This composition could have furnished Klee or Kandinsky with abundant material for reflection on the functioning of ambiguities between space and form, contrast and chromatic harmony, rhythm and balance.

Spontaneously, and without recourse to the formal analysis which we owe only to modernism, the public of 1789 reacted enthusiastically to David's work, but this triumphant reverberation wasn't shared by the academic establishment, for all that.[14] Indeed, J. B. M. Pierre, director of the Académie Royale and First Painter to the King, in visiting David in July 1789, criticized the painting because David placed 'the main figure in shadow', and added, 'Where have you ever seen a composition that is made without a pyramidal line?'[15] And it's precisely the fact of having placed *Brutus* in shadow which brought him such public adulation.

But David's great invention in this composition is not only the fact of hiding Brutus, it is also the fact of hiding the corpses, his sons' bodies, letting only their legs appear. In another letter to Wicar, still in Florence, and dated 17 September 1789, David writes: 'One praises chiefly the conception of having placed him in shadow, there is something Florentine in my *Brutus*.'[16]

[14] David in this regard: 'The academy is like a wig-maker's boutique, you can't come out without having your clothing whitened with powder . . . because they make a craft out of painting; as for myself, craft, I despise it like mud.' J. L. J. David, op. cit. , p. 57

[15] cf. L. Rosenthal, *Louis David*, 1905, p. 99

[16] Letter from David, Paris, Institut Néerlandais

And Girodet, who wasn't in Paris then, wrote to Gérard: 'Tell me if, as I hope, *Brutus* is the king of the Salon. I am sorry not to have seen him mount the throne and I believe he won't be taken down before my return.'[17]

David did not get to this magisterial composition straight off. The preparatory drawings illustrate its evolution. The two compositional sketches at the Musée Bonnat already show a division into two groups, but they still lack the tension prefigured in the two preparatory drawings at Albi (Musée Toulouse Lautrec) and Malibu (Paul Getty Museum). In these last two drawings there are none the less four additional figures, and the corpses of the two sons are still in full view.

III

The tragic and horrifying action is suggested without being depicted. Brutus is seated in semi-darkness, at the feet of the statue of Rome, afflicted; his wife, abruptly interrupted in her needlework by the sudden entry of the lictors carrying the corpses of her sons, screams in terror, her right arm outstretched; her two daughters cling to her, sinking in despair, while the overwhelmed servant in the corner is draped in pain. Composed on a single plane, like the antique frescoes, David abolished the horizon line, avoided the vanishing point as well as the point of station, and painted his figures, objects and background interacting on one plane. His composition does not attract the eye into depths nor into a dramatic chiaroscuro. The semi-darkness in which he placed Brutus is not a *sfumato*, but of a great tonal clarity, broken and darkened. The black spaces between the columns are not holes but forms; they function the same way the figures do. The space is divided vertically by the column placed at the harmonic intersection of the golden mean ($\sqrt{5}+1:2 = 1.618033989$); an invisible line is stretched horizontally between the corpses' legs at the left-hand side (also placed at the harmonic intersection), and the fingers of the mother's outstretched hand, igniting a current setting off the horizontal pull. This pull is amplified by the dark chording of the upper left-hand rectangle (of which the lower vector is defined by the legs), while from the other side of the column at the right, pulling in the opposite direction, the low chords of the four rectangles and a fraction of a large black rectangle reverberate (as an echo to the figure of

[17] Unpublished letter, Paris, Bibliothèque Doucet; Jean Adhémar, 'L'Enseignement académique en 1820. Girodet et son atelier', *Bulletin de la Sociétié de l'Histoire de l'Art Français*, 1933, p. 280

Brutus and the fraction of his sons' bodies on the left, mother, daughters, servant on the right). These chords ring like the bass in Beethoven, or like the blows of destiny.[18] Our sight is then guided from angles to curves, towards the convulsed group of the mother and her two daughters in the light (whose pose is inspired by bacchantes of Roman sarcophagi);[19] one is terrified, the other has fainted; the white undulating toga of the younger one underlines the cold vermilion of the table-cloth and the warm yellow ochre of her elder sister (fainted); in turn this red-yellow harmony underlines, by contrast, the servant's blue toga in the corner. Its oblique rhythm pulls to the right like a drawn bow; it's the principle counterpoint pulling towards the left in the composition. This figure whose quiet weeping we can hear is a brilliant invention.[20] It leads us to the upper left by an inverted triangle of a ray of light cast on the curtain drawn along the colonnade (a reminiscence of Poussin) of a soft grey, in counterpoint to the cold green shrouds on the left. In this atmosphere of dismay the eye finds a moment of respite: the peaceful sight of a spool of grey thread, and a lady's fancy-work in the basket. Grey on vermilion, a contrast of the everyday life in this terrible tragedy. This small still life, one of the most beautiful in the history of painting, breaks the heart. It is only then, in coming back from the lower part to the upper, across the furniture (which David designed for the cabinet-maker Jacob in order to be able to paint it from observation), we discover the figure of Brutus, of which only certain parts are painted from life: arms, legs, drapery. The head was painted from a cast copy of an antique bust called *Lucius Junius Brutus* (Rome, Museo Capitolino),[21] which David believed to be the effigy of the first Consul (also copied by Piranesi, 1761) but which in fact it wasn't. For reasons of verisimilitude, David could not have someone pose for Brutus and

[18] The use of black was criticized even by such a friend as Cochin. In a letter to Jean-Baptiste Descamps, apropos of the Salon and dated 20 October 1789, he wrote: 'Monsieur David has two paintings, one, large, of Brutus in his affliction after having sacrificed his two sons. It is very beautiful, very important and of a most careful execution. The only thing I reproach him with is to have fallen in to his old black system.' C. Michel, *Archives de l'Art Français*, vol. XXVIII, 1986, p. 88

[19] cf. letter to Wicar of 14 June 1789

[20] A preparatory squared drawing for this figure is at Tours (Musée des Beaux-Arts). Only nine preparatory drawings for this painting are known.

[21] David was in possession of this copy which in 1790 he lent to the theatre for the performance of Voltaire's play mentioned above; cf. Herbert, op. cit., pp. 76–7

paint him from life. The stone model is unfortunately sensed here. It doesn't vibrate as strongly as those of the mother, the daughters or the servant, all painted from life. Full of life. Of feeling. 'Feeling and drawing, these are the two real masters that teach one how to move the brush. No matter if your hatchings are from the right, from the left, from top to bottom, up and down or to and fro.' [22]

[22] David, Letter of 14 June 1789 to Wicar

JEAN-AUGUSTE-DOMINIQUE INGRES[1]

'Car j'use de la musique . . . J'en ai autant besoin que
pouvait en avoir Saül pour sa guérison' [2]

In August 1897, Degas made the pilgrimage to Ingres' birthplace, Montauban.[3] As Henry Lapauze put it,

> Ingres was his god, practically his preoccupation. He loathed those who wrote on art, and it seemed to him that to explain the masters was to betray them. 'If ever these drawings at Montauban are published, I'll be there,' he said. It is a great pity that Degas never followed through with this project, for the sake of which he even solicited the Montauban town council. It would have been a rare treat to have Degas, pen in hand, comment on Ingres' drawings.[4]

'History painter, pupil of David,'[5] as Ingres described himself,[6] it may be in spite of his ambitions that he remains such a great portrait painter. He did not

[1] Introduction for the exhibition catalogue, originally written in French 1979–80 (*Ingres, Cinquante trois Dessins sur le Vif du Musée Ingres et Musée du Louvre*, French and Hebrew, Israel Museum, Jerusalem, 1981); second version for the Musée des Beaux-Arts, Dijon, 1981. Translated into English with the invaluable help of my wife Anne Atik-Arikha, then revised and expanded, between 1983–5, for the exhibition I curated at the Museum of Fine Arts, Houston, 1 February–16 March 1986, and at the Frick Collection, New York, 6 May–15 June 1986 (*J.-A.-D. Ingres, Fifty Life Drawings from the Musée Ingres at Montauban*, Houston, 1986, 120pp). The entries, lists and bibliography are not included here.

[2] Ingres, letter to Gilibert, 15 March 1831

[3] *Lettres de Degas*, published by Maurice Guérin and Daniel Halévy, Paris,1931

[4] Henry Lapauze, 'Ingres chez Degas', *La Renaissance de l'Art Français et des Industries de Luxe*, Paris, March 1918, pp. 9–15

[5] David wrote on 22 June 1820, from his exile in Brussels, to his former pupil, Baron Gros: '. . . give up trifling subject matter and finally get down to beautiful history painting' (p. 46), following the belief that art can and should 'instruct and delight'. That 'a flower or a landscape have no effect on behaviour' was stated at the *Société Républicaine des Arts* in the month of Germinal, year II (March–April 1794),

153

paint any still lifes or landscapes, apart from the tondo *Raphael's Casino* (1806–7, Paris, Musée des Arts Décoratifs). There are two others, that are questionably by his hand: *The Belvedere of the Villa Borghese* and *The Aurora Casino of the Villa Ludovisi* (both 1806–7, and both in Montauban, Musée Ingres).

In his portraits,[7] 'he pursues the soul down to the slightest ripple of the skin', Delécluze wrote about him.[8] Ingres was engaged in this 'pursuit of the soul' from the very beginning, in his marvellous portraits of the Rivière family (1805, Paris, Musée du Louvre), but his singular formulation did not take final shape until he was in Rome, beginning with the portrait of *Madame de Senonnes* (1814–16, Nantes, Musée des Beaux-Arts). What is striking in Ingres' portraits is the accord between *resemblance* and *representation*. Ingres seems to abide very closely by the principles on which history painting is founded, namely *reduction* and *transposition*. Indeed, each of his portraits is conceived as a metaphor, the better to generalize. The portrait had to become *heroic*, the resemblance undergoing a 'total transfiguration';[9] Ingres was not

where the request was put forward that Flemish paintings that 'had no meaning for the soul or spirit' be banned from the museum. David's pupils J. B. Wicar and J. Lebrun also asked the *Société* to send genre painters back to the *Manufacture* (p. 44); cf. François Benoît, *L'Art Français sous la Révolution et l'Empire – Les doctrines, les idées, les genres*, Paris, 1897, reprint, Geneva, 1975

[6] *'Peintre d'histoire, élève de David'*, Ingres, Notebook X, folio 4. There are ten Ingres notebooks, composed chiefly of excerpts from books, notes, bibliographies, ideas for paintings, lists of his works and addresses. Notebook IX contains his *Notes et Pensées*, first published by Delaborde, 1870

[7] The *portrait*, then, was outside the idea of beauty and the picturesque. 'It's a considerable waste of time, the efforts fruitless, because of the dryness of the matter, which is really anti-beautiful and anti-picturesque, and also, because you get so little out of it,' wrote Ingres to his friend Gilibert on 27 February 1826. He contradicted himself by also telling Gilibert: 'You know how I love to make portraits' (30 December 1843). And the contrary again: 'Cursed portraits! They always stop me from going on to great things that I can't get to do faster, a portrait is such a difficult thing!' (letter to Gilibert, 24 June 1847). It is evident that he loved it. What stopped him was not his natural inclination, but the ambition to be above all a history painter, in conformity with the hierarchy of genres still prevailing, even among the Romantics. Moreover, Ingres wished to escape the restraints of commissioned portraits placed on him, and 'henceforth get my inspiration from myself' (letter to M. de Guisard, Directeur des Beaux-Arts, 20 October 1851).

[8] Etienne-Jean Delécluze, *Louis David, son école et son temps, souvenirs*, Paris, 1855, p. 393

[9] Benoît, op. cit., 1897, p. 38

following idealist theory for which 'the word portrait is exactly the opposite of what is meant by ideal'.[10]

Did he really believe that 'essential forms of a general type are substituted for accidental ones'?[11] His portraits, based on absolute likeness, contradict this view. Ingres wrote that 'the history painter renders the species as a whole, whereas the portrait painter represents only the individual, that is, a subject who is often plain, or who has many imperfections',[12] and these lines seem to agree with Quatremère's view according to which 'the main procedure for the *mode idéal* is that one by which the artist generalizes'.[13] But Ingres seems to adhere to the idealist theory only partially, for his predilection for portraits – 62 oils and about 456 portrait-drawings – leads him toward the particular, towards that which is most singular in a face, as opposed to the theory of *le beau idéal*. He writes: 'Really to succeed at a portrait, first of all one has to be imbued with the face one wants to paint, to reflect on it for a long time, attentively, from all sides, and even to devote the first sitting to this.'[14] This conflicts with Quatremère de Quincy (1755–1849), who stipulated that one must 'de-compose the elements of a subject in order to recompose it into a system of abstraction'.[15] (That was also Baudelaire's opinion: ' . . . true portraits, that is to say, the ideal reconstruction of individuals.')[16] But the dispute is only an apparent one, for Ingres says this, too: 'The secret of beauty has to be found through truth. The ancients did not create, they did not make, they recognized.'[17]

This *recognition* seems to have had a double meaning for Ingres: that of truth, of a unique and individual truth, but in the sense of perfect form, of beauty. The quest for *beauty through truth* led him to weep in the presence of his

[10] Antoine-Chrysostome Quatremère de Quincy, 'Essai sur l'Idéal dans ses applications propre aux arts du Dessin', in *Archives Littéraires*, 1805, reprinted Paris, 1837, p. 50

[11] ibid., pp. 219–20

[12] Ingres, *Notes et Pensées*, cf.Henri Delaborde, *Ingres, sa vie, ses travaux, sa doctrine – d'après les notes manuscrites et les lettres du maître*, Paris, 1870, p. 153

[13] Quatremère de Quincy, op. cit., p. 191

[14] *Notes et Pensées*, cf. Delaborde, 1870, p. 153

[15] Quatremère de Quincy, op. cit., p. 252

[16] ' . . . des vrais portraits, c'est-à-dire, la reconstruction idéale des individus' (Baudelaire, 'Le Musée classique du Bonne-Nouvelle', in *Le Corsaire Satan*, Paris, 21 January 1946)

[17] 'Il faut trouver le secret du beau par le vrai. Les anciens n'ont pas crée, ils n'ont pas fait; ils ont reconnu.' *Notes et Pensées*, Delaborde, 1870, p. 117

model. 'You can only get a respectable result in art by weeping,' he said.[18] He was often, very often, desperate, and cried like a child in front of the canvas, according to Amaury-Duval, who goes on to recount Ingres' reaction: ' "It's very bad – I don't know how to draw any more . . . I don't know anything any more . . . A portrait of a woman! Nothing in the world is harder, it's not feasible . . . I'll try again tomorrow, for I'm starting it afresh . . . It's enough to make one cry." And the tears actually came to his eyes.'[19] His smoothly painted surfaces were the outcome of successive battles, the first one of which was the study from nature. 'One has to compose like Raphael, that is to say, adopt his manner of going about it, which was to compose with nature and to concern himself even in a composition of one hundred different figures, only with the main ones, as if there was no question of the others.'[20] But the concern for beauty constituted his horizon. He believed, if not in the *beau idéal*, at least in the sublime, and the term 'sublime' weaves through his letters like a filigree, amplified with years. (*The Turkish Bath* is actually an idealist painting.) Though not a theorist, Ingres knew theory and formulated his paintings with absolute rigour. He said of his *Jupiter and Thetis* (1811, Aix en Provence, Musée Granet), in a letter to Forestier, that the 'ambrosia had to be smelled from a mile away',[21] and we know how much research each of his paintings entailed. But what is also noteworthy is that his portraits, too, are conceived of as history paintings, not only in that *resemblance* coincides with *representation*, but because their formulation is also presented as an abridgment, or a sort of metaphorical snapshot. For example, *Monsieur Bertin* (1832, Paris, Musée du Louvre): Ingres waited two years before his sitter struck the right, unhoped-for but long awaited pose. They were having coffee outdoors after dinner in Bertin's country house at Bièvre, Les Roches; Ingres suddenly got up, approached Monsieur Bertin, and whispered in his ear, 'Come to the sitting tomorrow your portrait is done.' This is what Bertin himself told Amaury-Duval.[22] The portrait was painted at Les Roches and Ingres came

[18] ibid., p. 114

[19] Amaury-Duval, *L'Atelier d'Ingres* [1878], Paris, 1924, p. 33

[20] Ingres, note on an undated sheet (Montauban, Musée Ingres), cf. Lapauze, *Ingres, sa vie et son oeuvre*, Paris, 1911

[21] From Rome, 25 December 1806, cf. Henry Lapauze, *Le Roman d'Amour de M. Ingres*, Paris, 1910, p. 73, and Lapauze, 1911, p. 77

[22] ' "Venez poser demain," me dit-il, "votre portrait est fait," ' Amaury-Duval, 1924, p. 97. See also Delaborde, 1870, pp. 245–6.

out there every day, sometimes with Victor Hugo.[23] There is something unique in this pose, urgent, but also a sort of metaphor of the person as seen by the painter: wisdom, symbolized by the white hair, which is the dominant feature of this austere painting.

We find a like formulation in all of Ingres' portraits: *Madame de Senonnes* (1814–16, Nantes, Musée des Beaux-Arts) seems to incarnate luxury, *Madame Gonse* (1852, Montauban, Musée Ingres), austerity. The luxuriant red-yellow chromatism in the *Madame de Senonnes* is the antonym of the cool and austere black-green-violet chromatism of *Madame Gonse*, epitomized in the limpid purity of her blue eyes. The violet in the portrait of Mme Gonse is different from that used in the portrait of *Madame Moitessier Standing* (1851, Washington, National Gallery), though akin. The chromatism in the standing portrait of Mme Moitessier, black-green-violet-pink, differs. Violet dominates, vibrating in the ornaments appearing and disappearing on the wall, and it governs the whole upper part of the painting, determining its proportion. It is balanced by the black of the dress, the echo of which is repeated in the hair. And there again, a miracle: the roses in the hair re-echoed in the ornaments of the violet wall and again in the flesh tints, make a double-rhythmed echo in the tones of both sides of the face. Without these flowers the portrait would not hold. As to the metaphor, that is also apparent: the rose, an attribute of Venus; the fan, the gloves and evening dress, are attributes of a *femme du monde*; the whole united in the person of Mme Sigisbert Moitessier (née Marie-Clothilde Inès de Foucauld) with whom Ingres, according to Lapauze, was slightly infatuated and painted twice (*Madame Moitessier Seated*, 1852–6, London, National Gallery). About a first version, started in 1844–5 and destroyed, Théophile Gautier wrote: 'Never has a beauty more regal, more superb, and more Junoesque lent her proud lines to an artist's trembling pencil.'[24] Ingres approached his subject, then, history or portrait, in the same way. The subject was individualized and at the same time, through iconography, generalized.

For until he got old, Ingres never abandoned the *beau sensible* for the sake of the *beau sublime* as propounded by the idealists, and in this sense he is not an idealist trying to create imaginary figures, imitating nature 'without a model',

[23] Madame Victor Hugo, *Victor Hugo raconté par un témoin de sa vie* [III], Paris (without date), pp. 89–92; cf. Hans Naef, *Die Bildiniszeichnungen von J.-A.-D. Ingres*, Bern, 1979, vol. III, p. 121
[24] 'Jamais beauté plus royale, plus superbe et d'un type plus junonien n'a livré ses fières lignes au crayons tremblants d'un artiste', cf. Lapauze, 1911, p. 441

in the conviction that 'the ideal, understood in its true sense . . . really produces a copy of no one'.[25] For Ingres, 'art never succeeds better than when it is hidden'.[26] However, that changed during the last years of his life. A pertinent example of this shift is his *Venus at Paphos* (1858, Musée d'Orsay), which was painted from a drawing by Paul Flandrin of the beautiful Madame Balay, done on the same occasion as when his brother, Hippolyte, painted her (1852, Paris private collection). The painting, which remained unfinished, is a transformation into colour from a robed woman into a disrobed one. Its background landscape was painted by Ingres' pupil Alexandre Desgoffe (1805–82). Ingres' painting was first discovered by Hans Naef.[27] *The Turkish Bath* was also entirely painted from drawings, but, at least, they were his own.

He was violently opposed to theory. Romanticism seemed baneful to him, but so did '*le beau idéal*, an extremely subtle term, ready at hand for elocution, but false, erroneous, equivocal, one that has caused the arts more harm than Pandora's box scattered over earth'.[28] This was Ingres' retort to Quatremère de Quincy, perpetual secretary of the Académie des Beaux-Arts.

The Romantics had the same reaction against *perceptible beauty*, substituting for it *moral beauty*.[29] 'The nude was proscribed, beauty rejected, and subject matter from the Antique totally condemned.'[30] In about 1816, 'this revolution in the arts was as sudden and complete as is, in a state, the passage from monarchy to popular government.'[31] Perceptible beauty was false and ridiculous, and, in the opinion of the Romantics, the only meaning of 'classic' was 'false', 'worn out'.[32] The theory of the *beau idéal*, which, too, reflects perceptible beauty, is only a shade different from Romantic theory: ideal style

[25] 'L'idéal, entendu dans son vrai sens . . . donne réellement la copie de personne', Quatremère de Quincy, op. cit., p. 56. The classic illustration of the ideal portrait is the one Zeuxis is said to have painted, composed of the most beautiful parts of the five most beautiful maidens of Agrigentum, in order to obtain the portrait of Helen. Cf. Pliny XXXV, 62–5

[26] 'L'art ne réussit jamais mieux que quand il est caché', *Notes et Pensées*, cf. Delaborde, 1970, p. 117

[27] Hans Naef, 'Zuwachs zum Werk von Ingres', *Pantheon*, July–September 1979

[28] Ingres, in a letter to Raoul-Rochette, 1 May 1827, cf. Lapauze, 1911, p. 272, and Hans Naef, 1979, vol. III, pp. 89–91

[29] Delécluze, op. cit., pp. 383 and 389

[30] ibid., p. 384

[31] ibid., p. 376

[32] ibid., p. 388

Ingres, *Studies of an Eagle, c.*1811, graphite, 19.9 x 16.5 cm.
(Montauban, Musée Ingres)

is 'abstract in essence'.[33] But this shade of difference is of major importance because the Romantics, who insisted on substituting the moral for the physical, limited it only to subject matter. It was not a question of a change of form. In the realm of the ideal, 'forms and proportions are not the image, but the equivalent of what is familiar to us'.[34] The idealists believed that there was no metaphor without metamorphosis. They believed in a cerebral perception of art. As Benoît, paraphrasing Quatremère, puts it: 'The idealist artist forces the viewers of his "new world" to change their way of looking, to modify their perception of things, to transpose it from the eye's sensory function to the spiritual faculty of understanding'; Quatremère believed that 'the notion of the ideal is not necessarily linked to that of beauty in the realm of the senses, since it is possible for there to be an ideal ugliness and an ideal hideousness'.[35]

Quatremère de Quincy's Winckelmanian ideas on art were published at the same time as their antithesis by Toussaint-Bernard Eméric-David (1755–1839) who, though talking about sculpture, expressed views that concerned painting as well:

If an artist works without a model in front of him, what is his guide? Recollection; there can be nothing else . . . The artist who accustoms himself to this misleading guide thinks he has got hold of *le beau idéal*, because a certain phantom he takes to be the model for that preternatural beauty remains present in his imagination, and what he has really learned is only to see beauty in one single form. In all his compositions, his hand routinely represents the cherished idol his spirit formed. Eventually he stops being aware of the value of truth; he stops looking for it. Confronted with a live model, he will not know how to express its features: he has lost the ability to do so. He thought he was freeing himself from the servitude of imitation but, on the contrary, he has put shackles on his genius.'[36]

33 *D'essence abstraite*, Quatremère de Quincy [1805], 1837, p. 34
34 'Les formes, les proportions ne sont pas l'image, mais l'équivalent de celles qui nous sont familières', Benoît, 1897, p. 32
35 Quatremère de Quincy [1805], 1837, p. 34
36 T.-B. Eméric-David, *Recherches sur L'Art Statuaire considéré chez les Anciens et chez les Modernes ou Mémoire sur cette question*, Paris [1805], 1863, pp. 182–3; this work was awarded the Prix de la Classe de Littérature et Beaux-Arts of the Institut National during its session of 15 Vendémiaire, year IX (17 October 1800)

Géricault could not have formulated this crucial problem more clearly. Manet and Cézanne could have signed it. But had any of them read these lines? *Le ressouvenir* (obsolete for recalling) is the root of evil; no doubt, Caravaggio, Velázquez, Rubens and Rembrandt knew this to be so. However, this knowledge, the painter's knowledge, is not theoretical. It is visceral. Felt from within, often lacking the words. Painting is mute.

The rules of generalization, regularity, simplification and strictly mathematical proportions were familiar to Ingres, but he could not subscribe to a theory that excluded 'small truths of detail' or forbade 'rendering flesh and muscles, living flesh or the skin's moistness'.[37] Ingres was a 'lover of nature' as Amaury-Duval puts it. In his work, rendering of detail is of major importance. Look at the portrait of *Madame Marcotte* (1826, Paris, Musée du Louvre): the sensuality of her lips, her pristine skin, her hair, the softness of the fabric, the marvellous eyes, two small circles, bringing all the curves to a close (metaphor of sensuality). Moistness and penumbra dominate this painting all in curves underlined by burnt sienna ('brown-red, a colour come down from heaven'),[38] yellow and grey. But to achieve this perfect formulation in the portraits as well as in the history paintings, Ingres first drew, going from one study to another, sometimes even using several different models for the same portrait – a disharmony he was obviously not yet aware of: the hands in the portrait of Mme Marcotte don't seem to be her hands, but rather the hands of Madeleine Chapelle, Ingres' wife. This fact is not documented, though noticeable. The reason must have been that Mme Marcotte, a frail and sickly person, had difficulty in posing.

The greatest number of studies Ingres made were for the history paintings *The Vow of Louis XIII* (1824, Montauban Cathedral), *The Martyrdom of St Symphorian* (1834, Autun, Cathedral of St Lazare), *Antiochus and Stratonice* (1840, Chantilly, Musée Condé) and, especially, for *The Golden Age* (1842–9, unfinished, Château de Dampierre).

The study is the drawing. 'Drawing is the probity of art. Drawing contains everything except colour.'[39] But Ingres does suggest colour in his drawing, especially in those portraits that he called *portrait-drawings* and which constitute

[37] Quatremère de Quincy, op. cit., p. 35

[38] Ingres, quoted by Amaury-Duval, op. cit., p. 200

[39] 'Le dessin est la probité de l'art. Le dessin contient tout, excepté la teinte', Ingres, *Notes et Pensées*, cf. Delaborde, 1870, p. 123

a separate body of his work. Already in the portrait-drawing of *The Forestier Family* (1806, Paris, Musée du Louvre) colour is suggested by the variety of tone obtained by multiple graphic means: line, dot, stump. These means became reduced with time, getting more and more simple. Simplification is not expressed by a slackening off or by liberties taken with reality, but by attention to special features and by an interiorization of technical means.

Ingres found his style very early and all at once. He was to stay with it all his life. The change that takes place between the drawing of *Lucien Bonaparte* (1807, New York, Herring Collection) and the *Paganini* (1819, Paris, Musée du Louvre) or *Monsieur Leblanc* (1823, Paris, Musée du Louvre) is only a matter of degree; it is only a passage to more fluidity – even though, on the other hand, the portrait of *Madeleine Chapelle* (1814, Paris, Musée du Louvre) is more fluid and vibrant than the one of her from 1830–5 (Montauban, Musée Ingres).

The portrait of *Delécluze* (1855, Cambridge, Mass., Fogg Art Museum), for example, is purer in style than the portrait-drawing of *The Forestier Family* because it is expressed with line only. The graphic means employed there are not mixed or various: no point, no stump, no hatchings in combination. There is nothing but the single line and a minimum of hatching, less systematic than when he first began but also less rhythmical than in the portrait of *Mrs Vesey and Her Daughter Elizabeth, Lady Colthurst* (1816, Cambridge, Mass., Fogg Art Museum). In this portrait Ingres performed wonders with oblique rhythmical lines, like staccato in counterpoint. It is there that the mixed technique appears as fully justified as a musical ensemble of different instruments: there is something Mozartian in this drawing. This is not surprising. Ingres was a professional musician, haunted by Gluck, Haydn, Mozart, Beethoven. (Yes, Beethoven, as early as that!) Fanny Mendelssohn (Felix's sister) wrote about Ingres on 8 December 1839: 'You know that he is a great violinist before the Lord.'[40] What is characteristic and distinctive in an Ingres drawing is not its elegant virtuosity but rather its musicality, of which his line is a trace. 'Ingres is not only a great painter, he is also an excellent musician, sensitive to all the beauties of melody and harmony, taking part in a quartet as though, instead of brush and palette, his hand had learned to hold nothing but a bow.'[41]

[40] 'Ihr wisst dass er ein grosser Geiger vor dem Herrn ist', Tagebücher, Hensel 1921, p. 105

[41] Fromental Halévy, 'Ingres chez Cherubini', *Revue et Gazette Musicale de Paris*, 23 July 1841, pp. 349–51

Ingres, *Portrait of Mrs Vesey and Her Daughter Elizabeth, Lady Colthurst*, 1816, graphite, 29.9 x 22.4 cm.(Cambridge, Mass., Fogg Art Museum)

Drawing is an immediate trace marking the slightest eddy of feeling, provoked by perception. To seize the unattainable *other* by the inexpressible *self* – that has always been its aim. More than painting, drawing –once it achieves this miracle – remains *closer to the soul* (as song did for Aristotle) than any other means of expression. 'If I could make you all into musicians, you'd be better painters. In nature all is harmony; a bit too much, a bit too little will shift the scale and strike a wrong note. You have to sing in key with a pencil or brush as well as with the voice; rightness of forms is like rightness of sounds.'[42] Timeless in their perfection, but within time in their truth, Ingres' drawings are unique in the history of art. They rank with those of Pisanello, Holbein and Raphael 'in their blend of extreme facility and firm exactitude, the deliberate unfinished state of certain parts setting off the careful execution of others; in short, the perfect harmony between the approximate and the absolutely defined'.[43]

The corpus of Ingres' drawings consists of studies, mainly for paintings, history drawings such as *Homer Deified* (1840–65, Paris, Musée du Louvre), and portrait-drawings, which are autonomous works. It is in his studies that Ingres is at his most spontaneous. They are a sort of intimate journal, the contents of which he did not want divulged. 'I am not a niggling maker of sketches or drawings . . . So, when I make studies, whether on paper or canvas, they're meant chiefly to serve me and not to be cabinet displays.[44] But at the same time he was conscious of the fact that 'everything imitating nature is a work of art' and that 'this leads to everything'.[45]

Ingres' portrait-drawings are unique in the history of art in so far as their finished nature, expressed through black and white, is a composite of light, shade and tone. They are far from being in the chiaroscuro tradition. But they did not spring forth in a void. In 1790, Jacques Conté succeeded in mixing graphite (which had been in use in its pure form since the sixteenth century) with clay, thus obtaining a range of gradations from soft to hard, calling it 'plombagine' (after the traditional *plumbago* or *piombino*, though it was not lead, but graphite). The new medium took at once. At the same time, the number

[42] Ingres, *Notes et Pensées*, cf. Delaborde, 1870, pp. 123–4

[43] Henri Delaborde, 'Les Dessins de M. Ingres au Salon des Arts Unis', *Gazette des Beaux-Arts*, vol. I, 1861, pp. 257–69; also quoted in Charles Blanc, *Ingres, sa vie et ses ouvrages*, Paris, 1870, pp. 44–5

[44] Letter to Gilibert, 15 June 1821

[45] 'Toute chose imitée de la nature est une oeuvre . . . cette imitation mène à tout', Ingres, letter to Gilibert, 24 December 1821

of highly finished drawings, generally in mixed media – graphite or black chalk, pen and wash, black and bistre – exhibited at the Salon between 1796 and 1798 doubled, and between 1800 and 1808 increased sevenfold.[46] The critics were enraged at this 'painting with pencil' ('*peindre avec le crayon*') mania, considering it exclusively the domain of poor talents.

The total of Ingres' portrait-drawings, according to Hans Naef,[47] comes to about 456 drawings known to date (Delaborde, 1870, mentions only 300). But the final number will probably never be known, for there is no counting all the tourists who came to his studio in Rome to have their portrait done during his difficult years, after the collapse of the empire, between 1815 and 1817. The greater portion of his portrait-drawings, commissioned or done in his period of financial need, date from before 1824, the year of Ingres' first triumph. (Hans Naef numbers 280 drawings for the first period and about 170 for the second.) Ingres loathed commissions, although on the other hand he loved drawing his friends. According to Raymond Balze[48] a portrait-drawing took him 'four hours, an hour and a half in the morning, then two and a half hours in the afternoon, he very rarely retouched it the next day. He often told me that he got the essence of the portrait while lunching with the model, who, off guard, became more natural.'[49] He drew his portraits mostly with graphite, at first using a variety of techniques – hatching, dotting, and even stump – evolving quickly to greater economy, using only line and hatching, alternating between harder and softer gradations, the hardest being 'good firm English 3H pencils'.[50] But he always used a sharp point, sometimes even a chisel-shaped tip,[51] which enabled him to vary the thickness of the line and to shift from thin to broad, as in music. He often used means less austere than the 3H graphite, above all in his studies, for such details as *Monsieur de Pastoret*'s jacket (*c*.1822–3, Montauban, Musée Ingres), or *Madame Moitessier*'s left arm (*c*.1851, Montauban, Musée Ingres): black chalk, black crayon – often with stump and white

[46] Benoît, op. cit., 1897, p. 419

[47] Hans Naef, *Die Bildniszeichnungen von J.-A.-D. Ingres*, 5 vols, Bern, 1977–80

[48] Raymond Balze, *Ingres, son école, son enseignement du dessin par un de ses élèves*, Paris, 1880

[49] cf. Henry Lapauze, 'Raymond Balze. Notes inédites d'un élève d'Ingres', *La Renaissance de l'art français et des industries de luxe*, Paris, May 1921; also cf. Naef, 1977, vol. I, p. 18

[50] Boyer d'Agen, 1909, p. 419

[51] Marjorie Benedict Cohn, *Ingres Centennial Exhibition*, Technical Appendix, Cambridge, Mass., Fogg Art Museum, 1967

highlights, very seldom wash. These studies make up a separate corpus in Ingres' work, even though they represent a first step to the finished work. There are thousands of studies, a great part of which are at Montauban. There are about 100 studies for the *Vow of Louis XIII*, more than 200 studies for *The Martyrdom of St Symphorian*, about 300 preparatory drawings and studies for *Antiochus and Stratonice*, 80 known studies for the portrait of *Madame d'Haussonville* and about 500 for the unfinished *Golden Age*. Included in the approximately 4,000 studies at the Musée Ingres are notes, small sketches, copies, tracings, and drawings by Ingres' pupils and friends, not yet clearly identified. It is in them that Ingres' creative power, the breadth of which stunned Degas, Matisse and Picasso, is revealed. Ingres' paintings have held a great fascination for modern art ever since the exhibition of the Salon d'Automne of 1905, as well as the one organized by Lapauze in 1911 at the Georges Petit Gallery.

'There is no such thing as an unimportant subject in painting: all depends on seeing well, and right, everywhere.'[52] For Ingres that meant *seeing* and *imagining*. Baudelaire considered this a 'defect in imagination', a 'heroic immolation, a sacrifice on the altar of faculties he sincerely held to be more important and grandiose'.[53] What was more 'grandiose' for Ingres was sublimated truth, the representation of a person – hence the uniqueness of an individual elevated to timeless universality. Sublimation was probably as important to him in the realm of form as it was to be to Freud in the realm of the psyche. 'In a way an ideal composed partly of health, partly of calm, almost of indifference, somewhat analogous to the ideal of antiquity to which he added the peculiarities and minutiae of modern art.'[54] But Baudelaire had no idea of the torments Ingres went through in order to attain this 'calm' and to finish a painting. Studying from life, wrenching truth from experience, squaring, enlarging, transposing on to canvas, going back, if necessary, for this or that model, were his usual work stages. It was an over-elaborate, almost obsessive proceeding, the aim of which was to get ever nearer to the truth of the matter. Sometimes the initial tremor of what had been wrenched from experience was lost in the finished work. It sometimes became applied truth like applied art. A total, but cold, formal rigour. That is why his painting seemed as 'flat as a Chinese mosaic' to Baudelaire.[55]

[52] Letter to Gilibert, 29 August 1822
[53] Charles Baudelaire, 'L'Exposition Universelle 1855', *Portefeuille*, 12 August 1855; and *Curiosités Esthétiques*, Paris, 1962, pp. 222–30
[54] Baudelaire, ibid.
[55] Baudelaire, 1846

The innumerable studies for *The Golden Age, Stratonice, The Martyrdom of St Symphorian, The Apotheosis of Homer*, etc., illustrate Ingres' way of proceeding from 'simple nature to beautiful nature'.[56]

On a visit to Ingres one day, Charles Blanc (Director of the Arts, and founder of the *Gazette des Beaux-Arts*) stopped in front of two portrait-drawings of Madame Ingres née Ramel: 'One was drawn with perfect veracity and was absolutely natural; the other was in some way enhanced, intentionally, for the sake of style, simplified, idealized. "Which of the two do you like better?" he asked me. After a moment of hesitation I answered, "As far as my taste is concerned, I prefer, in intimate portraits, the one that is more true over the one that is more noble." I had hit it just right: the painter was delighted.'[57] In spite of the fact that he is not an idealist, or classic or romantic, and as difficult as he is to place, he is perhaps a little bit of all at once. The fabric of his work is complex: anxiety and intent are its warp and weft.

Like David, Ingres had his models pose in the nude so that the slightest fold would fit the body; yet he pretended to know nothing about anatomy: 'If I had to study anatomy, I, for my part, gentlemen, wouldn't have become a painter.'[58] What he wanted was 'to feel – to discern and feel' and not to 'know nature by heart', as he said to his pupils one day when he caught them drawing from the *écorché* model, saying also: 'You'll lose all faithful respect for nature, the painter's most important quality, and the most precious, which is naïveté.'[59]

All the studies for the history paintings are studies from the nude. As an example of his method one could quote this extraordinary preparatory drawing for the figure of St Symphorian's mother, Augusta (42.5 x 40.5 cm., Montauban, Musée Ingres INV 867, 1894). This drawing well illustrates Ingres' approach, inherited from Raphael and passed down through David: 'First draw the nude who is to be enveloped by the drapery, then the drapery that is to envelop the nude'[60] – see the folds of the hem on the left foot. But that is also the case with certain portraits when it comes to difficult poses, such as that of Cherubini (1842, Paris, Musée du Louvre), of which the nude torso studies (Montauban) are probably not of the composer himself. This is also true for the nude study (Bayonne, Musée Bonnat) for the portrait of *La*

56 Benoît, op. cit., 1897, p. 30

57 Charles Blanc, *Ingres, sa vie et ses ouvrages*, Paris, 1870, pp. 61–2

58 Amaury-Duval, op. cit., pp. 39–40

59 Charles Blanc, *Grammaire des arts du dessin*, Paris [1867], 1880, p. 393

60 Charles Blanc [1867], 1880, p. 541

Baronne James de Rothschild (1848, Paris, private collection) or the *Princesse de Broglie* (New York, Metropolitan Museum of Art), the last commissioned portrait Ingres accepted. 'If what's asked of you is an Achilles, that most handsome of men, and all you have at your disposal is a boor, that's what you'll have to use as regards the structure of the human body, motion and balance. The proof is in what Raphael did, when beginning studies of movements using his students, even for his divine picture, *The Disputà*.'[61]

Thus, Ingres drew from life the structure of the human body, often leaving out the head, for the sake of another head, real or ideal. This eclectic leftover is a logical error, disrupting the organic unity of the painting, and is noticeable, disturbing even, as in *Roger and Angelica* or *The Turkish Bath*.

Ingres' master David had 306 pupils according to the list given by Delécluze.[62] But according to Benoît (1897), quoting Delécluze, the figure was 293; Jules David (1880–2) counted 433, while Benoît himself only recorded those artists of some renown for the period 1790–1815. He enumerates more than 150 of David's pupils.[63] Actually there were more. Delécluze had not counted Julie Forestier (Ingres' first fiancée). But the exact number does not matter. What counts is that, talent apart, one whole generation received this *pictorial code* from master to pupil, from Raphael and Titian onwards. In some ways David was its repository (via Boucher and Vien) without being its theoretician. 'David was a man of instinct' though he was 'not a scholar, still less a systematic man; he obeyed his imperious instincts', he transmitted the rudiments of chromatic grammar to his pupils, in a 'permanence of taste rooted in serious beliefs'.[64] The teaching transmitted by David, 'who understood so well that teaching is not transmission of a manner',[65] perpetuated this pictorial code, each pupil adopting it according to his or her ability and bent. Apart from the stress on the purity of drawing, strict composition and lofty subject,

David had practised and taught the art of painting by employing hues in painting from nature which had to be applied one near the other, not blended with the brush but juxtaposed with enough precision so that they

[61] Quote from undated text by Ingres, in Boyer d'Agen, 1909, p. 481
[62] Delécluze, op. cit., pp. 414–18
[63] Benoît, op. cit., 1897, p. 304
[64] Delécluze, op. cit., p. 398 and p. 402
[65] ibid., p. 292

succeeded one another without offending the eye, expressing the shades of tone and light . . . This procedure, the one that demands the most talent and attention and which was put into practice by Raphael in *The Transfiguration*, as well as by Paul Veronese and Poussin in their most beautiful works, is the one that David strove to revive.[66]

This optical blending of colour by juxtaposition of pure tones is an astounding description of the simultaneous contrast of colours, anticipating Chevreul, who set forth these ideas for the first time at a lecture given at the *Institut* on 7 April 1828. David also advocated 'composition on one plane, procession-style',[67] so as to cancel any effect of the 'picturesque in perspective' as put by Benoît,[68] Paillot de Montabert and Quatremère de Quincy. These ideas were due to Flaxman's influence, which was, around 1800, very strong, especially through his illustrations. They provoked the idea of reduction to one line, composition on one plane (like Ingres' *Apotheosis of Homer*), substitution of 'reading' for seeing, through a system of symbolic signs. Thus, substituting 'the idea of a thing for its image', in the belief that *le beau sublime* can be 'defined only by theory and appreciated only by reason'.[69] These ideas were fermenting in the minds of young people like Maurice Quai and the 'Barbus', and Ingres was not immune to them either. For example, Ingres did use a ruler, an act in itself disturbing but legitimized by Flaxman. In his early drawings of Rome (1806) or in the *Lucien Bonaparte* (1807), the straight line drawn with a ruler plays a central role in the tension created with the curved line of the thigh, giving the drawing a horizontal pull. Also, the straight, ruled lines serve, in the architectural setting, as a contrast to the ascending verticals. Ingres' early Roman drawings are done with an astounding economy of means. They are sometimes like signs reduced only to line, reminiscent of Flaxman, whom Ingres had studied a good deal. Moreover, Flaxman himself had written: 'My view does not terminate in giving a few outlines to the world.'[70] Flaxman most certainly played an important role in Ingres' early years. The reductive element is central. But Ingres was after truth, not signs.

[66] ibid., p. 305
[67] ibid., pp. 120 and 220
[68] Benoît, op. cit., p. 36
[69] ibid.
[70] Quoted by Sarah Symmons, in *John Flaxman, R.A.*, London, 1979, p. 153

Ingres, *The Apotheosis of Homer,* 1827, oil on canvas, 386 x 515 cm., painted for the ceiling of the Salle Clarac (Paris, Musée du Louvre)

'The appearance of *The Apotheosis of Homer* (1827, Paris, Musée du Louvre) marks for us the bounds where the school of David came to an end. M. Ingres has invigorated, has given new life to the fundamental principles of the great master,' wrote Delécluze.[71] (But Delécluze, as nearly everybody else, was probably not aware that the fresco by Luigi Sabatelli [1772–1850] on the ceiling of the Iliad room in the Palazzo Pitti, Florence, *Olympus,* finished in 1819, although inferior in formulation and execution, might have been Ingres' main source for his composition: Ingres arrived in Florence in 1820 and remained there until 1824; he knew Sabatelli very well.) In fact, at the time that was the ardent wish of many young painters – composition on one plane, reduction to symbolic signs and especially to black or grey and white – eventually realized 130 years later by Picasso in his *Guernica.* The realization at last of this primary, *primitive* sign, elemental, *without the model* and without colour, *Guernica* is, in fact, the last great history painting.

But there were other views as well. 'The supporters of Romanticism claimed that the aim of art is truth. They considered the ideas of beauty and

71 1855, p. 397

Luigi Sabatelli, the *Olympus,* fresco, 1819–20, ceiling of the Iliad room (Florence, Palazzo Pitti)

ugliness to be conventional. They felt that, philosophically, nothing is beautiful, nothing is ugly, that only reality is a fixed point to which one must bend unswervingly.'[72]

At the beginning, Ingres followed the teaching of David, as can be seen in the *Torsos* (1800, Montauban, Musée Ingres), in the portrait of *Gilibert* (1804–5, Montauban, Musée Ingres), or later in the portrait of *Desdeban* (1810, Besançon, Musée des Beaux-Arts et d'Archéologie). In these, as in his master's best portraits (those of Madame de Pastoret, Trudaine and Récamier) the brushstrokes are left apparent. These visible brushstrokes give these works a rhythmic power which the later, smoothed-out painted surfaces lack. Ingres gave them up for the sake of a regular smooth surface. 'However skilful the brushstroke, it must not be apparent, otherwise it hampers illusion and immobilizes everything. It makes the process visible instead of the

[72] Delécluze, *Journal 1824–1828*, Paris, 1948, p. 382. This statement, which Champfleury would have loved, but could not have known, since Delécluze's *Journal* remained unpublished until 1948, was written on 3 January 1827.

represented object; it exposes the hand instead of the thought.'[73] Hence, what was important to him very early on was 'thought' and 'illusion'. But he maintained a concept of colour very like the one of his teacher, as far as juxtaposition is concerned, but not in his modelling, in which he detaches himself from David. 'I was misled,' he wrote to Monsieur Forestier from Rome, upon his arrival there. That was mostly in reference to modelling after looking at Raphael, at his *Fornarina* above all.

Smooth surface – white in the shadows ('*du blanc dans les ombres*') – indicates that he broke the warm intensity of burnt sienna or umber used in the shadows of flesh tints, with white. David shaded his flesh tints with red. This he learned from Vien and especially from Boucher, who received it from François Lemoyne, who in turn inherited it from the Rubens tradition. Indeed, flesh tints were shaded with warm tones and highlights were painted with cool ones. Burnt sienna, which warmed Titian's shadings, was replaced with red ochre, sometimes even vermilion – which is brighter, not warmer – by Rubens. David followed this path (see the hands or feet of the sisters in the *Vow of the Horatii*). Henceforth, Ingres' smooth flesh tints would often even be shaded with cold tones, as for example in the portrait of *Madame Panckoucke* or *Monsieur Bertin* – shaded with black (!) – as well as *Madame Moitessier Standing*. Ingres' drive for '*le fini*' was certainly intensified by his increasing fear of failing. The smooth surface, therefore, is not an expression of calm, academic certitudes, but rather a veil for his continuous torment.

'So few people can feel my work,' Ingres wrote to Gilibert ('Je ne puis être senti que par un si petit nombre', 15 March 1831). He wrote 'feel' not 'understand', as Quatremère would have liked it to be. Ingres knew that art is in the realm of feeling, a stage deeper than simply understanding. But his generation failed to 'feel' him. It had to vanish so that the misunderstandings Ingres' work provoked could be cleared up. These misunderstandings were due mostly to prejudice and ignorance of his work, which remained un-known to the general public. Only a few of Ingres' paintings were exhibited after his 1846 (Bazar de Bonne Nouvelle) and 1855 (Exposition Universelle) exhibitions. From 1834 onwards Ingres no longer showed his work at the Salon, which every year attracted about one million visitors. There was only one exhibition of his drawings (1861, Salon des Arts-Unis). The three portraits of the *Rivière* family entered the Louvre's collection only in 1870. *The Source* and *Oedipus and the Sphynx* in 1878. The *Valpinçon Bather* and *Monsieur Bertin* in 1879; *Monsieur Cordier* in 1886, *The Grande Odalisque* in

[73] Ingres, quoted in Delaborde, 1870, p. 150

1899, *The Turkish Bath* in 1911, *Madame Marcotte de Sainte-Marie* in 1923, *Madame Panckoucke* in 1953. There was, of course, the retrospective exhibition at the Ecole des Beaux-Arts in 1867, but it was seen through a thick fog, the fog of prejudice. In spite of their respective merits, Ingres' pupils Amaury-Duval, Cambon, Pichon, Mottez, Desgoffe, Lehmann, the Flandrin brothers and the Balze brothers could not clear the fog. Seurat, who was Lehmann's pupil, admired Ingres, but for Cézanne, 'Ingres, for all his style and admirers, is only a small painter.'[74]

It was not until the exhibition of 1905 at the Salon d'Automne that some light was shed on Ingres' work, elucidating it with something other than the idealist or academic doctrine. For Matisse, Ingres was the first one 'to use pure colours, outlining them without distorting them'.[75] Picasso, for his part, learned about the simplification of forms and purity of line from Ingres. His 'classical' period of the twenties is indebted to Ingres. Picasso, on his way to Spain stopped at Montauban – at unknown dates – where more than 300 drawings were then on permanent display. Ingres' immediate pupils arrived, however, at an impasse. It took Degas (pupil of Lamothe, himself a pupil of Hippolyte Flandrin, Ingres' beloved disciple), Matisse and Picasso to see Ingres' work with a fresh eye.

But what is the relation between these different views of Ingres' work and the very essence of his painting? 'It is that one doesn't look at a painting by Ingres the same way one looks at a painting by Corot.'[76] Neither classic nor romantic nor realist, he is all those at one and the same time, especially in his studies and drawings. If he idealizes in his painting, it is only in order to formulate better; in other words, to define visual truth through form. Torn between facility and anxiety, he did not want to innovate but rather to continue, following the loftiest examples from the past. Believing he followed Raphael, he ended by doing something else: doing Ingres.

[74] Cézanne, letter to Emile Bernard, 15 July 1904
[75] Henri Matisse, *Ecrits et Propos sur l'Art*, Paris, 1972, p. 199
[76] Michel Laclotte, *Ingres Exhibition Catalogue*, Petit Palais, Paris, 1967, preface, p. ix

Degas, *Portrait of Two Friends on Stage,* 1879, pastel on beige paper (enlarged sheet), 79 x 55 cm. (Paris, Musée d'Orsay)

ON TWO PASTELS BY DEGAS[1]

Portrait of Two Friends on Stage – Ludovic Halévy 1834–1908 and Albert Boulanger-Cavé 1832–1910

Ludovic Halévy noted on 15 April 1879, 'Me, serious in a frivolous place, that's what Degas wanted to do.' In fact there is nothing frivolous in this rather austere pastel. Indeed, the verticality, set off by the angle which is formed by the umbrella's diagonal and cuts the receding line, excludes all horizontal support. Whence the disturbing sensation which overtakes us.

The two friends are looking at each other but everything separates them – their portraits seem to have been done separately, not on stage. Apparently there was only the bare wall initially, which Degas covered with large green-to-yellow pastel strokes, broken by white – an abstraction that one can interpret as being the stage set, thanks to the actual wings, partly concealing Albert Boulanger-Cavé.

This contrast between the open and closed, the uncovered and covered, the apparent and the hidden, haunted Degas from his very beginnings.

The notion of the *state of the soul*, which Degas couldn't bear and which was still anchored in the collective subconscious of his generation, was replaced by him with the notion of the *state of the eyes*.

Degas replaces descriptive representation with the very act of *making visible*, with the difficulty of seeing in itself.

His modernity resides in this *difficulty of seeing*, which, at a stroke, bring us back to the constituent pictorial elements, hence to painting as *verb*; that is to say as a qualitative visual experience independent of any figured meaning. What counts is the accord between the cold green and the warm yellow, the horizontal tension between these two colours, and this or that representation which we are tempted to imagine by the fact of its being a stage set. What count are the abrupt vertical strokes of pastel, intensifying the strident accord of green–yellow. They are there to underline the heavy and sombre diapason

[1] Notes for a lecture given at the Musée d'Orsay, 28 October 1988

of the two friends standing face to face.

Antecedent works: Madame Jeantaud in Front of a Mirror, 1875 (Paris, Musée du Louvre, 1879), later coming to a head with *At the Milliner's,* 1882 (New York, Metropolitan Museum of Art)

Female Bather Reclining on the Floor

Degas, *Female Bather Reclining on the Floor,* 1886–8, pastel beige paper, 48 x 87 cm. (Paris, Musée d'Orsay)

Degas asked his model to take this position, in which her left arm hides her face, probably not so much so as to portray her in an attitude of self-defence, as is suggested in the *Degas Exhibition Catalogue* (1988, No. 275), but rather for reasons more appropriate to painting than to literary interpretation. Degas, who was preoccupied, as mentioned before, by what he called the 'state of seeing' (as opposed to the 'state of the soul'), probably made his model take this *posto-contraposto* pose, formulated by him in an earlier *ébauche* (*Medieval Battlefield,* 1865), the connotation of which is not so much warlike as Michelangelesque. Point and counterpoint, uncovering, covering; the counterpose opening of the arms; the face covered, the body uncovered, the breasts showing . . . the legs hidden.

176

CEZANNE: FROM TREMOR TO CHEQUERBOARD[1]

There is a paradox, a contradiction even, between what Cézanne said and what he painted. The emotion which governed him (and his rather bad character), governed his brush – but not always his thought, conditioned by the acquired mediations of a whole culture. Emotion on the other hand is a *tremor*, just as pain is, a concrete experience felt by its sufferer alone. Cézanne's paintings are affected by such tremors and vibrate as *quivers,* not as formulas. However, it is the Cézannian formula *per se* which dominated this century. The continuous interpretation of his statement 'to treat nature through the cylinder, the sphere, the cone, all put in perspective . . . '[2] (actually a neoplatonic mannerist formula) resulted in the substitution of a very partial vision for the whole of his work – similar to what happened to Caravaggio's work, because of the Caravaggists, in the seventeenth century.

Quoted by Félibien as having said: 'Caravaggio came to destroy painting',[3] Poussin could not foresee that one day his own painting would fascinate a painter who was to 'destroy painting' in his turn, namely Cézanne. It may be said that Cézanne was to the twentieth century what Caravaggio was to the seventeenth, but in an inverse order: Caravaggio defied the norms of *buonmaniera* and accepted no other master than the model.[4] He disarmed art in disarming himself before the visible, and imitated art without art.[5] In so doing he 'destroyed' painting: by discarding *maniera* he made its code obsolete and no longer credible. In fact, Caravaggio renewed the antique classical precept of *rem tene verba sequuntur.*

While rejecting the neo-classical norm of representation which had become

[1] Originally written in French and published in *Art International*, Lugano, May–June 1977, vol. XXI/3, pp. 17–23

[2] Paul Cézanne, letter to Emile Bernard, 15 April 1904

[3] Félibien, *Entretiens* (1688), 1725, vol. VI, p. 194

[4] Giovan Pietro Bellori, *Le Vite de' pittori, scultori e architetti moderni* [Rome, 1672], pp. 201–2, Milan,1976, p. 211–12

[5] ibid.

academic, Cézanne rationalized the visible in relation to the pictorial plane. Although he said: 'Imagine a Poussin completely redone from life, that is what I mean by classic.'[6] Evidently, painting is mute, and feeling is transmitted through only feeling, beyond words. Often words lag behind, belonging to a time that has passed, without always being in step with painting. This dichotomy was also experienced by Cézanne. His theories are rationalistic, but not his paintings. Is this a failure? And if so, of what? Of his words or of his brushwork? 'I proceed very slowly, nature offering itself to me in great complexity, and the progress to be achieved is incessant. The model has to be very well seen and with great precision . . . '[7] But such a statement in itself did not suffice to bring about the rebirth of a new pictorial code. Or of a new manner.

This manner struck its roots in Cézanne's *quivers* and became, in spite of himself, a posthumous legacy, which can be defined as follows: no flat colour expanse, no sharp contrasts, no local colour, no sharp nor clear contours, no pure single lines; but instead, a process of short strokes (flat brush preferably), chiaroscuro by line and stain, equally distributed by reciprocal imbrication or overlapping. And, of course, no colour saturation. This anticipated Paul Klee's 'optical grey'. Thus, the visible becomes representable. Close scrutiny is supplanted by a distant and loose abstraction. From now on the visible only serves as a pretext to make a painting.

The evolution of the chromatic grammar from the quattrocento to David, having reached its culmination in Velázquez, broke down early in this century. There was a schism between painting and the visible as such. Seeing and painting what one sees require rapid chromatic reasoning. Without this there is no way to express natural colours by those on the palette. There is a discontinuity between the colours we see around us and the pigments with which we paint. It may seem absurd to pretend to grasp what we see and to hold it via pigments on a flat plane. Nevertheless, see Titian. Or Velázquez. Colours have their conjugation. It is this conjugation and its laws that seem lost today. One no longer knows 'how' to paint. This, of course, is not due solely to Cézanne's legacy and its interpretation. The modernist creed, which screens us from the visible, stems not only from Cézanne but also from the collective style as it developed from the early days of the twentieth century.

<p align="center">★ ★ ★ ★ ★</p>

[6] Cézanne, to Joachim Gasquet, 1926
[7] Cézanne, letter to Emile Bernard, 12 April 1904, in Emile Bernard, *Souvenirs sur Paul Cézanne et lettres*, Paris, 1907

Collective style is a sort of echo of a momentary collective phantasm. A fashion. A demonstration of exteriority by exteriority, corresponding to a sort of collective *eidos* still unclear and misunderstood. Collective style does not originate in inner tremors, it is all external. Because it does not spring from one's own deep experience, it leads to decay. But in spite of its fugacity, even in spite of its frivolousness, its rebirth is a continuously changing one, preventing us from seeing truly. When Pierre Crozat wrote to Rosalba Carriera about Watteau, saying that he was the only man 'able to produce something worthy of you',[8] he probably had no doubts as to which of the two was more important – Rosalba was then at the height of her fame, incarnating this sort of collective phantasm. Watteau was still in the shade. And wasn't he confused, for a century, with Pater and Lancret? The charming *scènes champêtres* and minute frivolousnesses threw a veil over Watteau, the veil of fashion, deforming his painting for several generations. It needed a Thoré-Bürger for him to be unveiled.

Cézanne was not a victim of collective phantasm, but rather of interpretive theory. This interpretive theory did to him what Poussinism did to Poussin. In both cases the distortion was due to systematization, transforming the soul into a tool. There is, indeed, an interesting relation between classical theory and modernism, in so far as in both there is a strong appeal to doctrine. But the analogy does not go further. There have been an infinite number of doctrines in the twentieth century, perhaps due to the acceleration of historical time. It is interesting to note that the blooming of doctrinal diversity in our century is reversed in proportion to the narrowing credibility of one, single, normative doctrine. These numerous doctrines have all been short-lived, ending up by being to the artist what a cage is to a bird.

Because it became a pictorial method, Cézannism alone, as it developed from 1904–7 on, endured, being first an underground source and only later more subconscious. It was not an avant-garde position, openly declared, such as a manifesto, but, rather, a kind of acquired, rigorous method, the only possible one. Maurice Denis said: ' . . . we define Cézanne first of all as a reaction against modern painting, against impressionism'.[9] At Cézanne's death the press was unanimous in declaring that 'all his work aimed at style. It is evident that Cézanne is a kind of a classic, and that the young generation considers him a representative of classicism.'[10] It is probably out of opposition

[8] See Francis Haskell, *Patrons and Painters*, London, 1963, p. 277
[9] Maurice Denis in *L'Occident*, September 1907: cf. *Théories*, 1913, p.238
[10] ibid.

to what may be described as self-indulgence and sloppiness in Impressionism that Cézanne's quivers were perceived as rigorous, thus becoming the constitutive element of a pictorial language, of a language otherwise lost. 'Cézanne is not an Impressionist. He is a classic, because whether it was *Bathers*, *Mont-Sainte-Victoire* or whatever, all his life he painted the same thing . . . '[11]

This 'classical' principle, as Matisse seems to conceive it, implies a dominant form. A reduction, in fact. And actually, Cézanne's painting evolves from just such an element, which, in this case, is the *quiver*. However, for Cézanne himself, his painting was not reducible to one element. He most certainly was unconscious of it. 'Only oil painting can be my support. One has to go on, persevere. I have to bring it about from nature. The sketches, the canvases, if I work on them, will be nothing but constructions from nature, based on the means, the feelings and developments suggested by the model, but I always say the same thing . . . '[12] Hence, for him, too, there was no other master but the model. Like Caravaggio, he was disarmed in front of what he saw. That his quivers would one day be transformed into formulas would have been surprising, indeed distressing, to him.

<p style="text-align:center">★ ★ ★ ★ ★</p>

It is also interesting to note that successive painting-manners throughout history were in fact collective styles, each one of them founded on a dominant form. A *key form*. This key form reduces the visible to itself. A dominant form is a sort of straightjacket simplification. Such was the case with the *linea serpentinata* which dominated so much of the sixteenth century. Everything, or very nearly, in the plastic arts was subordinated to it (a straight line was an affront to *buon maniera*). This serpentine line made a smashing and brief reappearance in *art nouveau*, reborn in the form of a *curl*, elegant and melancholic. This *sigmoid* form was the dominant of fashionable modernism between the 1890s and the early years of this century. But nearly at the same time a new key form emerged, a new dominant: the *chequerboard*. It emanated from Cézanne's work. An imbrication of contrasts, the chequerboard came to dominate much of this century's art; to begin with, Cubism. The chequerboard illustrates perfectly the method which arose from the Cézannian heritage,

[11] Henri Matisse to Georges Duthuit (1948) in *Ecrits*, Paris, 1972, p. 44, note 7
[12] Paul Cézanne, letter to his son, 13 October 1906

being a quintessence of a vibrant screen, constituted of opposites, thus permitting the rationalization of all visual data and its distribution on a flat plane. The chequerboard is an optical trap, by holding the viewer's gaze within its imbrication, leading it back and forth from one point to the other. In this respect, the chequerboard is as much a conductor of sight as perspective, which it replaced. The chequerboard is to the twentieth century what perspective and the serpentine line were to the sixteenth.

Progressively, it consolidated the autonomy of the painted surface in relation to all representation. Hence, the chequerboard is the key form *par excellence*, not only of Cubism, but also of Abstraction (see its importance to Klee, Mondrian, Kandinsky). It permitted the break away from representational painting, but although it sprang from Cézanne, it also departed from him by separating the act of seeing from the act of painting the visible.

Progressively, the rupture between seeing and painting brought in the triumph of artifice, the confusion between painting and image, between painting and applied art, painting and simple decoration. A page of history seems to have been turned. Seeing and painting from seeing implies a graft of the eye to the hand – that's the challenge.

1976

BONNARD[1]

Bonnard was somehow eclipsed by the long preoccupation with late Monet, and was judged to be 'too pretty'. After barely a few decades, he remains to be rediscovered. Even without following his steps in painting, and taking a rather opposite direction (getting closer to the visible, for me, is not transposing it), how can one look at his work and not love it? He is moving, incarnating doubt. Starting his painting with the perceptible motif, he doubted that perception, and continued without it. He doubted every line, every colour, returning to it repeatedly, in order to have it in pitch with his feeling. He was haunted by the 'second layer' awaiting him, interrupting each colour with another, without coming to an end, until he was on the verge of his grave, from which, through the hand of an intermediary, he still corrected *l'Arbre en fleurs*. Like Russian dolls fitting one into the other, his colours fit in until they sing. A very moving, very sumptuous song. A unique song.

New York
31 December 1983

[1] Written originally in French and published in the *Petit Journal* of the Bonnard Exhibition, Musée National d'Art Moderne, Centre Pompidou, Paris, 1984

MATISSE'S *JAZZ* AND THE *BEATUS APOCALYPSE OF SAINT-SEVER* [1]

Separated by nine hundred years, each of these books had a considerable influence on its time. Whereas Matisse's cut-outs, as we know, had an impact on contemporary painting, the Saint-Sever *Beatus*[2] has for the most part inspired sculpture. It was in fact one of the principal sources of Romanesque sculpture, its 'book of patterns'; sculptors found in it, as Emile Mâle put it, 'the secret of line and the storehouse for a tradition'.[3] But only for its outlines. Its colour formulation sank into oblivion, and had to wait – mystery of

[1] Written in 1971–2 for the Los Angeles County Museum of Art, and published there in a shortened version (brochure) for the exhibition *Two Books: The* Apocalypse *of Saint-Sever and Matisse's* Jazz, 11 April to 28 May 1972

[2] Lat. Ms. 8878, Paris, Bibliothèque Nationale, acquired 1790. Parchment 14 x 11in, 290ff. divided into twelve sections, a preface and a prologue, it contains: the Genealogy of Jesus Christ, a commentary on St John's Apocalypse by Beatus of Liébana; St Jerome on the Book of Daniel; Ildefonso de Toledo on the Virgin Mary; a number of documents of the Abbey of Saint-Sever, etc. The Beatus commentary on the Apolcalypse was first published by the Augustin P. Henri Florez, Madrid 1770. The *Apocalypse of Saint-Sever* was first very briefly described by Léopold Delisle in his inventory of the Latin manuscripts, Bibliothèque Impériale, Paris 1863. After the [dull] reproduction of a few pages in Charles Louandre *Les arts somptuaires* (Paris 1858) and Count Auguste de Bastard, *Peintures et ornements des manuscrits*, Delisle wrote on it further in *Mélanges de paléographie et de bibliographie* (1879). But it is only since the 1920s that Ms. 8878 of the BN has come to be seen and studied. Camille Couderc (1927); Philippe Lauer (1927); Emile Mâle (1928); Henri Martin, Dominguez Bordona (1929); Georges Bataille reproduced a few pages in *Documents* no 2, 1929; Boeckeler (1930); Henry A. Sanders, in *Papers and Monographs of the American Academy in Rome*, 1930; Wilhelm Neuss's fundamental study of all 28 Beatus manuscripts: *Die Apokalypse des heiligen Johannes in der altspanischen und altchristlichen Bibel-Illustration* (1931); Gómez-Moreno (1934); E.Tériade, in *Verve* II (1937–8), three plates; Emile van Moé, *l'Apocalypse de Saint-Sever*, facsimile reproduction (hand-copy) printed in lithography by Mourlot, Editions Cluny, Paris 1943; Degenhart (1950); Menéndez-Pidal (1954); Porcher (1959).

[3] Emile Mâle, *L'Art Religieux du XIIe siècle en France*, Paris (1953), 1966, p. 45; cf. ch. I, II & XI

atavism! – for Henri Matisse to bring it back from sculpture to painting via his cut-out gouaches. 'Drawing with scissors: Cutting out directly in colour reminds me of the direct cut of sculptors,'[4] he wrote. From the outline to the chisel, from the chisel to the scissors, from the scissors to the edge as line. One knows to what extent the edges or outlines determine the perception of colour. It is by the edge, the margin, that a qualitative change between two colour zones is provoked. For example, the diad red–blue is determined by the sharpness of the gradient separating them. Thus, the sharpness of the margin intensifies the contrast. The clear-cut colours in these 'sharp and violent sounds', as Matisse described his colour cut-outs which constitute *Jazz*, and which he qualified as 'simultaneous reactions' of 'chromatic and rhythmic improvisations', reach a highly intensified state. Colour here vibrates indeed, like sound. Its concreteness is akin to sound.

Perhaps it was because colour is concrete, like sound, that the painter who 'decorated' the *Beatus Apocalypse* succeeded in replacing eschatology with beatitude. So did Matisse, sublimating the terrors of his day, nine centuries later.

It's as though the painter[5] of the most outstanding pages of the *Beatus*[6] *Apocalypse of Saint-Sever* knew instinctively the essence of chromatic simultaneous contrast: apparently colour was for him as concrete and independent of reality as colour-symbolism allowed it to be.[7] He probably also had the

[4] Henri Matisse, *Jazz*, 1947

[5] The first painted *Beatus*, dated 926 by Abbot Victor, was the work of Magius Arxpictor (according to Focillon, *Art d'Occident*, 1955, p. 26) and was probably produced at the scriptorium of San Miguel d'Escalada. Copies of this manuscript were executed by Magius himself, by his pupil Emeritus, as well as by the nun Erde (975, Gerona); it is her painted manuscript that could have been the model for the Saint-Sever Beatus.

[6] St Beatus, Abbot of Liébana (*c.*738–98) was probably one of Alcuin's teachers. He wrote in 776 his commentary on St John's Apocalypse, which continued to be copied and decorated especially throughout the Mozarabic monasteries of Leon and Catalunia. The text originally fights the heresy of Adoptionism featured by Elipandus, Archbishop of Toledo, and Felix, Bishop of Urgel. They and their doctrine were condemned by the Frankfurt Synod in 794, in which Charlemagne himself took part.

[7] Although colours were fixed liturgically in the twelfth century by Innocent III restricting them to *white, red, violet, green, black* and exceptionally *pink* on Sundays and holidays, supplemented with gold, the medieval colour-symbolism allowed for more colours to be used. Their symbolism was as follows: *White= Absolute Truth. Red = Love of God. Red & Blue = the Holy Spirit. Blue = Divine Wisdom. Yellow = Revelation, and the Word transmitted through Light. Green = Creation. Orange = Fire illuminating the Spirit of the Faithful. Grey = Immortality. Black = Error, Void, Negation of Light.*

Apocalypse of Saint-Sever, folio 58, 'The Church of Ephesus'

Matisse, *The Snail*, 1952–3, gouache cut-out, 287 x 288 cm. (London, Tate Gallery)

meanings of each colour in mind. His chromatic articulation, although related to the *Gerona Beatus*, is of a stunning serenity. Around the year 1000, for roughly forty years, because of various predictions, all Christians were led to envision the End of the World. The vision of the Apocalypse, emphasized by the climate of terror and wonders, of penitence and purge, should have inspired this great artist to paint in fear and trembling, and to express it. And yet, it is beatitude and not panic that emanates from his marvellous illuminations. Was it due to *la trêve de Dieu* which was thought to have been brought upon the world by the collective rites of purge and penitence, spreading from Aquitaine all over Gaulle? Like most pious Christians of his time, this great artist had faith in eternity, hence in his future, although that also meant faith in the Last Judgment. Events on earth and in the skies were seen as signs flashing from the Book of Revelation. And yet, the sixteen or eighteen illuminations (out of eighty-four) due to this master's hand don't inspire fear or despair, but ecstasy. Indeed, the main source of inspiration was the Book of Revelation VI, 2–7, i.e., the revelation of divine glory and eternity to come. He painted them not from the point of view of the torment proclaimed to be the inevitable cost of it, but as if seen from that of eternity. So eschatology was replaced by Utopia.

Origin

Links between Gascony and Spain started early and were reinforced by the pilgrimages to Santiago de Compostela,[8] and by the wind of millenarism which emerged with Marculf, in the seventh century, who saw that 'evident signs announce the end of the world'. *Mundum terminum ruinis* . . . The Book of Revelation of St John imposed itself more and more through Beatus' commentary, which was copied and painted throughout the Mozarabic monasteries of the Kingdom of Leon, through Navarra and Catalonia, across the Pyrenees to Saint-Sever. Connections between Saint-Sever and other abbeys across the mountains must have existed, especially after Sancho III 'the Great' (named 'Imperator Iberorum') devastated Moorish Spain with the help of his ally Sancho Guillaume, Duke of Gascony, in 1027. Gregorio Muntaner became abbot of Saint-Sever in 1028. He, and probably the artist who was to paint this manuscript, both seemingly Hispanics, must have been brought over from across the Pyrenees following the Gascon invasion, and with them a pictorial tradition.

Thus, the old Visigoth tradition, the Mozarabic and Carolingian styles in which some Byzantine influence is also present, converged in most Iberic scriptoriums, making it impossible to separate stylistically the Beatus manuscripts one from another. It is evident that the Saint-Sever Beatus is linked to Spain, but has no close affinity other than to the Beatus of Gerona. On the other hand, the Beatus of Saint-Sever is unique in its formal rigour.

Written and painted at the scriptorium of the Abbey of Saint-Sever[9] during the abbotship of Gregorio Muntaner (whose name appears on folio 1, *Grigorius abba nobis*), between 1028 and 1072, the 290-folio manuscript contains eighty-four illuminations, starting with folio 27. There are fifty-eight whole- and half-page paintings and twenty-six vignettes. Sixteen to eighteen of the paintings seem to be by one hand, and the others by various hands. These sixteen or eighteen painted pages are of an extraordinary quality. They are the masterpieces which carried this volume through time. An inscription on folio 6 is intriguing. It reads: *In nominæ trinitatis incipit Stephanus Garsia*

[8] Indeed, one of the first pilgrims was Gotescalc, Bishop of Le Puy, in 951. Incidentally, he had a painted manuscript from the monastery of Albeda copied for him.

[9] Saint-Sever, today a small town in the province of Landes (France), is the place where once stood the Abbey of Saint-Sever, founded in 523 by St Sever, second bishop of Avranches. It was ruined by the Normans and restored in 963 or 980 by Sancho-Guillaume, Duke of Gascony, and became a Benedictine abbey. It was devastated by the Huguenots in 1596.

Apocalypse of Saint-Sever, 'The Fall of the Stars', folio 116 (Paris, Bibliothèque Nationale)

Matisse, *The Fall of Icarus*, summer 1943, cut-out gouache, 35 x 26.2 cm.
Frontispiece for Verve no. 13, Paris, 1945.

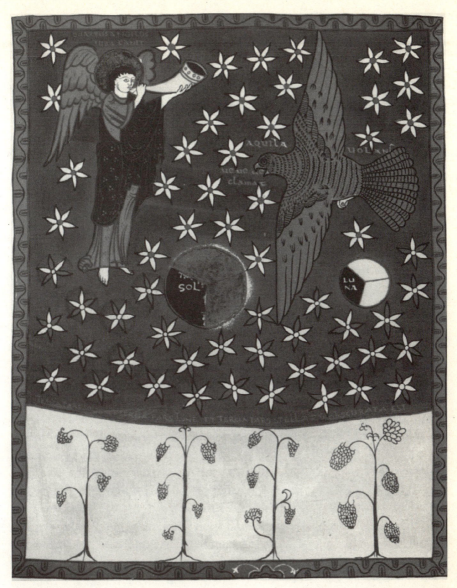

Apocalypse de Saint-Sever, folio 141 recto, 'The Fourth Trumpet'

placidus ads. Whether this inscription reveals the name of the great artist, who may have been this '*placidus*', gentle Stephanus Garsia – the adjective suggests that the inscription is posthumous – remains unclear. Prudent historians overlooked the question. Nor did anyone tackle the material from a stylistic point of view.

Colour and Form

What strikes one first in this painted manuscript is the separation between the style of figure drawing and the articulation of colour, which subsequently provokes a series of unpredictable forms. This is probably why Mâle, van Moé, Neuss and others, remarked on the fact that the figures 'detach themselves' from the background. In fact there is no 'background'. Conceived in superposed registers, reminiscent of Byzantine tenth-century Apocalypses, the pages are built vertically, from top (dark, heavy, or central) to bottom (bright, light, warm) and from left to right.[10] See for example folio 58 ('The Church of Ephesus'). The entire painting is fixed by the horizontal black-and-white symmetry of the two heads. The central gold square, outlined in black, is placed in the middle. The two white hands point to the right where two diagonals converge in the spiral rhythm of the wings. The wings make the nimbus rotate in a clockwise direction. The rotating movement is continued, becoming angular, in the upper yellow stripe. The colour contrast is enhanced first by the presence of black and white, and then by the sharp, straight horizontal stripes. Their superposition creates the vertical movement. A magnetic relationship is created by the central square and the black and white symmetry. There are colour-fields and colour-lines complementing each other. One colour is sharply delimited from the next one either by an inclusive outline (or edge) or by a supplementary colour-line. The colour-line, used both as outline and as unifying element on the overall page, is sometimes straight and sometimes undulating. It appears also to follow a strict scheme: red line between orange and blue, cold blue and yellow, yellow and yellow; and red as a dominant element unifying the page. Blue line appears always between yellow and red; it is also used internally in red and orange colour-fields. Black line is used in white, red and warm brown areas, never as a unifying element. No other colour is used as line.

[10] Left (*sinister*) is malefic, right is benefic. North is assimilated to left, and south to right: '*Aquilo* [the north] *diabolus vel homines infideles aut mali . . . Auster* [south] *Spiritus Sanctus calor fidei . . .* '

Technique

Red and yellow ochre are not present, except in folio 203 (red). Vermilion is used for the red. (This mercuric sulphide has been mined in Sisapo, Spain, since antiquity.) There is apparently no other red in the restricted group of the master's paintings. Azurite is used for both blues. (This basic copper carbonate was natural or artificially obtained.) Also indigo (folio 194). Probably arzica or some similar dye is used for the yellow. (Called *weld* in English, arzica is extracted from the plant *Reseda luteola*.) The cold green is malachite (also a basic copper carbonate). Black is probably a lamp-black or a similar organic pigment. An unidentified white is used, which could be either ceruse, basic lead carbonate, or bone-ash. Orange, warm green, light brown, blue tint and purple appear to be composites. Indigo or woad were used in folio 193, 'The Beast', and in a number of pages executed by another hand. The outline of the figures was drawn with pen, sometimes brush, and ink. The medium is probably *glair*.[11]

Conclusion

Colour in this *Apocalypse* is independent of subject-matter (as in late Romanesque frescoes, where colour was not used realistically). It is applied in broad, saturated and unbroken colour-fields. What is most important is that the Saint-Sever painter felt intuitively the relation of edge sharpness to colour intensity. (About saturation and quantity Matisse said: ' . . . one square inch of blue is not as blue as one square yard of the same blue'.)[12] We know today that the *marginal gradient* corresponds to a qualitative change between two colour-fields, provoking contrast and *equalization*, one colour enhancing or inhibiting perception of the next. Contrast and tone focus the painting in our eye. At a congress on colour (Paris 1954), Meyer Schapiro remarked:

> I would like to attract attention to the fact that in art, it is perception as activity which transforms the phenomenon or datum, given by nature, which is important. It is in that context that those small perturbations which one calls simultaneous contrast become a concrete factor in the painting rather than an abstract factor of perception.[13]

[11] The information about colour is based on my examination with a x50 magnifier, since sampling is not possible

[12] quoted by Aragon, *Henri Matisse, roman*, Paris, 1971, vol. II, p. 308

[13] *Problèmes de la couleur,* Exposés et discussions du Colloque du Centre de Recherches de Psychologie comparative, held in Paris 18-20 May 1954. SEVPEN, Paris, 1957, p. 249

Jazz

Matisse 'cut out in colour' (*a découpé dans la couleur*) his series of tinted paper cut-outs which he entitled *Jazz*,[14] in 1943–4. The period was also apocalyptic. Suffering was everywhere. But he, too, was more concerned with colour than with subject matter, with beatitude than with eschatology. His colour cut-outs, too, inspire bliss and not fear and trembling, although he also used subject matter as a form and colour generator. This colour-generation is prefigured in the Saint-Sever *Beatus*, which is 'decorated' rather than illustrated. Matisse is reported by Georges Duthuit to have said: 'Expression and decoration are but one, the second term being comprised in the first.'[15] He believed in expression through colour saturation, in construction through saturated surfaces.[16]

It is unlikely that Matisse actually saw the Beatus Ms. 8878 before it was exhibited at the Bibliothèque Nationale in 1937, although he must have been familiar, through reproductions, prior to 1937, with some of its pages; however, the most striking ones were not reproduced. It is also unlikely that his encounter with it had less effect on him than the Persian miniatures he so often referred to. The *Beatus Apocalypse* actually had a more important effect on Matisse's work. A page like 'The Fall of the Stars' (folio 116) or 'The Second Trumpet' (folio 139 verso) must have influenced him greatly. But there is no written statement by Matisse about Ms. 8878, although he mentioned it often, according to Cartier-Bresson. The facsimile printed in lithography by Mourlot (who was also Matisse's lithographer) was published in Paris in May 1943. Matisse started work on *Jazz* in the autumn of the same year, although the first cut-outs were made by Matisse in 1931-2 while he was working on the *La danse* panels for Dr Albert Barnes about which he said:

> That dance – I have long had it in me. I put it in the *Joie de Vivre*, then in my first large compositions. Yet this time, wanting to sketch on three one-meter canvases, I could not. Finally, I took three five-meter canvases, of the same dimensions as the wall, and one day, armed with a long bamboo

[14] Henri Matisse, *Jazz*. Twenty prints, printed by Edmond Vairel by *pochoir,* at Draeger, Paris, reproducing the cut-out gouaches, with the same colours used by Matisse in the originals. Published by Tériade, Paris, 1947. 270 copies with text and 100 portfolios without, on *vélin d'Arches,* and 20 copies HC 17 x 12in

[15] cf. Raymond Escholier, *Matisse ce Vivant*, Paris, 1956, p. 221

[16] cf. Interview with Tériade, in *L'Intransigeant*, 14 and 22 January 1929, Henri Matisse, *Écrits et propos sur l'art*, Paris, 1972, pp. 92–100

stick, I began to draw at once. It was like a rhythm that carried me. I had the *surface* in my head.[17]

Later (1951) he said:

I am now turned towards more immediate, more mat materials, which lead me to look for new ways of expression. The cut-out paper allows [it is then that the idea came to Matisse to use coloured paper] me to draw in colour. It is a simplification. Instead of drawing an outline and filling in the colour – in which case one modifies the other – I am drawing directly in colour, which will be the more measured as it will not be transposed. This simplification ensures accuracy in the union of the two means . . . It is not a starting point but a culmination.[18]

And indeed, from the beginning Matisse looked for *colour-intensity*, for 'construction through saturated surfaces', in the belief that 'expression comes through the coloured surface which the beholder grasps as in its wholeness'.[19] The *gouaches découpées* are in Matisse's work a logical miracle. In 1943, says Tériade,

Matisse had in view the maquette for a new issue of *Verve*. He made us come – Angèle Lamotte and myself – to his house in Cimiez and showed us not only the cover for *Verve* [vol. IV, no. 13, 1945] but also two large compositions of glaring colours: *The Clown* and *The Toboggan*, which were to become the first and last plates of the book *Jazz*. The cycle of *Jazz* was born.[20]

The other compositions were made in Vence, where Matisse settled down in the villa *Le Rêve*. First he used to cover large sheets of white paper with gouache, then he arranged them around him on the wall of his studio. The colours were so violent that, as I remember, Matisse wrote to me that his physician ordered him to wear dark glasses in this room, after work. In these coloured sheets he used to cut out with scissors forms which he arranged and rearranged as long as necessary until there was a balance between these pure colours. He didn't trace a single line during this work . . . [21]

[17] From Matisse's conversation with Gaston Diehl, *Les Arts et les Lettres*, Paris, 16 April 1946

[18] in *Les amis de l'Art*, no. 2, Paris, October 1951

[19] 'Propos d'Henri Matisse à Tériade', in *L'Intransigeant*, Paris, 14 January 1929

[20] Matisse made his first cover for *Verve* in 1937

[21] E. Tériade, from his text for the German edition of *Jazz*, Piper, Hamburg, 1957

SOUTINE

He hallucinated whatever he painted, twisting his subjects into inextricable knots, pulling and spinning to swirl and scream. Soutine's painting is modern and not. Old and not. Masterful and not. Primordial and derived. It is painting from painting, but painting from life. With Rembrandt behind his shoulder he painted from life the hanging piece of meat, forgetting Rembrandt. The page-boy at Maxim's – haunted by the red and blue of the stained-glass windows of Chartres. The herring. The chicken. Flowers and trees. No tree he fixed his gaze on, no face the likeness of which he seized, remained untwisted. Never cool, nor straight, nor calm. But furious or aching; nothing is certain; breathless, he painted what he saw. He turned what he saw upside down, inside out, as long as he could. But couldn't for long. His scream is lasting.

1987

ON ABSTRACTION IN PAINTING

'Round is always round and
square is always square'

Piet Mondrian

Abstraction in painting[1] is as ancient as art itself. It appeared at its dawn in Palaeolithic sculpture and incision, where complex subjects were turned into simplified shapes used as representational conventions.

Rare in later, personal, idiosyncratic styles, it usually appeared unconsciously in the final phase in life, as in the late work of Titian, Rembrandt or Cézanne. Abstraction is to their work what wisdom is to life: unintentional and transcendental. However, it was not perceived as such before our century, even by 'connoisseurs'.

There was another form of abstraction, which also appeared at the dawn of art, and that was *total abstraction*. This can be achieved by anyone, anywhere, any time. This is *ornament*.

Painting, drawing (incision originally) and sculpture have as their purpose, knowingly or unknowingly, the preservation of the traces of life. They are a storehouse of feeling and fact, unintentionaly sent into the future. Like the light of extinct stars. That fact and feeling can be recorded on surface or stone is a marvel. And art history is partly the chronicle of such marvels.

Ornament, on the other hand, which is adornment, transformed a bone or a flint-stone into an artefact. A pottery vessel into a collective ceremonial object. A pattern into a sign. This sort of transformation is due to stylization. In ornament, style is prior to truth. Stylization is achieved by this *Kunstwollen* (art-will) as Alois Riegl qualified it (but he was concerned with ornament – the stylization of the acanthus plant),[2] by which ornament is segregated from *naturalism*, i.e. sublimating the mimetic need. But art-will (*Kunstwollen*) ends

[1] Originally written in English (Jerusalem,1980). Published (with editorial errors) in *Arts*, New York, October 1980; revised version in *Arikha*, Hermann/Thames & Hudson, Paris/London, 1985; French version in *Les Cahiers du Musée National d'Art Moderne*, vol.10, 1982. Slightly revised in 1989
[2] Alois Riegl, *Stilfragen*, Berlin, 1893

up in artifice and finally leads to conformity with a ritual, a fashion or a *collective style*.

Abstraction as it appeared in our century – as a system and a collective style, an ideology – is wrongly held to be unprecedented. Considered as the coming to a head of a long, parallel legacy of insurgence, of anti-tradition, and qualified in more recent times as 'avant-garde', its roots stem more from *idealist* theory and the evolution of ornament[3] than from the last works of Titian, Rembrandt or Cézanne.

Plato's division of imitation (*mimesis*) into *eikastike* and *phantastiké*,[4] (*eikastike* meaning likeness without illusionism, and *phantastike* illusionist likeness), Aristotle's division of poetry into *elevated* and *vulgar*[5] and the latter's definition of *ideal imitation*[6] are the origins of classical idealism in art, which dominated, and imperceptibly still dominates the Western world. This set of concepts was transmitted and refined by Quintilian, Cicero, Horace and Vitruvius, among others, and after a relative but not absolute oblivion, resurrected by such theorists as Ficino (1544), Castelvetro (1576), Lomazzo (1590) and Comanini (1591), among others. Comanini, ranking the *phantastike* higher (and attributing it to Arcimboldo),[7] misunderstood Plato's division of imitation. This misinterpretation was maintained by Bellori. Bellori condemned the *pittori icastici*, whom he confused with *facitori di ritrati* (ordinary 'portrait-makers').[8]

In accordance with the Platonic concept that Beauty does not stem from matter, that Nature is in itself imperfect, he condemned naturalism[9] (because it simply copies, 'i difetti di corpi'),[10] as well as Caravaggio, 'primo capo di naturalisti',[11] for having preferred 'resemblance to beauty'.[12] Beauty, according

[3] cf. E.H. Gombrich, *The Sense of Order*, Oxford, 1979

[4] Plato, *Sophist*, 235–6

[5] Aristotle, *Poetics*, 1448[b] 24 and 1454 [b]

[6] Aristotle, op. cit., 1451 [a] and [b]

[7] Gregorio Comanini, *Il Figino*, Mantua ,1591

[8] ' . . . *pittori icastici e facitori de'ritrati, li quali non serbano idea alcuna e sono sogetti alla bruttezza del volto e del corpo*', in Giovan Pietro Bellori, *Le Vite de' pittori, scultori e architetti moderni* [Rome, 1672], Turin, 1976, p. 19

[9] The term *naturalism* was probably first used by Francesco Scannelli, referring to Caravaggio, in his book *Microcosmo della Pittura*, Cesena, 1657, dedicated to the Duke of Modena, Francesco d'Este, who was painted, during his visit to Madrid in 1638, by Velàzquez (Modena, Galleria Estense).

[10] Bellori, ibid., p. 22

[11] Scannelli, op. cit., p. 197

[12] Bellori, ibid., p. 211

to the classical ideal, was to be selected from Nature's 'better parts'. The example already mentioned of Zeuxis painting the portrait of Helen, picked in segments from five of the most beautiful maidens of Agrigentum,[13] remained the paradigm of eclecticism. Horace's *'docere et delectare'*[14] was to remain its moral axiom. Art had to instruct and delight and improve mankind through its moralizing power, by illustrating the loftiest and most heroic actions. It was believed that this sort of painting would perpetuate the *immortal principle of a mortal creature*[15] more vividly than the written word. In other words, painting was to be judged essentially by *what* it represented and not so much by *how* it represented it. The quality, the way of holding an instant of life by pigment on canvas came second. But not to painters.

Art was caught in a dilemma from its start: it could not seize truth without imitation, and could not transmit this verity without art, i.e. style.

Style is a frequency. It is to the artist what pitch is to one's voice. It is self-recognizable. What I call a *microform*, it transforms all forms according to its vector, and so generates style.

But there is another form of style, which is *collective style*. Its range extends from the ritual to the political, from ornament to knick-knack. *Invocatory* (as in some Palaeolithic cave-paintings or in primitive art such as Sepik or Dogon, in which it became a system of signs), *evocative* (such as in all forms of surrender to political, religious or secular power of the law, as Assyrian, Egyptian or Mayan monuments, glorifying a God or a King), in its lesser, and more recent, aspect of social-realism in Communist lands, or simply in fashion, knick-knack: *collective style* exercises its tyranny by prohibition.

<div align="center">

★　　★　　★　　★　　★

</div>

Inheriting from antiquity, carrying the ideas of Bellori, Winckelmann and Mengs a stage further, towards totalitarian aesthetics, Antoine Chrysostome Quatremère de Quincy (1755–1849) thought that *ideal* art can be attained only without imitation. The 'ideal style' is for him a 'system of abstraction'. He saw it as *d'essence abstraite* and 'superior in quality to what Nature shows ordinarily'.[16] In order to achieve this, Quatremère states: 'the first procedure

[13] Pliny, *Natural History*, XXXV, 62–5

[14] Horace, *The Art of Poetry*, III, 33

[15] Plato, *Timaeus*, 42ᶜ

[16] Quatremère de Quincy, 'Essai sur l'Idéal dans ses Applications Propre aux Arts du Dessin', *Archives littéraires*, Paris, 1805, reprinted (Le Clerc), Paris, 1837, p. 3

of the ideal mode . . . is the one by which the artist generalizes his subjects'.[17]
By generalizing, he does not only mean 'to have recourse to collective,
abstract and general forms' (ibid., p. 192), but he also gives his definition of
generalization: 'To generalize a subject, is, in this theory, to restore, as much
as possible, the object to be imitated or the model, to the simplicity of its
principle' (p. 194). He proposes to decompose reality: 'To decompose the
elements of a subject, in order to recompose them into a system of
abstraction'(p. 252): this is, in fact, cubism.

But there was more: Quatremère saw the 'new' ideal art as addressing itself
as much to the mind as to the eye (p. 258). To the mind of Quatremère, seeing
was to be sublimated into a sort of reading, or rather decoding, of an *écriture
figurative* (p. 107) constituted by signs, based on the principle of dissimilarity,
principe de dissemblance (p. 107). He wrote: 'Just as the sign is part of an image in
hieroglyphic writing when it designates objects . . . so the image can retain
some of the sign's properties' (p. 99).

No question of a portrait, i.e. the faithful depiction of a person, being
accepted by this theory: 'The word *portrait* is precisely the opposite of what
ideal means' (p. 50). But idealism was not necessarily the theory of Ideal
Beauty. 'The notion of ideal art is not necessarily linked to that of beauty, in
the sphere of the senses, since there can be an ideal horribleness and an ideal
ugliness' (p. 34). As mentioned in the chapter on Ingres, this was a point of
view a priori acceptable to the Romantics, who also refused, though to a
lesser extent, the visible verity as such.

* * * * *

Idealist theory proposed an entire arsenal of pictorial grammar: *simplicity,
regularity, mathematical proportion.* Idealist painting had to be attained without
observing the model, 'though the model is in Nature, Nature is not in the
model,' thought Quatremère (p. 45). History painting was still considered to
be the crown of the hierarchy of genres. Portraiture remained inferior, not to
mention landscape or still-life, which remained on the lowest rung of all.
Even for Baudelaire an ideal portrait was the 'ideal reconstruction of an
individual'.[18]

But the idea of abstraction, of painting as a *sign*, had to wait one century.
The ideas formulated by Quatremère de Quincy in 1805 about art as a *vue*

[17] op. cit., 1837, p. 19
[18] Charles Baudelaire, in *Le Corsaire Satan*, 21 January 1846

intérieure based on the principle of *dissemblance*, the idea of an *écriture figurative* which is no longer the image, but the sign, are prophetic. These forgotten ideas, unknown to modernist abstractionists, were fulfilled and furthered by them. However, modernist abstraction drew more from the theory of ornament, from *design*.

Nevertheless, the idealist undercurrent remained. The highest aim in painting remained the *composition* proper to history painting, of greater or lesser complexity, as, for example, one with numerous figures (Cézanne's *Bathers*), or dramatic subject (Picasso's *Guernica*). The 'overall' treatment is what remained of 'generalizing'. Painting from observation – 'naturalism' – was again to be gradually excluded from modernist ideology. It became stale. Terms like *La haine du naturalisme* ('the hatred of naturalism'),[19] which expressed that feeling, made artists like Maurice Denis long for *l'expression par le décor* (p. 22). Although Maurice Denis's purpose was not ideological but theoretical. His explicit preference for ornament, for 'ornemanistes' as against 'naturalistes', was due to his understanding of the intrinsicality of the pictorial language. He perfectly understood what a painting was: not an 'open window on nature', *une fenêtre ouverte sur la nature,* but 'a plane surface covered with colours assembled in a certain order'[20] – a definition reminiscent of Borghini's *. . . un piano coperto di vari colori in superficie . . .* given three hundred years earlier.[21] Maurice Denis's main contribution to Borghini's definition is the idea of 'a certain order', which contains more than it seems, since it implies formal and chromatic intrinsicality. Denis stands out as the foremost theorist of the modernist innovation, before Kandinsky and Klee. Indeed, the ideas of 'line-ornament', 'line-arabesque', that 'painting is an art of flatness'[22] were in the air.

However, this change would probably not have come into being without the radical reform in the decorative arts which took place in Britain after the

[19] Maurice Denis, *Préface de la IX^e Exposition des Peintres Impressionistes et Symbolistes* (at Le Bare de Boutteville,1895), in *Théories*, 1913, pp. 25–9

[20] Maurice Denis, *Théories*, 1913, pp. 1, 22, 26 and *passim.'Les peintres dont je parle pensaient, eux, qu'avant d'être une représentation de nature ou de rêve, un tableau était essentiellement une surface plane recouverte de couleurs dans un certain ordre assemblées.'* (First published in 'Définitions du Néo-Traditionnisme', in *Art et Critique*, 23 & 30 August 1890, under the pseudonym 'Pierre-Louis' – Maurice Denis was then still a student at the Ecole des Beaux-Arts.)

[21] Raffaello Borghini, *Il Riposo*, Florence, 1584, p. 170

[22] Rudolf Czapek, *Grundprobleme der Malerei*, Leipzig, 1908

Kandinsky, *No 2*, 1912

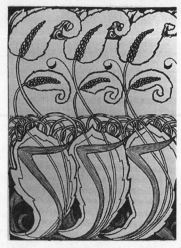

Art Nouveau wallpaper, 1898

1840s, bringing about the preoccupation with symmetry and geometric form as expressed through *flatness*.

Flatness, which was to become the *conditio sine qua non* of modernist painting, stemmed not so much from Borghini's *piano* as from Pugin's or Redgrave's definition that ' . . . flatness should be one of the principles for decorating a surface'.[23] The rejection of sense-deceiving imitation of nature and the ever-growing preoccupation with the function of form and colour by way of flatness clarifies the dominance of *contrast* in modern art, and consequently the fading out of tonal painting in the *round*. 'There are two provinces of ornament, the *flat* and the *round*; in the flat we have a contrast of light and dark, in the round a contrast of light and shade.'[24] On the other hand, 'all ornament should be based upon geometrical abstraction',[25] as ' . . . for instance, a panel, which by its very construction is flat, would be ornamented by leaves or flowers drawn out and extended, so as to display their geometrical forms on a flat surface.[26] Pugin was right to point out that 'Nothing can be more ridiculous than an apparently *reversed* groining to walk upon . . . the ancient paving tiles are quite consistent with their purpose, being merely ornamented with a pattern not produced by any apparent relief,

[23] Richard Redgrave, in *Supplementary Report on Design*, London, 1852

[24] Ralph Nicholson Wornum, *The Exhibition as a Lesson in Taste*, Crystal Palace Exhibition Catalogue, London, 1851, p.xxi

[25] Owen Jones, *The Grammar of Ornament*, London, 1856, vol. 1, Proposition 8

[26] A. N. W. Pugin, *Floriated Ornament*, London, 1849, introduction

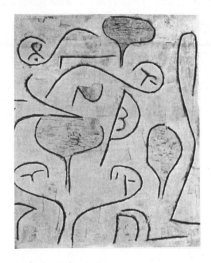

Klee, *Peach Harvest*, 1937

but only by *contrast of colours* . . . '[27] Interior decoration was brought back by Pugin, Owen Jones, Wornum and their followers, from picturesque perspectivism to its true origin and purpose: *ornament*.

From the 1840s onwards, flatness in interior decoration was accepted as being in good taste. On the other hand, the clarity of its theory was, more and more, convincing a new generation of artists disillusioned with the old rhetorical laws of Ideal Beauty. 'Granted that *design* includes both construction and ornamentation and that this latter should arise naturally out of the appropriate decoration, of suitable materials, we should arrive at a law of good taste.' [28] However, interior decoration is not painting. Who would have thought then that these very ideas, one hundred years later,would dominate painting itself and not only interior decoration? Was Clement Greenberg wrong in asserting that 'flatness, two–dimensionality, was the only condition painting shared with no other art'?[29] In fact, the particularity of European painting since Antiquity was the brushstroke modelling in the round, as opposed to the flatness of Egyptian, Indian, Persian or Mayan painting. The convex-concave relationships expressed by brushstrokes, as exemplified by Velázquez, are actually the traces of life: the ambiguities of shape and colour, between abstraction and representation – not an artifice of perspectivist

[27] A. N. W. Pugin, ibid., 25 seq.

[28] Richard Redgrave, *A Manual of Design*, London, 1876

[29] Clement Greenberg, 'Modernist Painting' in *Art and Literature*, Lausanne, Spring 1965, vol. 4, pp. 193–201

illusionism, as it eventually became, in its worst examples of *trompe-l'oeil* deceptions.

But the obsession with 'good taste' in design, the *frisson* of the utopian wind blowing from the Arts and Crafts Movement, the collapse of proper art-training with the extinction of the school of David, and above all, this consciousness of *la modernité*, all combined to give way to the ideas of *pure design*, which infiltrated painting during the last quarter of the nineteenth-century. Indeed, pure design had more to offer: it investigated colour (although this investigation started one century earlier[30] culminating in Chevreul's theory published in 1839) and its effect on feeling, within the interactions of colour, form and line. It offered a new view of the past, seen through form, not dominated by literary content. However, 'The principles discoverable in the works of the past belong to us; not so the results. It is taking the end for the means.'[31]

<p style="text-align:center">★ ★ ★ ★ ★</p>

While art training at the Ecole des Beaux-Arts was in full 'eclecticist' decay, from 1863 on, under the teachings of Cabanel and Bouguereau, pure design offered exciting investigations into formal and chromatic interactions. Indeed, Cabanel's or Bouguereau's colour is *pompier* because chromatically illogical. 'Decoration, if properly understood, would at once be seen to be a high art in the truest sense of the word, as it can teach, elevate, refine, induce lofty aspirations, and allay sorrows.'[32] Indeed, Maurice Denis, and later, Matisse, followed this creed. But it is at the Bauhaus that pure design was turned into pure form.

On the other hand, the search for the secrets of form and colour replaced the sense of colour, whence the loss of the ability to seize the visible. At the same time, the interest in the visible, nature or figure, diminished rapidly. It was replaced by the infatuation with 'pure painting', following 'pure design'.

[30] The first known treatise on design was written by Père Dominique Douat, a Carmelite friar, and presented to the French Academy in 1704, entitled *Méthode pour faire une infinité de desseins différents avec des carreaux mi-partis de deux couleurs par une Ligne diagonale* . . . , Paris 1722, cf. E.H. Gombrich, *The Sense of Order*, Oxford, 1979, p. 70

[31] Owen Jones, op. cit., Proposition 36

[32] Christopher Dresser, *Principles of Decorative Design*, London, 1873, repr.1973, p. 25

By pure design I mean simply order, this is to say, Harmony, Balance and Rhythm, in lines and spots of paint, in tones, measures and shapes. Pure design appeals to the eye just as absolute music appeals to the ear. The purpose of pure design is to achieve order in lines and spots of paint.[33]

Kandinsky was anticipated by Denman Ross, but was he aware of it when in *Ornamentik* he defined his goal in terms of '*Klang*',[34] a music-like vibration, a sort of visible sound? The analogy between painting and music (let alone architecture as 'frozen music') was probably always on some artist's mind. Arcimboldo's 'chromatic clavichord' note system (described by Comanini, 1591) and his colour-scale were performed as music. It was a first analogy between colour and sound, though a naïve one, and was only a curiosity. Poussin described and applied a theory of 'modes', based on Zarlino, by which each composition was conceived according to a 'mode' or a key. This was however, forgotten. It was again recognized in the nineteenth-century in analogy with ornament, but not with painting. 'I believe the analogy between music and ornament to be perfect. One is to the eye what the other is to the ear,' wrote Ralph Wornum in 1856.[35] However, this analogy, later formulated in detail by Kandinsky and Klee (who was also a musician),[36] was far removed from questions of affective qualities, the expressive values of intervals, and their analogy with colour. Although what Kandinsky meant by *Klang* also had mystical connotations: he believed in its effect on the soul. He looked for interiority, for *Innerlichkeit*, and saw it as abstraction, not content. Ornament was the gate to it. He found abstraction in Rosetti, Böcklin and even Segantini,[37] in the way one or the other handled structure, and not only in Cézanne's brushstrokes. In his search for the analogy between painting and music, he was cognizant of their dissimilarities, but also of their common structural essence: abstraction. He looked for 'the emancipation from Nature',[38] the bent for the *Nichtnaturellen*, for the 'inwardly abstract nature', the *zu*

[33] Denman W. Ross, *A Theory of Pure Design*, Boston and New York, 1907

[34] Kandinsky, *Über das Geistige in der Kunst*, Munich, 1912, passim

[35] Ralph Wornum, *The Analysis of Ornament*, London, 1856, p. 24

[36] Paul Klee, *Das Bildnerische Denken*, Basel 1956, pp. 285–7

[37] ' . . . nahm ganz fertige Naturformen, die er manchmal ins kleinste durcharbeitete (z.B. Bergketten, auch Steine, Tiere uw.), und immer verstand er, trotz der sichtbar materiellen Form, abstrakte Gestalten zu schaffen, wodurch er innerlich vielleicht der unmateriellste dieser Reihe ist', ibid., p. 50

[38] ibid., p. 114

innerer Natur[39] and 'melodic composition'.[40] He believed that 'colour has a direct influence on the soul, that colour is a key; the eye, a hammer; the soul, the piano with all its strings'.[41] He believed that purging the 'melodic composition' of any subject-matter, forms, lines and colours alone will reveal their inner *Klang*, like a melody.[42]

Musical analogy helped abstraction at the beginning, in liberating the process of painting from representational connotations. Formal autonomy with this *Prinzip der inneren Notwendigkeit* (principle of inner necessity)[43] as the heart of painting, transformed the picture from a transparency through which an illusion of Nature can be seen, to an opacity, a thing in itself, an *ipseitas*. Quatremère's idea of a principle of dissimilarity was realized. Art was at last completely detached from Nature, from the idea of imitation. Worringer, who strangely enough believed that art was at last emancipated from the scientific approach, celebrated this 'new art' as the 'real classical one', while condemning the 'old one' as 'joyless'.[44]

Imitation, though, is part of human nature, a need, perhaps originating in molecular recognition. Seeing is recognizing. Painting or drawing from life is a part of it. All communication beams back and forth through recognition. Form recognized as form in itself, as abstraction, contributed immensely to broaden art-perception even within drawing from Nature, thus liberating the qualitative dimension of a work from its signifying attributes. It was, in Mondrian's words, to ' . . . free itself from the domination of the subjective'. However, ' . . . every form, even every line, represents a figure; no form is absolutely neutral'.[45]

Pure abstraction enriched our perception, but under the influence of ornament it soon became ornate and self-referential. A mere sign. Thus breaking and disrupting the relay-cycle between art and nature. It disconnected

[39] ibid., p. 54

[40] ibid., p. 139

[41] 'Die Farbe ist die Taste. Das Auge ist der Hammer. Die Seele ist das Klavier mit vielen Saiten', ibid., p. 64

[42] ibid., p. 140

[43] Kandinsky, op. cit., pp. 64, 78, 126, and *passim*

[44] 'Die Alte Kunst war ein freudloser Selbsterhaltungstrieb gewesen; nun, da ihr transzendentales Wollen vom wissenschafftlichen Erkenntnisstreben aufgefangen und beruhigt wurde, schied sich das Reich der Kunst vom Reich der Wissenschafft. Und die neue Kunst, die nun ensteht ist die klassische Kunst', Wilhelm Worringer, *Abstraktion und Einfühlung* [1908], Munich, 1958, p. 182

[45] Piet Mondrian, 'Plastic Art and Pure Plastic Art', in *Figurative and Nonfigurative Art*' [London, 1937], New York, Wittenborn, 1945, pp. 50–63

painting from painting, expression from depiction, and the imaginary from the real. It followed ornament and design: 'Ornamental design is, in fact, a kind of practical science which, like other kinds, investigates the phenomena of nature for the purpose of applying natural principles and results to some new end.'[46]

The 'new end' was to become painting with painting as its end.

The idea that painting from life is wrong, that the 'sublime' picture is necessarily an abstraction, that it speaks to the mind rather than to feeling, that its aim is to improve mankind morally, derives from classical idealism. (Kandinsky was against it.)

The belief that style is prior to truth, that it results from *Kunstwollen* ('artwill')[47] – just as for any Egyptian mason who proceeded with his stone cutting from a squared pattern – that it was *Stilgerecht*,[48] derives from idealism (for the priority of style) and ornament (for the 'artwill').

The dogma that the appropriate modernist picture ought to be *flat*, that the concave and convex had to be discarded, that illusion is vulgar, came into painting from the shift of taste in interior decoration.

Modernist abstraction permitted the liberation of painting from the literary misunderstanding, from the anecdote (that virus of the eye) and gave the illusion that the old *mimesis* had vanished into oblivion. But she didn't. It permitted Mondrian to clean Vermeer's room, and empty it of its content. Mondrian closed the door, but left the key behind.

[46] William Dyce, 'Lecture on Ornament delivered to the Students of the London School of Design', *Journal of Design*, London, 1849, vol. I, pp. 26–9, 64–7 and 91–4; cf. Alf Bøe, *From Gothic Revival to Functional Form*, New York, 1979

[47] Alois Riegl on this subject in Erwin Panofsky, 'Die Theorie des Kunstwollens', in *Zeitschrifft für Ästhetik und allgemeine Kunstwissenschaft*, 1920, XIV

[48] Riegl, ibid., *passim*

ALBERTO GIACOMETTI:
A creed of failure [1]

Modernist – not quite. Traditionalist – not quite. His sculpture: neither realist nor abstract, looking old, as if excavated, but new because of its originality. His painting: nearly colourless. His drawing: a web of hesitations. Alberto Giacometti was paradoxical. Much has been said and written about his work – about his life,[2] calling it into question. Indeed, the aura around Giacometti's fame during his lifetime has somehow dimmed. This aura, made of words, was independent of his essential and moving art. It had definite literary connotations given by Sartre, Genet, or by himself, thus giving an added significance to the work, now less familiar to younger generations. He was among the first to break away from the modernist dogma, to point beyond his horizon to a restoration of the connection of art to nature. And yet, he was sceptical about the possibility of such a renewal, and was regarded as part of the avant-garde. But most of his imitators, practising messy drawing and messy painting, reflect upon him unfavourably, and it is through them that he is seen by his censors (a distorted view frequently brought upon masters by followers, as in the case of Caravaggio by the Caravaggists), but not by his admirers. Indeed, Giacometti's work grows on you: the more you look at it, the more it looks at you.

The oldest son of Annetta Stampa and the painter Giovanni Giacometti (1868–1933), Alberto was born on 10 October 1901 in the village of Stampa, (Grisons) in the Bregaglia valley, just below Maloja. And into art. The names of Cézanne, Van Gogh, Gauguin rang around his cradle, and Ferdinand Hodler (1853–1918), Cuno Amiet (1868–1961), Giovanni Segantini (1858–99) and cousin Augusto Giacometti (1877–1947), all artists of great renown then, leaned over it. The house at Stampa was one of the main nests of the new art in Switzerland, of the belief that a painting is an autonomous creation, that 'colour and line are means of expression far richer and more accomplished

[1] Written in 1988 for *The New York Review of Books*, and published in a shorter version under the title 'Giacometti's Code', vol. XXXVI, no. 8, 18 May 1989, pp. 20-4
[2] James Lord, *Giacometti: A Biography*, New York, 1983

ALBERTO GIACOMETTI

than the word, and what is actually said by such means can never be repeated by the word'.[3] The passionate discussions on the new art were among the earliest sounds in Alberto's ears. 'I began to draw in my father's studio as long ago as I can remember,' said Giacometti, who grew naturally into art having received a continuous 'natural' training. He chose to become a sculptor. 'I began to do sculpture because that was precisely the realm in which I understood least,' he said (Lord, p. 62). After passing through the Ecole des Arts et Métiers (Geneva), where he actually learned little, he went to Italy (1920–1) and then to Paris (1922), where he studied with Archipenko and Bourdelle, at the Académie de la Grande Chaumière. He was joined there by his brother Diego, who became an artist in his own right, creating objects, lamps and furniture in bronze (the last of which he created for the Musée Picasso) of a quality not seen since antiquity.[4] Except for the years of the German occupation, during which he was back in Switzerland where he later married Annette Arm, he remained in Paris (frequently visiting his mother in Stampa), creating all of his work from 1927 till the end of his life in the same run-down studio, 46 rue Hippolyte Maindron, in the fourteenth *arrondissement*, although he could have afforded in later years a more comfortable place . . . He died on 11 January 1966.

Alberto Giacometti was a born writer as well as a born artist. And by saying *writer* I mean that he possessed, besides the gift, in his case an extreme gift, for handling words, a need to give emphasis to syntax over reality. Just like Chateaubriand who often believed more in what he wrote than in what he saw. Giacometti's first published writings of the early thirties were in a Surrealist vein and remained whimsical throughout his life. Emphasis on syntax and a certain taste for rhetoric (and paradox) dominated Giacometti's writing and statements. In an interview given to Pierre Dumayet in 1963[5] he said: 'Resemblance? The more I see people the less I recognize them' – and to the question whether he recognized his brother, he answered:

He has posed for me ten thousand times, but when he poses I don't recognize him. I'm eager to have him pose for me in order to see what I see. When my wife poses for me, after three days of posing she doesn't resemble herself any more. I definitely don't recognize her . . .

[3] Giovanni Giacometti, in a letter to Cuno Amiet, 12 January 1909; cf. DU, Zurich, June 1987, p. 32
[4] Daniel Marchesseau / Jean Leymarie, *Diego Giacometti*, Hermann, Paris, 1986
[5] Pierre Dumayet, 'La Difficulté de faire une tête: Giacometti', *Le Nouveau Candide*, Paris, 6 June 1963

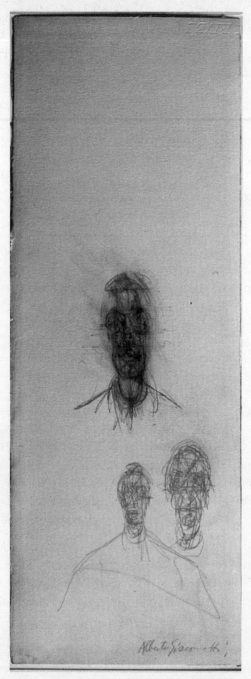

Giacometti, *Studies of Diego,* 1957, graphite,
50 x18 cm. (Paris, author's collection)

The entire question of working from observation was even more empha-
sized in his talk with Gotthard Jedlicka:[6]

This is strange! And yet I know this person! I even know what sort of hat
she wore thirty years ago. When I meet her in the street, her appearance is
familiar to me from afar; the way she walks, her figure, her face, I think I
could even draw her from memory without difficulty. But now, when
she's seated in front of me, I have the impression of being in front of a total
stranger . . . I don't know how I could think that I know her. I regret my
weakness in accepting to make her portrait.

No one, as far as I know, has questioned the topic of working from life as
emphatically. Indeed, the difference between a person we think we know well
and the same person as a sitter for a portrait is conditioned by the difference in
perception. In passing from passive seeing to heightened scrutiny, a known
face can suddenly become remote. Scrutiny necessarily transforms each
familiar face into an enormously complex formal sequence, into some sort of
unknown landscape. And yet, Giacometti did not work from life only, but also
from memory. Only his drawing was strictly done from life. In his statement
for his Museum of Modern Art exhibition (1965) he mentions that he 'worked
with the model all day from 1935 to 1940' and that 'nothing was as I had
imagined'. But strangely enough, he continued to sculpt from memory. Was
he not aware that working from memory leads to projection, back to things
known and stale, to regression, to mannerism? Although he said:

But wanting to create from memory what I have seen, to my terror the
sculptures became smaller and smaller, they had a likeness only when they
were small, their dimension revolted me, and tirelessly I began again, only
to end several months later at the same point . . . All this changed a little in
1945 through drawing.[7]

Likeness was what he looked for. The way to achieve it, he thought, was
through 'copying'. But the gate to 'copying' passed for him through failure.
Through the failure of seeing 'normally'. 'Le raté m'intéresse autant que le

[6] Gotthard Jedlicka, 'Fragmente aus Tagebüchern', *Neue Züricher Zeitung*, 4 April
1964

[7] 'A Letter from Alberto Giacometti to Pierre Matisse, 1947', first published in
New York, Pierre Matisse Gallery, Exhibition of Sculptures, Paintings, Drawings,
19 January–14 February 1948. Reprinted in *Alberto Giacometti*, Museum of Modern
Art, New York, 1965, p. 28

réussi' ('a failed work interests me as much as a successful one'), he said in an interview on the BBC to David Sylvester in 1964.[8] A few years earlier, in the preface he wrote for the catalogue of the André Derain exhibition (Galerie Maeght, 1957), he expressed a similar view: 'Mostly it is only when I like the defective work of a painter, his worst canvas, that I like his work. I think that for everybody the best canvas contains the traces of the worst, and the worst the traces of the best.'[9]

Failure interested him far more than skill, or virtuosity, for which he had a profound dislike. He refused pure single-line drawing, fashionable in the thirties and forties, and practised by so many Picasso and Matisse followers, or by Jean Cocteau. These single-line drawings were mostly lines for the line's sake. Virtuosity. Giacometti believed, as he told me, in the small hesitant line, in the point-by-point approach by which a sitter's likeness can gradually be captured. This was his connection to Cézanne. The single-line drawing generalizes, and Giacometti rejected this sort of generalization. His drawing sheet, or rather the space he delineated in it, is determined by an overall distribution of lines and blanks (which he often marked by the eraser). He used the eraser quite a lot (contrary to Picasso) and used to say: 'Of the two drawing tools, the pencil and the eraser, I don't know which is the more important.'

Drawing is an empirical activity subjected to concrete situations, such as the distance between the draughtsman and the model. Giacometti was literally obsessed with the problems of distance. For many years he drew from afar, as for example the fabulous drawing of Pierre Loeb (1950, Paris, Albert Loeb Collection) or the Stampa interiors and landscapes. During his last years, he moved closer and closer to his model – during my last visit to him, in the autumn of 1965, he showed me a portrait of Caroline, saying 'this is a close-up'. Lord mentions a still-life drawing Alberto began to draw in his father's studio, in Stampa at the age of eighteen or nineteen, which is a striking example of this preoccupation with distance:

> . . . he began to draw a still-life of pears on a table. He started by making the pears the same size he knew the pears on the table to be, as if a realistic appearance depended on the representation of known proportions. As he

[8] 'Fragment d'un entretien avec David Sylvester', *L'Ephémère*, Paris, vol. 18, pp. 183-9

[9] Alberto Giacometti, catalogue introduction for Derain exhibition, published in *Derrière le Miroir*, no. 94-5, Paris, February 1957, pp. 7-8

worked, he kept erasing what he'd done, until the pears had grown tiny. Giovanni [Alberto's father] observed this, and apparently assumed that the tiny pears were an affectation. He said, 'Just do them as they are, as you see them.' Starting again, Alberto ended up half an hour later with the same tiny pears.[10]

The fact is that Alberto drew them 'as they are', i.e. as he *saw* them, not as he knew them. It was the distance of the pears on the table from the viewer that determined their measure, hence their shrinking from what he knew of their size to what he actually saw. All his life Alberto was concerned with distance which determines the passage from concrete size to pictorial measure, the passage from perception to depiction. What is surprising is that at eighteen he already sensed the problem. But this quote is a rather free interpretation of Alberto's own words extracted from the BBC interview with David Sylvester, already mentioned. Alberto gave this example in order to emphasize the difference there is between seeing 'normally', which one has to understand, to my mind, as passive seeing, and active seeing, which would be perception through drawing.

Lord describes the same phenomenon as it occurred again eighteen years later, in 1937:

He had laboured hard to model from life a head which would be convincingly lifelike; he had begun the series of figures in plaster which, to his consternation, became tinier and tinier as he worked on them. Nothing satisfied him. The impotence so often experienced in intimate relationships seemed to have become a condition of creative life as well.[11]

Whatever . . . Lord disregards the ways by which the work in progress imposes and dictates its own laws: as soon as a line is drawn the line imposes its own rules. Freudian theory is of no avail in matters of art. Freud himself erred on the subject of Leonardo.[12]

In his recurrent description, which all of his friends and acquaintances knew by heart, having heard it again and again, of how one day, while watching a film at the Cinéac (a cinema now gone in the defunct Gare du Montparnasse)

[10] Lord, p. 33

[11] ibid., p. 182

[12] cf. Meyer Schapiro, 'Leonardo and Freud', *Journal of the History of Ideas*, vol. XVII, no. 4, 1954

he was struck by the distance of one nostril from the ear in the face of the person seated next to him. He became aware of the difficulty to depict, to 'copy' as he named it. 'You never copy the glass on the table, you copy the residue of a vision' . . . he said, which is indeed a phenomenological statement about transcending intentionality, but the pencil is not made of words, nor thoughts, but follows sensations. This statement may have been influenced by phenomenology (as suggested by Valerie Fletcher)[13] namely by Merleau-Ponty, but not his drawings. Although Giacometti was a great reader, he knew that art is not philosophy.

The truth is that in spite of his utterances, Giacometti remained a modernist. He was a reductionist, not unlike Mondrian, though different, not neat, nor fanatic. Both Mondrian and Giacometti developed divergent but austere plastic idioms of order versus disorder, with nothing else in common but austerity itself. Whereas Mondrian reduced his painting to nothing but the grid, Giacometti reduced his sculpture to the rod, and treated clay, the way one carves stone, not by *adding* as tradition has it, but by *taking out*, leaving hardly anything, but the armature, the bone, a metaphor of starvation.

It is astonishing in the first place that his wiry elongated figures, his colourless line-webbed paintings and later his scribbled life-drawings should have won the acclaim which was understandable for his earlier Cubist or Surrealist works – works which he himself qualified as 'objects which were for me the closest I could come to my vision of reality',[14] such as *The Spoon Woman* (1926), *Woman with Her Throat Cut* (1932), *The Palace at 4 a.m.* (1932–3) or *Invisible Object* (1934–5).

They were in line with the fashion and spirit of the time. In fact they are based on ambiguity, heavily depending on their title, which was essential for their power of fascination. The role of an appended title approximates the one played by the 'radical' in the Chinese characters by which the meaning of a sign is determined. (It is true though that Klee, too, titled his works, appending them with a poetic significance, for which reason he was 'annexed' by the Surrealists. And so did Miró.) The Surrealists brought back the literary or 'poetic' anecdote into the visual arts, even if irrationally tinted. Eidetic anecdote was their preference. Hence the importance of the titles. Without its

[13] Valerie J. Fletcher, *Alberto Giacometti 1901–1966*, exhibition catalogue, with essays by Silvio Berthoud and Reinhold Hohl, Hirshhorn Museum and Sculpture Garden, Smithsonian Institute, Washington DC, 1988

[14] Alberto Giacometti to Pierre Matisse, 1947, op. cit.

title would we still be fascinated by the *Palace at 4 a.m.*? It is the title which holds its mystery. Not the form. Is *Woman with Her Throat Cut* – without its title – not rather a mysterious crab-like object?

But this is also the case with other contemporary work such as Julio Gonzales's *Hair* (1930) or *Danseuse à la Palette* (1933) or Brancusi's *The Beginning of the World* (1924) or *Mademoiselle Pagany* (1920). This was extraction of symbolic form, which Giacometti practised as well. *Head Skull* (1934), originally called *Tête d'Homme*[15] is one of the most striking examples. His sculptures of the period 1926–35 fluctuated between the imitation of primitive art (such as the *Spoon Woman* or *Couple* [man and woman]) and symbolic forms, such as *Woman with Her Throat Cut*. They are in fact more objects than sculptures, but fascinating objects, which designate a subject, as it is *imagined*, not seen. He later wrote about this period: 'It was no longer the exterior forms that interested me but what I really felt.'[16]

This is also true for the later work as well, although after 1935 Giacometti gave up the poetic titles, and the *exterior forms* for nameless heads and figures, completely interiorized, such as *The Dog* (1951), *Walking Man* (1960) or *Bust of a Man* (Diego)1965. The pressure of his inner form produced an eruption of volcanic sculptures which were, unlike his drawings and paintings, not really done from life. He posed and re-posed the question of likeness, in paradoxical terms: 'It's impossible to reproduce what one sees,' he said,[17] after having said that between a portrait of Dürer, one of Raphael and a photograph of Marshal Foch, he preferred the photograph of Foch. And about the sculpture of *The Dog* (1951):

> For a long time, I'd had in my mind the memory of a Chinese dog I'd seen somewhere. And then one day I was walking along the rue de Vanves in the rain, close to the walls of the buildings, with my head down, feeling a little sad, perhaps, and I felt like a dog just then. So I made that sculpture. But it's not really a likeness at all . . . Anyway, people themselves are the only likenesses. I never get tired of looking at them. When I go to the Louvre, if I look at the people instead of at the paintings or sculptures, then I can't look at the works of art at all and I have to leave.[18]

15 cf. Valerie Fletcher, 1988, p. 106
16 Alberto Giacometti to Pierre Matisse,1947. op. cit.
17 James Lord, *A Giacometti Portrait*, New York, 1965, p. 21
18 Lord, ibid.

Thus, he was aware of the fact that a likeness cannot be created from memory, and yet he worked from memory in contradiction to his strong inclination to working from life, to picking without mediation a true likeness of an observed face, from the face. Not from memory. As a fruit is picked from a tree. Not from a can. He tried and failed. *Je recommence tout* he used continuously to say, instead of 'hello'. He started a head all over again and again, as Rembrandt did (according to Joachim von Sandrart): see the three successive busts of *Elie Lotar* (1965), masterpieces of trembling bronze.

When Alberto Giacometti gave up his symbolic forms in trying to sculpt a figure, and after a week wasn't getting anywhere, he said ' . . . I am going to begin by doing a head.'[19] André Breton is quoted as having declared (see chapter 'On Drawing from Observation'), 'Everybody knows what a head is.'[20] But he was wrong: each head differs, and getting one likeness is of no help in getting another. On the contrary: the artist will have to struggle hard in order to delete the traces of the former head while trying to capture the features of the present one. Breton couldn't possibly have known that. In spite of his immense culture, Breton was an outsider to the particularities of painting, though he was evidently fascinated by it, and had strong opinions on its subject. He detested Cézanne and had no use for Matisse. His interest was conditioned by the Surrealist experiment, in which Alberto Giacometti took part in 1930–5. On leaving it, Giacometti is reported as having said to Breton: 'Everything I have done till now has been no more than masturbation.'[21]

Preceded by Derain, Giacometti returned to the visual source, linking back seeing to doing and doing to feeling. But he remained a modernist believer, convinced that there was no way back to David or Ingres. But Cimabue and Giotto, Egyptian and Byzantine art, Pompeii, Fayoum and Cézanne were his beacons. He felt that his task was to make a work which would 'work both ways', as he used to say – as a thing in itself, independent of subject-matter, and as a 'copy' of the given subject-matter. Its representation, in his words *likeness*, or *'copy'*, was, however, something unreachable unless it passed through failure. But unlike Beckett's idea of failure, Giacometti's actually led to a 'happy-end' (and was qualified by Beckett as an *échec à récupération*). He often said, 'The arm which most resembles an arm is the Egyptian arm.' But the painting which least 'resembled' reality was, for him, High Renaissance

[19] James Lord, 1983, p. 154
[20] Simone de Beauvoir, *The Prime of Life* [1960], 1962; cf. Lord, p. 154
[21] Lord, 1983, p. 155

painting. However greatly he admired such a work as Le Nain's *The Cart* (1641, Paris, Musée du Louvre), he was certain this kind of painting was definitely over. There was evidently a contradiction at the core of his theory of which he may have been unaware: on the one hand he considered abstraction at an impasse, but such representational painting as Le Nain's, on the other hand, he considered beyond revival. Was it because he believed that the joy of seeing is completely disconnected from the act of painting, or that the gift to do it is lost, and now belonged to a lost Golden Age? Or is it that seeing, sensing, being moved by something and painting it was forbidden because considered naïve by the modernist canon? There was certainly a mixture of both. Giacometti often remarked ironically but with delight, that although his place was with the '*peintres de dimanche*' (amateur-artists), his work was always being exhibited with the abstractionists.

In leaving the Surrealist group, he gained their hostility and disdain – he 'became an Impressionist' they said. (Nothing could be worse in their eyes.) He found himself isolated again. But not for long. Somehow the aura gained by the Surrealists' sway reverberated in other circles as well and proved to be lasting. On the other hand, Giacometti's collaboration with the then famous interior decorator and designer Jean-Michel Frank (the main cause of his 'excommunication' by Breton) was to become decisive.

The world of art and fashion being both intermingled and interdependent, success in one often goes hand in hand with success in the other. Alberto soon found himself launched in fashionable Parisian circles to which he had *entrée* not only as a promising artist but also as a collaborator of Jean-Michel Frank, and he was accepted immediately by the beau monde.[22]

The objects Alberto created in collaboration with his brother Diego (who developed them further on his own) were at once the rage. His sculptures were to follow. The favour of the *gens du monde*, at least of the most enlightened ones among them, never abandoned him. Even when the frivolity of the thirties gave way to gravity in the first post-World-War-II years. When pieces such as *Head of a Man on a Rod* (1947) – which is not without affinity with the influential Julio Gonzales'(1876–1942) *Head of Montserrat* (1941–2) – made their appearance, the response was immediate. But what was read into Giacometti's frail figures was again literary content,

[22] ibid., p. 124

this time tinted with Existentialist overtones and Sartre's blessing. Sartre, whom Alberto first met in 1939, wrote in 1947 an important essay on him.[23] He was among the many writers and poets who formed Alberto's entourage, among whom his closest friends were Michel Leiris and Georges Bataille.

Alberto Giacometti's personality was magnetic. His wit, irony, love of ambiguity, complexity and finesse are not easy to define now, nor were they easy to capture then. Writing his biography therefore, would have required, as in poetry translation, an author not too much unlike himself; it should have been the equivalent of painting his portrait from life; entirely from life; by words, told from life. But, alas, this is undoubtedly an impossible task. Imagination is the invisible veil hanging between author and subject; it leads to self-projection, to fiction, which is the matrix a novel is made of. Not a biography. James Lord chose to write not a 'life' in the *vite* tradition, but a biographical novel. In it sources (of which 307 are listed, but there are many more) of a vast variety, memories, facts, gossip and fiction are knitted into a vast depiction of an epoch. Venturing on such an ambitious task obliged the author to have recourse to his imagination whenever a detail was missing. Despite his long-standing acquaintance with Giacometti, he couldn't possibly have witnessed everything.

In his introduction to Daniel Defoe, Anthony Burgess writes: 'The Defoe we prize is not a working journalist but a novelist whose method is that of the working journalist. To be termed "an imaginative writer" would have terrified him. The purpose of the pen was to render, in seemingly unconsidered immediacy, true events . . . '[24] The method Lord employed in his first book, *A Giacometti Portrait*,[25] was that of the 'working journalist'; he certainly tried to stick to the search for truth in the vast biographical enterprise of his second book, *Giacometti: A Biography*, which was greeted favourably by critics who did not know Giacometti personally, but aroused vehement dissent among Alberto's friends and acquaintances, some of whom published a manifesto protesting the 'distorted portrayal of the man we knew'. David Sylvester expressed a view which I am afraid many share, in which he says: 'My problem with this book is that it seems highly informative when it is dealing

[23] Jean-Paul Sartre, 'La recherche de l'absolu', in *Les Temps Modernes*, Paris, January 1948, pp. 1153-63

[24] Daniel Defoe, *A Journal of the Plague Year*, edited by Anthony Burgess and Christopher Bristow, with an introduction by Anthony Burgess, Harmondsworth, Middlesex, 1966

[25] James Lord, *A Giacometti Portrait*, Museum of Modern Art, New York, 1965

with matters of which I have no knowledge but is constantly inaccurate when dealing with matters I do know about.'[26]

Alberto's wit, sense of humour and wisdom come across better in James Lord's rightly celebrated slim volume *A Giacometti Portrait*. In it, Lord registered with accuracy and modesty what he observed and heard during the eighteen sittings for his painted portrait. But the 68-page volume, a little masterpiece of journalism, is not a biography. (One of the worst examples in the field of biography in recent years is the unauthorized 'biography' aimed at the life of Samuel Beckett – who opposed the project. Its author, who saw Beckett only once, added ridicule to injury in producing a 'life' rightly qualified by the late Richard Ellmann as 'The Life of Sim Botchit'.)[27]

In writing an artist's biography, the psychoanalytically biased writer can hinder the impact of the artist's work and may even mislead the reader, since the true artist reduces the particulars of life to ashes, like Alberto Giacometti, who burned his life for his work.

[26] David Sylvester, 'Giacometti and Bacon', *London Review of Books*, 19 March 1987, pp. 8–9
[27] Richard Ellmann, 'The Life of Sim Botchit', *New York Review of Books*, 15 June 1978, pp. 3–8

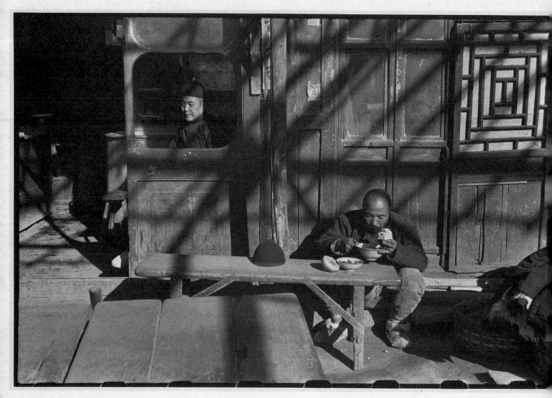

Henri Cartier-Bresson, *The Last Days of the Kuomintang, Peking, 1949*, photograph

HENRI CARTIER-BRESSON [1]

You might say about him that he carries proportional compasses in his eye. Clearly, every one of Henri Cartier-Bresson's photographed images is rigorously defined by its proportions, its dynamic and the distribution of its blacks and whites. Subjects come to him miraculously, as if to order. They come formulated in advance. This is because his eye, like the eagle's eye, a painter's eye, is on the lookout. Because he sees in any given subject, what the subject is made of, and seen from this angle, no subject is indifferent. The image in front of me, *The Last Days of the Kuomintang, Peking, 1949*, in its composition reminds me of Caravaggio's *Beheading of St John* (1608, Malta, Cathedral). In a horizontal space at perfect right angles, two men. One, immobile, looking away, the other, eating, looking into his bowl. The black at the left and the white at the right trigger the tension. The shadowy corner on the left has its response in the door on the right, on top of which a second entwined rectangle generates a hypnotic rhythm. On the left, a door leading to a black space, its opening, an inverted rectangle, frames in counterpoint the immobile Chinese man looking away. His riposte: the man seated eating, placed exactly at the harmonic intersection (the Golden Mean). He holds a bowl in his hands. Another bowl, placed on the bench, echoes the first. The black skull-cap is their counterpoint. A hatched diagonal shadow strikes by miracle from upward to downward, and from right to left, disturbing the peaceful horizontality of the scene. All hinges on it.

[1] Originally written in French, for the Centre National de la Photographie, at the occasion of the tribute paid to Henri Cartier-Bresson on his 80th birthday

LOOKING AT PAINTING[1]

In all that is, all that is no longer is evoked: testimony, echo, a mirror's shadow, what a life was. It will end without a surveyor's view of it. Only traces inadvertently left. For this time-delayed riddle, someone else will have a key.

Being moved by a poem another life has given birth to is to be moved for oneself. The continuity of the poem resides in its being read, but what exactly that reading reveals is not clear. The continuity of the painting resides in the contemplation of it. We contemplate it, we can be moved by it, but we cannot discern with precision what in it moves us. Nothing is sayable. It remains as separate as the mirror does from its onlooker.

A picture changes in each person's perception. It risks being taken for what is projected into it. It can be darkened or lightened, seen as beautiful or forbidding, moving or common. It can be made into an object. It can become a passion. The picture: namely, one of its two sides – the painting. The other side is the image.

Painting is visible outside significance. An image is visible through significance. Painting reveals. An image reminds. The two sides are thus back to back. To see only one side unleashes darkness on the other. Painting is not seen the same way as is the image. The erroneously directed gaze will result in reading becoming the substitute for seeing, and in transforming a source of emotion into a system of signs, thus extinguishing the painting and lighting up the image.

The image has to be read. It is an ideogram, more or less complex, made to represent an event or an idea exterior to itself. It is somewhat like information, given and received, of an event which one did not actually experience oneself. The image is not a visual event, as the painting is. The image depends on deciphering or decoding, and has no other value. Illusory congruence, as if access to two simultaneous points of view were possible. Of the impression of

[1] Originally written in French in 1964–5 and published in *Les Lettres Nouvelles*, Paris, May–June 1966, pp. 75–7, under the title 'Peinture et Regard'. Translated by Anne Atik.

having been there and here, when really one was neither there nor entirely here.

Painting is not to be read. It is not an ideogram. It has no role to play. It is not a materialization and represents truly only what it is: lines, forms and colours in interaction on a plane. Somebody worked on it, let his plane organize itself until it closed. And abandoned it. Later, something in it will become visible to somebody else. A dead angle. Is it the bird's-eye view? It is, rather, a particular quality, invisible until now. Not to be compared, and without material existence. A living shadow. Is it the painter's mirror? Or that of the passer-by?

The painter, in painting, is alone; his painting is separated from what's around him. Contemplating a painting is like looking into someone's eyes. Though only the hand shows through. His hand operates. His eyes follow. The hand proceeds blindly, a source of sight. What will he have painted? What he saw? What he would have liked to see? His hand will have accomplished something else. His hand will have disappointed him. Lost in an unsuspected zone, instrument of perdition or revelation.

The painter at work. Carried away. When the head intervenes, that stops. If only the hand, that stops. Carried away, he is neither in the past nor in the present, but only there in what is truest in him. If he's not carried away, he will remain inert in front of his canvas, the arbitrary his only recourse.

Art is nothing. It is a breath, it passes through the breath and stays in the breath.

<div align="right">1964–5</div>

AN OFFSHORE GLANCE AT
PAINTING IN BRITAIN[1]

Painters of a variety and quality such as not to be found elsewhere in Europe today emerged in Britain during the last two decades, not only Francis Bacon. To the *Englishness* on the one hand and influences of the *Ecole de Paris* on the other, something else followed, something I would qualify as 'Interoccidental'. Stanley Spencer's Englishness was transcended by Lucian Freud, and carried much further, in such a way that we can now see Stanley Spencer thanks to Lucian Freud. Something similar can be said about Auerbach versus Bomberg. Auerbach's manner, his impastos squeezed from nature, reflect back on Bomberg's versatility and depth. There is a wide dimension and true authenticity in quite a number of painters in Britain, such as Freud, or Kitaj, which seem to have emerged naturally and without loss of the pictorial tradition, as happened elsewhere. On the contrary, their modernity is rooted in the pictorial legacy. Kitaj revives history-painting in a modernist idiom by transmuting literary ideas into enticing images. Freud's powerful figures, Hockney's splendid drawings, Auerbach's expressive brushstrokes, Bridget Riley's chromatic experiments, or Richard Hamilton's wit, Hodgkin, Blake, Kossoff and others, all differ, but merge in their high quality. What essentially distinguishes painting in Britain today from any other, is its high level. Generally, art training elsewhere is in poor shape today. A young person born with a gift for art risks not being able to develop that gift, and many tend to start painting without training, thus falling into an insufferable amateurism. Although art training collapsed in France long ago, with the extinction of the School of David, followed later by the 1863 reform of the Ecole des Beaux-Arts, there were still alternatives. Tools and methods were still transmitted, within the inevitable change of taste, from one generation to the next. A young person with a gift for art could still receive the necessary training. This

[1] Written for *Art International*, vol. I, no. 1(new series), Paris, Autumn 1987, pp. 62–4

222

is still relatively so in Britain, where art schools are generally governed by a keen vision of professional competence, with draughtsmanship at the root, as should be the case. In France, as well as in other places, professional competence and drawing as the 'probity of art', seem to have been replaced by audacity,which is at the root of the very notion of avant-garde. It is this notion of avant-garde which now makes the heart of most young art students beat. This shakes the foundations of knowledge received as tradition and now rejected as 'academic'. But avant-garde is a self-destructive concept. It is founded on novelty which produces an ever increasing spin, hence the acceleration of change. This is, in short, the situation prevailing today in France, where, after the extinction of the School of Paris, a cycle seems to have come to a close.

British painting came in late. But, like Russian literature in the nineteenth century, it came like an explosion. It had an impact in the early 1820s on such artists as Géricault and Delacroix, and although considered as somehow apart from European mainstream art, it was most admired by the French at the 1855 Exposition Universelle. Hogarth, who, as quoted by the Redgrave brothers (1866), said, 'we cannot vie with these Italian Gothic theatres of art, and to enter into competition with them is ridiculous; we are a commercial people,'[2] would have been perplexed by the sudden fashionable aura enhancing British painting in French eyes one century later. But the twentieth century somehow showed only one corner of British painting alight, viewed from the continent, and that was mostly marked by social portraiture. It was not any longer seen as a source for living art. No more lighthouses were seen from this shore, as they were seen one century earlier in Turner, Constable and Bonington. Fewer and fewer artists were aware that some of the theories and methods of Impressionism and Modernism were of British origin. Although Monet is quoted by Wynford Dewhurst, in *What is Impressionism*, (1911),[3] as having told a British journalist that most of the theory of Impressionism is to be found in Ruskin. Indeed, Ruskin's *Elements of Drawing* (1857) contains not only the theory of direct perceptual outdoor painting, but also the pointillist method (paragraphs 168 and 169). However, *The Elements of Drawing* was not translated into French – Ruskin's ideas, presumably

[2] cf. Samuel & Richard Redgrave, *A Century of British Painters*, London, 1947, pp. 1–2

[3] In *Contemporary Review*, London, March 1911

indebted to Chevreul, probably filtered back through the numerous treatises on colour sparked by the same Chevreul's *De la loi du contraste simultané* (1839), of which *Modern Chromatics* by Ogden Rood,[4] containing excerpts from Ruskin, namely paragraphs 168, 169 and 172, headed in his book 'Breaking one colour in small points through or over another', was translated into French and read by Seurat. But not only Ruskin's ideas contributed to the modernist movement. The theory of flatness beaming back and forth across the Channel – started by Chevreul (1827) – was carried further in Britain. To Chevreul's chromatic investigations, the one of form applying to ornament was added. The notion that illusionist perspective is in bad taste stems from A.W.Pugin's theory of interior decoration (1841). This theory was to evolve into the concept of pure design elaborated by Owen Jones, Ralph Wornum, William Dyce, Christopher Dresser, William Morris and the Arts and Crafts Movement, which I see as the main source of the notion of *peinture pure*. The Bauhaus, which owed so much to the Arts and Crafts Movement, unwillingly foreshadowed its legitimate ancestor in moving from ornament to painting. In this frenzy of pure painting, Matthew Smith and Sickert were overlooked. British art was seen from outside as being locked in the British Isles. This is no longer so.

[4] New York, 1879; second edition, entitled *The Students' Text-Book of Colour, or Modern Chromatics with Application to Art and Industry*, New York, 1881; French translation, under the title *Théorie Scientifique des Couleurs*, Paris, 1881

ON LIGHT
a fragment[1]

'Did I mention it?' writes Rilke in *The Notebooks of Malte Laurids Brigge*, 'I am learning to see. Yes, I start.'[2] He meant painting. Such a starting point would require an optimal possibility of viewing increasingly denied to us now – except in Munich's Alte and Neue Pinakothek.

Public galleries and museums which had suitable natural light, such as the National Gallery in London, the Prado in Madrid, the Museum of Modern Art in New York and too many others, blocked it all out, replacing natural with artificial light.

Consulting the masters, which has always been a necessity for every painter, became increasingly impossible because of the difficulty of correct perception. The days of viewing painting in normal light conditions, i.e. natural light, seem to be over. Can we imagine Cézanne's reaction to viewing Chardin or Poussin all distorted by artificial light? He would tremble with rage at not being able to sense with precision a picture's chromatic modulation.

The ancients must have known what our technological generation seems to have forgotten: the passage from brightness to dimness increases the perceptive capacities. Indeed, this is due to the regeneration of the visual pigments, particularly of Rhodopsin. Excessive artificial luminous intensity is known to have a worse effect on the perception of tonal painting than poor natural light. And yet, nearly all exhibitions of masterpieces of tonal painting are presented to the public in artificial light, or in a mixture of artificial and natural light, resulting in a total chromatic distortion of their perception. It is common knowledge that increased artificial luminance makes red and green-yellow appear more yellow, violet and blue-green bluer. On the other hand, artificial light, reconstituting one or another segment of the spectrum, tends

[1] A fragment of 'On Natural Light' published in *Le Débat*, no. 44, Paris, March–May 1987, pp.164-6; *Antique*, London, Summer 1987, p. 47; and *Art in America*, January 1988, pp. 102-4 (edited imperfect version)

[2] 'Habe ich es schon gesagt? Ich lerne sehen. Ja, ich fange an' – Rainer Maria Rilke, *Die Aufzeichnungen des Malte Laurids Brigge*, Leipzig 1922, p. 4

to set the relationship between brightness, lightness, hue and saturation of colour off balance. Thus distorting the equal intervals along the spectrum. The mixture of natural with artificial light, now a common museum practice, carries the imbalance even further by provoking an oscillation in the visual adaptation, whence the feeling of uncertainty, of malaise, we experience when we cannot tell what tone is what.

Seeing painting does not differ from attentive listening to music, note by note. Seeing painting right is seeing it tone by tone, hue by hue. But seeing right, sensing the chromatic effect of a cool shade meeting a warm one (often a key to a masterpiece), is increasingly impossible. Natural light, on which seeing painting right depends, is now banned from most galleries and museums. The entire pictorial legacy of Western civilization is being distorted by electricians . . . Museum and gallery directors, art historians and curators are often more familiar with the cultural aspects of painting than with its intricacies. Some of them, even the brilliant scholars, fall under the spell of their conservation advisers in the belief that natural light, because of UV rays, is a threat to the permanence of colour in painting – true, a crimson lake, which is an organic pigment, should definitely not be overexposed to natural light, but there is no such fear for a red ochre, for example, or any other inorganic pigment which is lightfast. The work of Velázquez, whose palette is constituted of inorganic pigments, can be exposed to daylight without danger, but not Duccio's; nor any illuminated manuscript; nor any sepia or bistre drawing. However, artificial light is not less harmful: the cool white fluorescent, tungsten filament and white mercury lamps also emit ultraviolet waves. Modern technology has developed possibilities of protection against UV by simply shielding the works of art - or better even, the windows – with perfectly neutral and translucent plexiglass. However, the ideal natural light for viewing painting is indirect north light; a painting should preferably be exposed so as to receive its light laterally, not facing a window and never under direct sunlight.

Tea merchants of the Far East would never dream of buying a new crop of tea without first examining its leaves by north light. Pearl traders trust only daylight when examining a pearl's 'orient'. Tonal painting, or any painting painted in daylight, must be viewed in daylight, for which there is no replacement yet.

Imagine a concert hall whose acoustics falsified pitch: Schubert off by a fraction. One would scream. But artificial light which distorts the perception of painting as bad acoustics would music is accepted. Protests are only heard when one dares put out the electric light supplementing daylight. It is

therefore in vain that painters have sought, and some still seek, the exact tone, which is doomed to be extinguished as soon as exhibited. Then again, reproductions have also contributed to the blunting of keenness of discernment. The importance of fineness is recognized in electronics but forgotten in matters of art. Strange that scientific and technological progress, instead of contributing to an improvement in conditions of viewing painting in museums, has ended in provoking such a regression by the use of artificial light.

True, public protest would be general if artificial light permitting one to see painting in a light bright but false wasn't switched on. To sing out of tune is still considered an absolutely intolerable assault upon the ear. But to see out of tone – that seems to be all right.

The young generation is thus deprived of all the pictorial subtleties which they will not have seen.

1987

FROM PRAYER TO PAINTING
On Being Given the Award of the FJF[1]

The often-discussed question of how it is that the lack of a Jewish pictorial tradition did not block the coming into the world, especially during this century, of so many painters of Jewish origin, arises again and again. An answer to this question can be found in a remark made by the Israeli writer S. Yizhar at the sight of a flower after hours of travelling in the Negev desert: 'A flower in the desert is like a mute who begins to talk,' he said.

Indeed, in obeying the law, Jews were visually mute, in spite of the fact that there were, here and there, anonymous masterpieces such as the *Dura-Europos* frescoes, the Beith-Alpha mosaic, or illuminated manuscripts. Nevertheless, ensuing from the image-prohibition, the desire for visual satisfaction was inhibited. But let us remember in passing that there was also a Byzantine iconoclastic period, and that the refusal of sacred images inspired by the Lutheran Reformation persuaded a number of artists, notably Grünewald, to renounce painting.

The words uttered by Rabbi Shim'on on condemning one who is arrested by the beauty of a tree or a field and who says: 'How beautiful it is, this tree, how beautiful it is, this field',[2] are aimed against distraction from, and especially the interruption of, study. Not against beauty itself. The prohibition of images in the ten commandments was aimed most of all against idolatry by the intermediary of images. In another way, rejection of the cult of beauty was motivated more by the fear of idolatry than by fear of beauty, considered rather to be profane or diverting.

[1] Le Prix des Arts, des Lettres et des Sciences – Fondation du Judaïsme Français, Paris, 25 May 1989. The members of the jury were: Elisabeth Badinter, Henri Atlan, Daniel Barenboim, Jean Blot, Elisabeth de Fontenay, Ernest Frank, Jean Halperin, Emmanuel Le Roy Ladurie, Simon Nora, Pierre Rosenberg, David de Rothschild, Léon Schwarzenberg, Elie Wiesel; presidency: Emmanuel Levinas; the speakers: Pierre Rosenberg and Emmanuel Levinas. Translated from the French original.

[2] 'Ma naeh illan zeh! uma naeh nir zeh! . . . umafsik mimishnato' – *Mishnah*, Nezyqin, avoth, G,Z

The theological prohibition was not the only obstacle to the development of a great pictorial art in the blinding light of the Middle East, more conducive to sculpture; it was caused especially by the successive destructions and dispersions. The ruins reduced to ash and dust did not permit a blossoming forth of a visual culture, if only architectural and decorative, and the persecutions didn't allow the long halt in front of beauty, often confused with luxury.

Visual meditation is essential in Taoism and Zen Buddhism, whereas Jewish mysticism mainly practised inward meditation, the eyes closed.

> The secret of the closed eye and the open eye is that the closed eye sees the luminous mirror and the open eye sees the mirror that is not luminous, from which it follows that the open vision of the non-luminous mirror is seeing, and that of the luminous mirror with the eyes closed is knowing.[3]

Seeing, therefore, is not considered here as a source of knowledge. And it is with closed eyes that colour is imagined – but not seen – by Rabbi Moshé ben Shem-Tov de Leon, the author of *The Zohar*, who has Rabbi Shim'on bar-Yohai say, 'There are visible tones, and invisible tones, and these and the others are faith's supreme secret, and men don't know it and don't see it . . . these invisible tones which no one merited until they were recognized by our ancestors.'[4]

These 'invisible tones' suggest chromatic sensations which stem from simultaneous contrast, although the tones evoked here are evidently not those of the palette, but of mystic speculation. Speculation giving prominence to the principle of revelation, *hitgaluth*, that only the omission of aesthetic perception sets apart from *satori* (Zen). However, certain precepts of the *Sepher Yetzira* (c.second century), like the distinction made between doing, producing and creating, in the *sephiroth*, could have been suitable for a theory of artistic creation. Certain principles, like that of revelation (*hitgaluth*) or of contraction (*tsimtsum*), are close to Tao or Zen. Others, as for example the principles of contemplation, intent and fervour – *hitbonenuth, kavanah* and *dvekuth* – are virtually convertible into precepts of artistic creation, merging with the principles of Aristotle, Cicero and Vitruvius that governed classical art. The principles of *hitbonenuthh, kavanah,* and *dvekuth* can be seen as

[3] *The Zohar*, Gvanim veoroth, 25
[4] *The Zohar*, Gvanim veoroth, 10–15

The Vision of Dry Bones (hazon haatzamoth hayeveshoth), fresco, detail, *c.* 240–245, Dura–Europos

constituting a sort of pendant to Cicero's rhetoric of the soul, gesture and expression.[5] Nevertheless, Ciceronian principles concern the orator as actor, with the view of influencing the public, whereas the Jewish mystics aimed only at the intensification of prayer. Does the ease with which the passage is made from prayer to painting for newcomers to art such as Soutine or Modigliani, Mark Rothko or Barnett Newman stem from there? In passing from prayer with closed eyes to painting or sculpture they were as if led by the same fervour, the same *dvekuth*. Drawing, sculpting or painting with *dvekuth* – isn't that a form of prayer? For it's the quality of prayer that distinguishes painting that is moving from painting that decorates.

Drawing or painting from life necessitates this *dvekuth*, this fervour of adherence to the subject which remains beyond, out of the imaginary range. A draped fold drawn from life discloses its secrets which can be turned into marvel (see Leonardo) but not an imagined fold, always bric-à-brac. An apple or a face cannot move us without being true, and cannot be true without being caught from life in their total likeness, uniqueness. It's more of a groping study achieved in a state of not knowing, but feeling. It's in a way a revelational act, whence its kinship with the mystic act, but also with scientific observation.

But why this necessity to retain through perception, by the eye and hand, what strikes us one instant? This need for form and colour? Is it the echo of Being, of molecular imitation? The desire to retain this living but vanishing instant? The result is a deepening of the world by aesthetic emotion. But this emotion, with 30,000 years behind it, that is art, always hides its cause. 'It is from the secret of the first point that totality ensued, in an impenetrable state.'[6]

Indeed, while serving magic, divinities, princes, beauty or entertainment, art's *raison d'être* remains as unfathomable as Being itself. And yet, art has been practised from the beginning of prehistoric times. It is likely that from the beginning there were those who saw, in a tracing of a bison, the beauty of the line, while the greater part saw only the image of the bison. Aesthetic emotion only reverberates through aesthetic vision. Routine reading or decoding abolishes it. An image has to be read, decoded. Not a painting. It demands a particular kind of looking, just as music demands a particular kind of listening. But the lack of visual culture still preponderates, and the visual

5 Cicero, *De Oratore*, III, 220-1
6 *The Zohar*, haelohuth, qav yashar h'a, 18, 71

sense is doubtless the least developed of the senses. Whence the confusion between seeing and reading. Regarding this, Ludwig Wittgenstein wrote: 'Many have learned the word "see" without making use of it.'[7] The faculty of seeing is universal. But not that of artistic perception. It resides in the given culture, and, as for certain kinds of fruit, it is possible that the variety of perception, its subtlety, is conditioned by geography. Yet the exception is the rule. Not time or place. Who was the inspired sculptor who sculpted the portrait of the Oni of Ife (Nigeria) around the year AD 1000, an incomparable artist and the only one in that part of the world? Art history is a history of exceptions. Heroic epochs don't necessarily favour heroic art, because they are already an expression. The renascence of the Hebrew State, for example, has found its epic expression in the poetic and literary but not in the pictorial form. This is because the equation between the subject and the means of expressing it has to be true. Wars and the reclaiming of the desert, combats, the comrades killed, the scream of the wounded, the smell of blood and powder – all that is too vast to be expressed by the pictorial idiom, because of its shrinking credibility. The equation between such a vast subject and the means of expressing it, could be found in film. Indeed, film has replaced and somehow superseded history painting.

The heroic ordeal is an epic, in itself an experience, inexpressible by art in its still burning immediacy. Its expression comes later, as in the *Iliad* or *Odyssey*. Holland's war of liberation against Spain, which lasted eighty years, didn't mark Dutch painting with a seal of the heroic, but, on the contrary, with peaceful and prosaic genre scenes. The expressible dwindles in relation to the amplitude of the subject. Painting amplifies the infinitesimal: the truth of a fold or that of a small shadow, and its totality hangs by a hair. The heroic experience makes it faint and disappear. Painting a tomato in the face of heroism seems derisory, and not painting it would be no longer to make art.

[7] 'Viele haben das Wort "sehen" gelernt und nie einen derartigen Gebrauch von ihm gemacht', Ludwig Wittgenstein, *Remarks on the Philosophy of Psychology*, 1980, vol. I, 12

INDEX

Kühnel, Bianca 27
Kunstwollen 195, 205

Laclotte, Michel 18, 173
Lancret, Nicolas 179
Landau, David 22
Lapauze, Henry 153, 156, 157, 158, 165, 166
Las Meninas 53, 54, 55, 57, 59, 60
lay figures 61, 74, 75, 76, 78
Le Blond de La Tour 76, 77
Le Brun, Charles 69, 123
Le Nain, Antoine, Louis and Mathieu 215
Lee, Rensselaer W 106
Leggiadria 16
Lemoyne, François 172
Leonardo, da Vinci 74, 78, 80, 81, 83, 99, 110, 112, 122, 123, 125, 126, 140, 141, 211, 231
Lessing, Gotholt Ephraim 97
Li 109
Lionello, d'Este 20
Lipsius, Justus 30, 39
Livy 62, 71
Locquin, Jean 130
Lomazzo, Giampaolo 74, 83, 104, 106, 120, 196
Longhi, Roberto 49
Lopez-Rey, José 45, 46
Lorenzo di Credi 123
Louis XIII 38, 79, 95, 161, 166
Louis XIV 69, 70
Louis XV 128
Louis XVI 145
Loyrette, Henri 18
Lumen 103
luminance 225
Lux 103

Madba 27, 28
Mahon, Denis 67, 68, 92
Mâle, Emile 183, 190
Malevitch, Casimir 106
Malvasia, Carlo Cesare 130
Mancini, Giulio 80
Manet, Edouard 60, 161

Mantegna, Andrea 19, 20, 21, 22, 23, 24, 25, 26, 27, 28, 120, 144
Marculf 186
marginal gradient 191
Marino, Giambattista, Cavaliere 65, 74
Martin, Gregory 39
Masaccio, Tommasso di Ser Giovanni 27, 118, 130, 138
Mascardi, Agostino 98, 103
massicot 74
Massimi, Cardinal Camillo (Carlo) 52
Matisse, Henri 60, 112, 131, 132, 148, 166, 173, 180, 183, 184, 185, 188, 191, 192, 193, 202, 209, 210, 212, 213, 214
Meder, Joseph 77, 116, 118, 120, 123, 140
medieval colour-symbolism 184
Medici, Cosimo di 112
Meiss, Millard 27, 28
Melzi, Francesco 83
Mendelssohn, Fanny 162
Mengs, Anton-Rapael 197
Menzel, Adolph 9, 132
Merrifield, Mary 138
Michelangelo, Buonarroti 34, 35, 75, 89, 110, 111, 125, 132, 138, 141
microform 134, 197
minium 74
minyan 66
Miró, Joan 212
Mishnah 228
modelling 130, 172, 201
modes 95, 96, 97, 98, 103, 203
modus humilis 64
Mola, Pier-Francesco 70
Mondrian, Piet 106, 181, 195, 204, 205, 212
Monet, Claude 182, 223
Monteverdi, Claudio 34
Morandi, Giorgio 132
morbidezza 58, 138
Morris, William 224
Moshé ben Shem-Tov de Leon 229
moti and *affetti* 68, 92, 98
Mottez, Victor 173
Mourlot, Fernand 183, 192
Mozarabic 116, 184, 186
Mu-chi 134

239